Winslow Homer *in the Adirondacks*

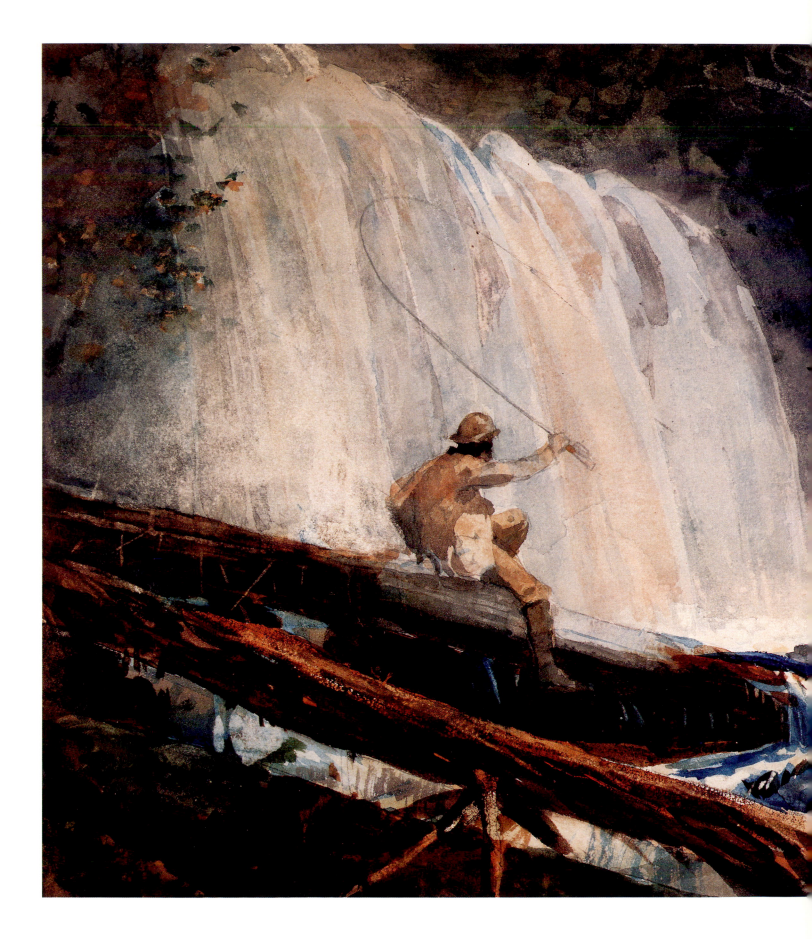

Winslow Homer
in the
Adirondacks

David Tatham

Syracuse University Press

Copyright © 1996 by Syracuse University Press
Syracuse, New York 13244-5160

First Edition 1996

96 97 98 99 00 01 6 5 4 3 2 1

Winner of the 1996 John Ben Snow Prize.

Frontispiece: Waterfall, Adirondacks, 1889. Courtesy of
the Freer Gallery of Art, Smithsonian Institution.

The paper used in this publication meets the minimum requirements of
American National Standard for Information Sciences—Permanence
of Paper for Printed Library Materials, ANSI Z39.48-1984.

Library of Congress Cataloging-in-Publication Data

Tatham, David.
Winslow Homer in the Adirondacks / David Tatham.
 p. cm.
Includes bibliographical references and index.
ISBN 0-8156-0343-6 (cloth : alk. paper)
1. Homer, Winslow, 1836–1910—Criticism and interpretation.
2. Adirondack Mountains (N.Y.) in art. I. Title.
N6537.H58T38 1996
760' .092—dc20 95-52921

Book design and production by Hillside Studio, Inc.
Printed in Hong Kong by Everbest Printing Company, Ltd.

Contents

Colorplates and Figures

Donors

Publication of this book is made possible through generous support from the following sources:

William Fleming Educational Fund

FURTHERMORE . . . the J. M. Kaplan Fund publication program

Friends of Lois Homer Graham, in her memory

Beatrice and Edwin Jahn

Eric and Judy Mower

David Tatham was born in Wellesley, Massachusetts, and educated at the University of Massachusetts and Syracuse University. Since 1972 he has been a member of the faculty of the Department of Fine Arts at Syracuse. He is the author of books, exhibition catalogues, and articles on painting and the graphic arts in nineteenth-century America, including *Winslow Homer and the Illustrated Book* (Syracuse University Press).

Acknowledgments

WHEN I SET OUT to write a study of Winslow Homer's Adirondack work, Leila Fosburgh Wilson took me on land and water to the places at the North Woods Club where the artist had painted. Over the years she has graciously provided insights into the history of an organization with which her family has been associated for a century. I am ever grateful.

Well before I began, Lloyd and Edith Havens Goodrich, whose pioneering research into Homer's life and work remains the foundation for all subsequent studies of the artist, encouraged me to undertake the project. Abigail Booth Gerdts, director of the Lloyd Goodrich and Edith Havens Goodrich/Whitney Museum of American Art Record of Works by Winslow Homer, has with great resourcefulness and constant good cheer facilitated my access to the Goodrich files. The Goodriches's catalogue raisonné of Homer's life work, which Mrs. Gerdts is completing, amplifying, and preparing for publication, has made it unnecessary for me to give comprehensive histories of the ownership and literature of the Adirondack paintings I discuss. Helen Cooper's study of Homer's watercolors has allowed me to omit, for the most part, descriptions of his watercolor technique.

Lois Homer Graham read with great care early drafts of parts of the manuscript and offered helpful comments about the life and work of her distinguished great uncle. Warder Cadbury has been a constant source of invaluable insights about a region he knows and writes about so well. I have been fortunate to know and learn much from Rose Flynn Brown, Elizabeth Flynn Filkins, Patrick Flynn, and Mary Flynn Jenkins, whose father, Michael Flynn, posed for many of Homer's Adirondack paintings. At the Adirondack Museum, Blue Mountain Lake, Gerald Pepper, librarian, and Caroline Welsh, curator-in-chief, have aided my research. So also have Dorothy Irving, librarian for Archives of the Keene Valley Library Association, Noelle Donahue of the Minerva Historical Society, Patricia Anderson Junker, assistant curator of American art at the DeYoung Museum, San Francisco, Margaret Conrads, curator of American art at the Nelson-Atkins Gallery, Kansas City, Randall Bond and Edward Gokey of the Syracuse University Library, and the late Charles Kays, who conducted me on a memorable morning's tour of the North Woods Club in 1966, long before this book was envisioned. Most of the book finally came to be written in London during the spring of 1995 and, as has been the case with several other of my studies in American art, I wrote it in the British Library's Round Reading Room: *ave atque vale.*

The participants in month-long National Endowment for the Humanities Summer Seminars for School Teachers held at Syracuse University each summer from 1992 through 1995 brought new insights and sharpened my thinking on many matters of interpretation. I thank especially Aksel Pedersen for his trenchant insights concerning matters of com-

Acknowledgments

position and technique in Homer's work. The members of graduate seminars I conducted in my own department on Homer and his work in 1992 and 1994 illuminated much about his practice and his times. In preparing a master's thesis on Homer's color theory, Jana Colacino caused me to reexamine some of my assumptions about his Adirondack work, with happy results. In a dissertation on the history of the Adirondack guide Richard Roth broadened my knowledge of that vital aspect of the region. John Fruehwirth has been an admirable copyeditor, Lucy Wellner, an able mapmaker.

I acknowledge with deep appreciation the support of the Syracuse University Office of Research in funding much of the travel and photographic work necessary to complete the project. William Fleming supported the progress and publication of this book with word and deed. A grant from the Fleming Educational Fund has made much of the color reproduction of Homer's work possible.

Thanks are due Jane Van Norman Turano and Jayne Kuchna of the *American Art Journal,* and Nicolai Cikovsky, Jr., curator of American and British art at the National Gallery of Art, for encouragement as in recent years I prepared three essays on aspects of Homer's time in the Adirondacks. Some of the substance of these papers, rethought and recast, appears in this book, but the three essays remain independent studies. All three papers reached print before evidence of Homer's 1877 visit to the region had come to light, requiring the redating of two major paintings; I thank Margaret Conrads and Abigail Booth Gerdts for sharing that discovery with me. I am much obliged to Margaret Fayerweather for directing me to Edwin Adams's daybook and to Sherman Gray for information about Adams himself.

In reading my manuscript prior to its final revisions, Georgia Barnhill has continued her practice of offering helpful criticism of my Homer studies. Abraham Veinus, mentor and colleague, set those studies in motion in the late 1960s with his espousal of the fundamental importance of American studies to an understanding of the development of twentieth-century culture world wide. Whatever is worthy in the present book owes as much to his tutelage in the realm of thinking and writing about art as it does to Lloyd Goodrich's sharply-focused advice to me, also in the late 1960s, concerning what needed to be done in Homer research.

As in past projects, Cleota Reed has taken time from her own scholarly work to aid the advance of her husband's. Some of her photographs of the scenery Homer knew well appear in this book. We thank the members of the North Woods Club for the warmth of their hospitality over several years, and their patient trust as, with pen and camera, we followed Homer's trail. Our youngest grandsons, Emmanuel Vernon Tiliakos and Lucas Reed Martin, gained their first views of that trail as I read proofs and made the task all the happier.

Introduction

WINSLOW HOMER first journeyed to the Adirondacks of northern New York State in 1870, at age thirty-four, when he was a rising star in his generation of American painters. His last visit to the region came in 1910, the year of his death, by which time he had gained a place of honor in the constellation of American Old Masters. All told, he traveled to the Adirondacks at least twenty-one times in the course of four decades, occasionally twice in a single year. No other locale, not even Prout's Neck on the coast of Maine, held his attention as an artist for so long a period.

His visits to the Adirondacks coincided with an era of intense public interest in this vast wilderness, a region of more than six million acres of deep forest then broken by only a few primitive roads and scattered villages. It was, and remains, among the most scenic regions of its size in America, more varied and intimate in its charms than the grander wild country of the West. In the Adirondacks' northeast quadrant more than forty peaks rise above four thousand feet. More than two thousand lakes and ponds lie throughout the forest. They feed the several rivers, including the Hudson, that radiate from the mountains.

Although artists had painted in the Adirondacks as early as the 1830s and had a regular presence in a few locales beginning in the mid-1850s, only in the 1860s and early 1870s did Americans in general begin to discover with their own eyes the distinctive topography and culture of the great forest. In 1870 Homer became part of the first major wave of sportsmen and tourists to arrive in the region. His long association with the Adirondacks spanned both the years of growing public awareness of this scenic wilderness and the years soon following when the arrival of massive logging operations threatened great expanses of the land. As the felling of the forest moved ahead, it aroused a public outcry that led in 1885 to the creation by the State of New York of the Adirondack Forest Preserve. By amendment of the state's constitution in 1892, the Adirondack State Park came into being. It remains an expanse of protected public and private lands far greater in size than any national park.

Except for a few visits to Keene Valley in the 1870s, Homer went always to the same place in the Adirondacks: a group of rustic buildings in a forest clearing in the Essex County township of Minerva, well south of the High Peaks. In duration, his visits ranged from a single week to as much as two and a half months. From these residences at the edge of wilderness came a number of drawings, six prints, a dozen oil paintings, and about a hundred watercolors. There has been a tendency over the generations to think of this Adirondack work as the product of an artist on holiday—as work somehow less serious in ambition or content than other paintings by his hand whose subjects seem deeper or more universal. But any close study of Homer's Adirondack work shows that it held a central

place in his development as an artist. Far from being "sporting" art or a record of play, his Adirondack oils and watercolors constitute a highly original examination of the human race's relationship to the natural world at a time when long-established assumptions about humans, nature, and art itself were undergoing profound change.

Except through the evidence of his work, Homer's thinking has never been easy to document. He wrote nothing for publication and left no discursive journals or diaries. His letters are remarkable chiefly for their taciturnity. They scarcely touch on art, except for its business side. In conversation, he was notoriously a man of few words. Almost nothing has survived of what he said about his Adirondack work, or most other aspects of his creative life. It would be wrong to attribute this reserve to diffidence, for he comprehended perfectly well the originality and importance of what he was doing. His disinclination to discuss his work came instead from his belief that an object of art must speak for itself. As he grew older he acted on this conviction by declining, at times with little grace, to comment on his paintings. More than most of his contemporaries, in matters of art he viewed history, criticism, interpretation, and even the explanation of subjects as extraneous to the act of looking—as intrusions into the realm of pure seeing. He staked his all on the visual intellect and mistrusted verbal constructions that purport to explain visual experience. He was right, of course; his paintings speak for themselves, and they do so with great eloquence. But as is true of all great art, his works can profit from an illumination of the circumstances of their production and reception and from a consideration of those many qualities inherent in them that so variously reward our contemplation.

Great talents travel in unpredictable directions. They compel us to follow, even when they seem to lead far afield. Homer's travels took him repeatedly to the Adirondacks. This book seeks to meet him there.

Winslow Homer *in the Adirondacks*

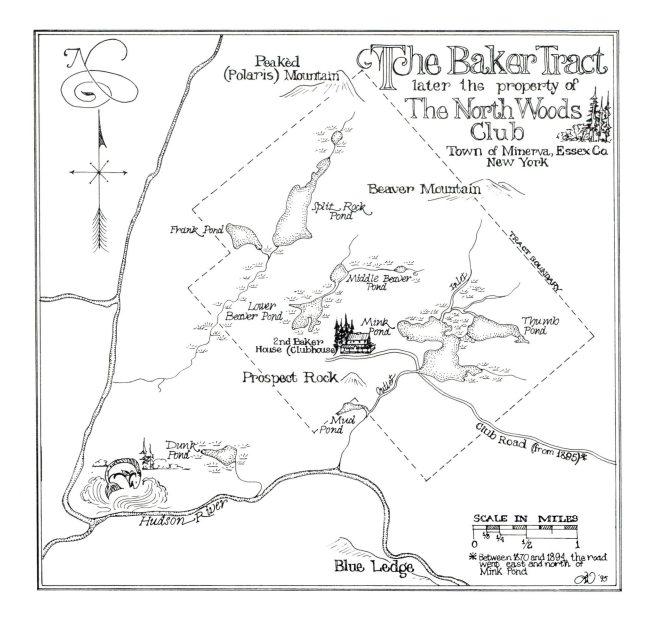

The Baker Tract
later the property of
The North Woods Club

Town of Minerva, Essex Co.
New York

Peakèd
(Polaris) Mountain

Beaver Mountain

TRACT BOUNDARY

Split Rock Pond

Frank Pond

Middle Beaver Pond

Inlet

Lower Beaver Pond

Thumb Pond

Mink Pond

2nd Baker House (Clubhouse)

Prospect Rock

Outlet

Club Road (from 1895) ✳

Mud Pond

Dunk Pond

Hudson River

Blue Ledge

SCALE IN MILES

0 ⅛ ¼ ½ 1

✳ Between 1870 and 1894, the road
went east and north of
Mink Pond

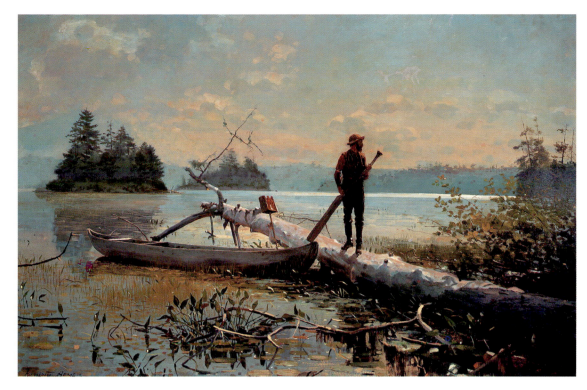

1. *The Trapper, Adirondack Lake,* 1870. Oil on canvas, 20 x 30". Colby College Art Museum. Courtesy of Colby College.

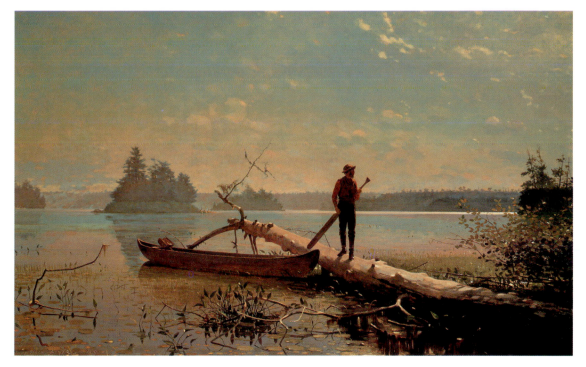

2. *Adirondack Lake,* 1870. Oil on canvas, 24 x 38". Henry Art Gallery, University of Washington. Photograph by Richard Nicol. Courtesy of Henry Art Gallery.

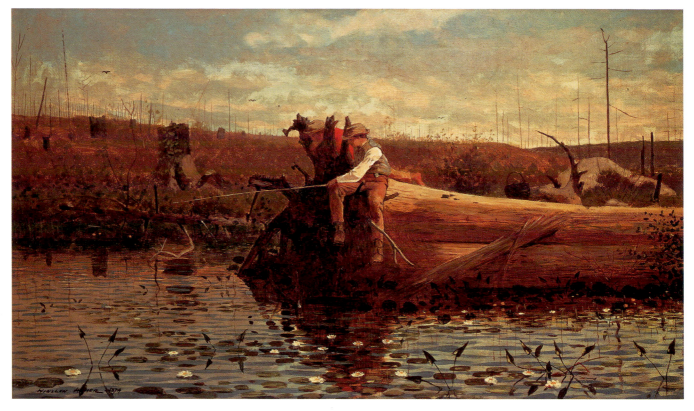

3. *Waiting for a Bite*, 1874. Oil on canvas, 12 x 20". Cummer Gallery of Art. Courtesy of the Cummer Museum of Art and Gardens, Jacksonville, Florida. Bequest of Ninah Cummer. C.119.

4. *Waiting for a Bite (Why Don't the Suckers Bite?)*, 1874. Watercolor, 7¼ x 13¼". Addison Gallery of American Art, Phillips Academy. © Addison Gallery of American Art, Phillips Academy, Andover, Massachusetts. All Rights Reserved.

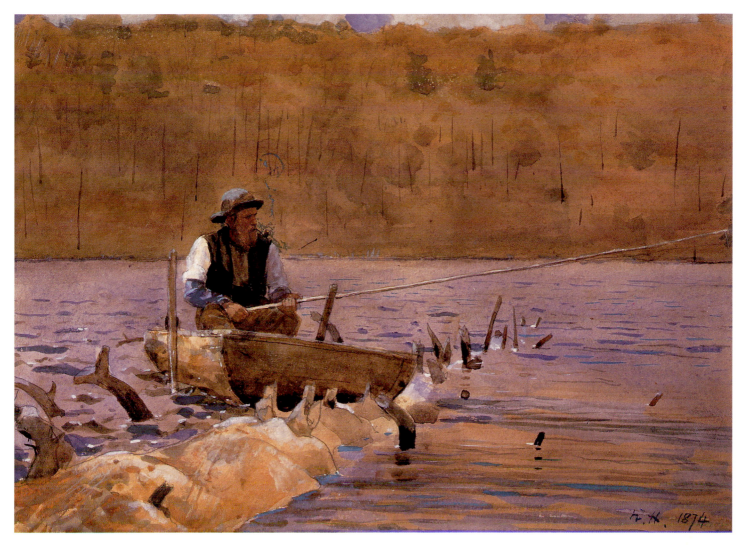

5. *Man in a Punt, Fishing*, 1874. Watercolor, 9¾ x 13½". Private collection.

6. *In the Mountains,* 1877. Oil on canvas, 24 x 38". Brooklyn Museum.
Courtesy of the Brooklyn Museum. Dick S. Ramsay Fund.

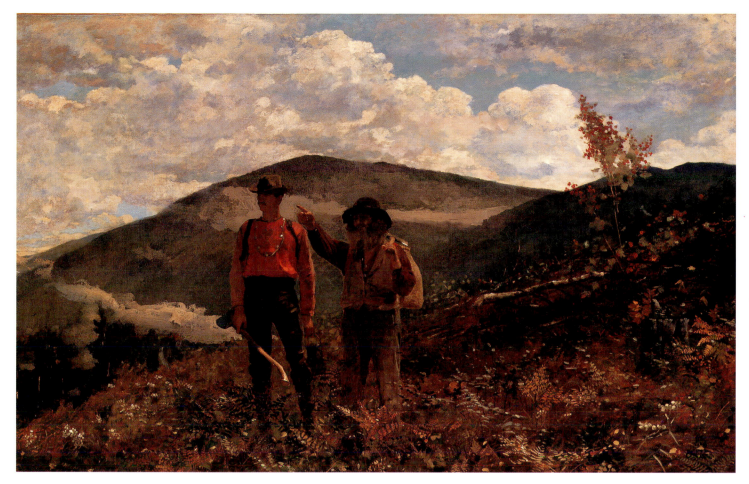

7. *The Two Guides,* 1877. Oil on canvas, 24¼ x 38¼". Sterling and Francine Clark Art Institute. Copyright © Sterling and Francine Clark Art Institute, Williamstown, Massachusetts. Courtesy of the institute.

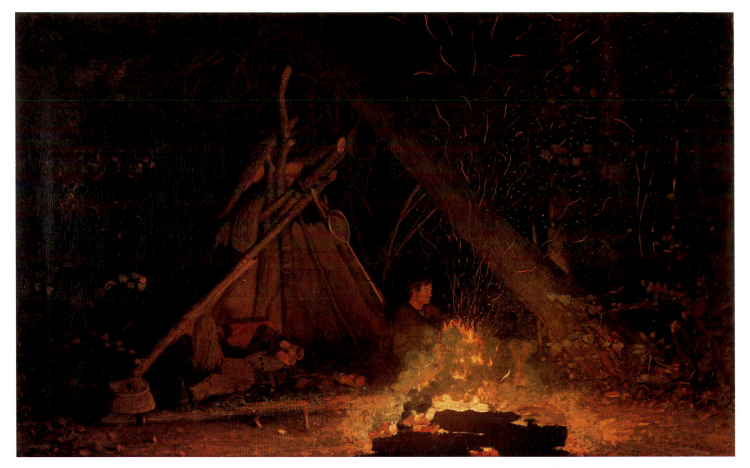

8. *Camp Fire,* 1877 (dated 1880). Oil on canvas, 23¾ x 38⅛ ". Metropolitan Museum of Art. Courtesy of The Metropolitan Museum of Art. Gift of Henry Keney Pomeroy, 1927 (27.181). All Rights Reserved.

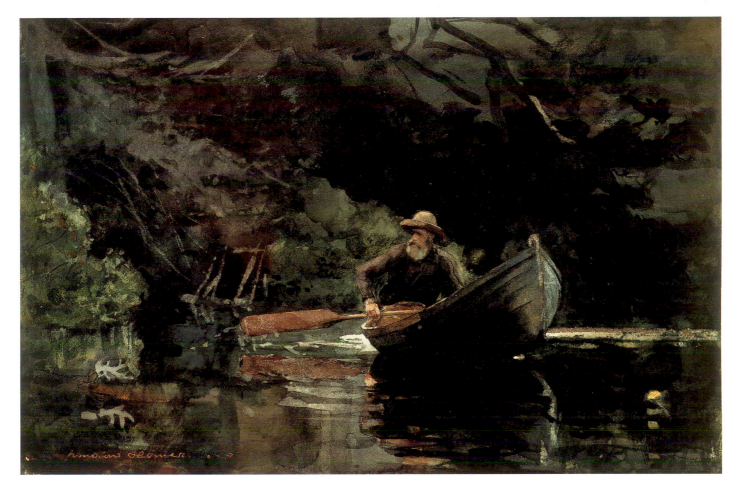

9. *The Guide,* 1889. Watercolor, 14 x 20". Portland Museum of Art. Courtesy of the Portland Museum of Art. Bequest of Charles Shipman Payson, 1988.55.8.

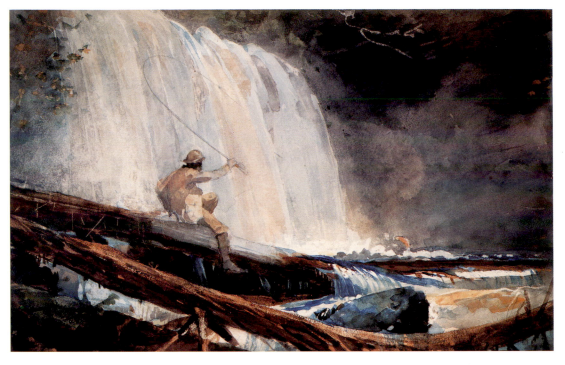

10. *Waterfall, Adirondacks,* 1889. Watercolor, 13⅝ x 19⅝". Freer Gallery of Art, Smithsonian Institution. Courtesy of the Freer Gallery of Art.

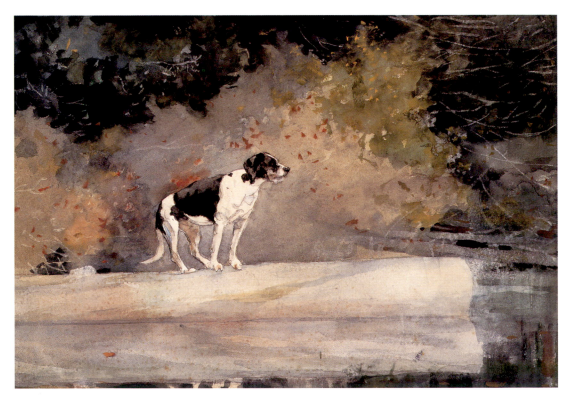

11. *Dog on a Log,* 1889. Watercolor, 13¹⁵⁄₁₆ x 19". Addison Gallery of American Art, Phillips Academy. © Addison Gallery of American Art, Phillips Academy, Andover, Massachusetts. All Rights Reserved.

12. *An October Day*, 1889. Watercolor, 13⅞ x 19¾". Sterling and Francine Clark Art Institute. Copyright © Sterling and Francine Clark Art Institute, Williamstown, Massachusetts. Courtesy of the institute.

13. *Jumping Trout,* 1889. Watercolor,
13 x 19¾". Brooklyn Museum.
Courtesy of the Brooklyn Museum.
In memory of Dick S. Ramsay.

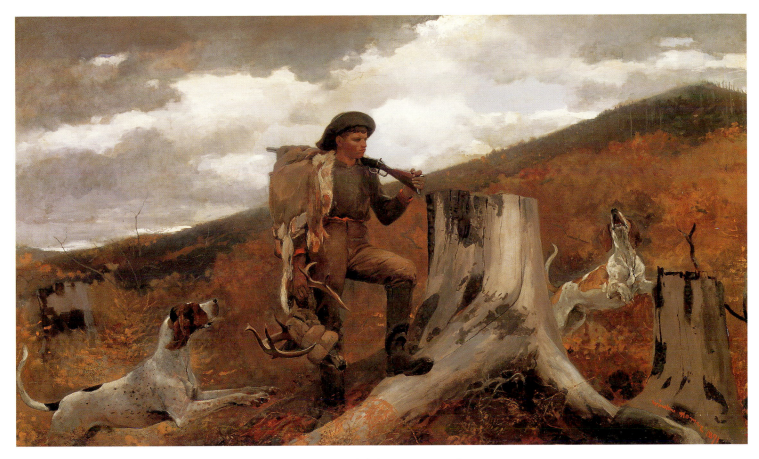

15. *Huntsman and Dogs,* 1891. Oil on canvas, 28¼ x 48". Philadelphia Museum of Art.
The William L. Elkins Collection. Courtesy of the museum.

14. *Leaping Trout,* 1889. Watercolor, 14 x 20". Museum of Fine Arts, Boston. Purchased, William
Wilkins Warren Fund. Courtesy of the Museum of Fine Arts, Boston (opposite).

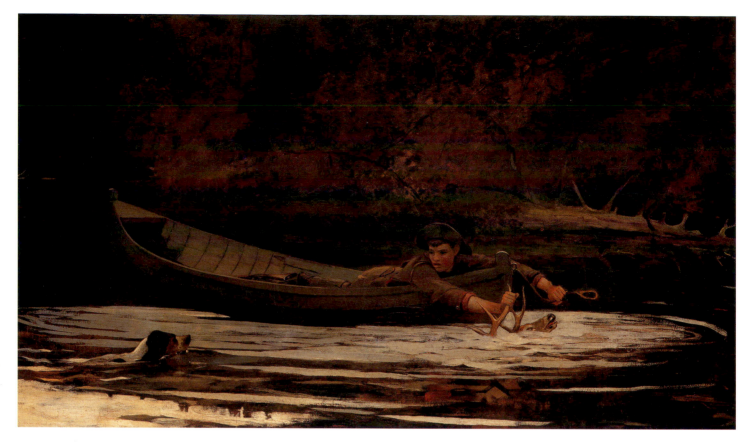

16. *Hound and Hunter,* 1892. Oil on canvas, 28¼ x 48⅛". National Gallery of Art. Gift of
Stephen C. Clark. © 1996 Board of Trustees, National Gallery of Art, Washington.

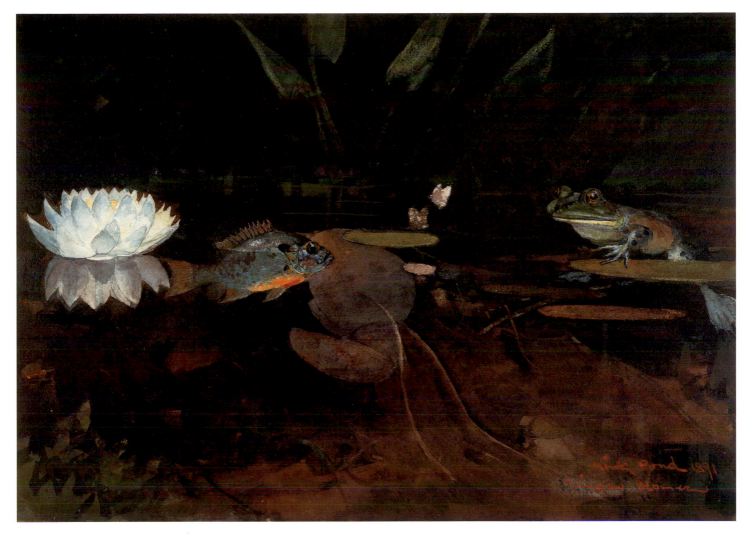

17. *Mink Pond,* 1891. Watercolor, 13⅞ x 20". Fogg Art Museum, Harvard University Art Museums. Courtesy of Fogg Art Museum, Harvard University Art Museums. Bequest of Grenville L. Winthrop.

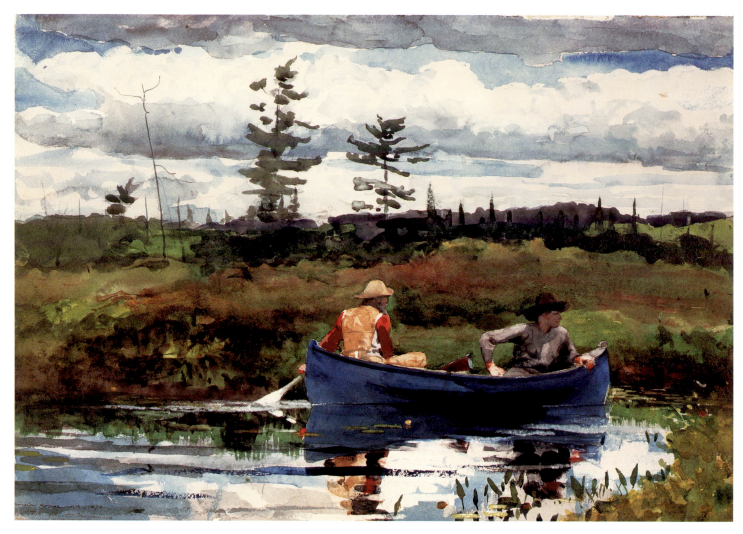

18. *The Blue Boat,* 1892. Watercolor, 15⅛ x 21½". Museum of Fine Arts, Boston.
Bequest of William Sturgis Bigelow. Courtesy of the Museum of Fine Arts, Boston.

19. *Old Friends,* 1894. Watercolor, 21½ x 15⅛".
Worcester Art Museum. Courtesy of the Worcester
Art Museum, Worcester, Massachusetts (opposite).

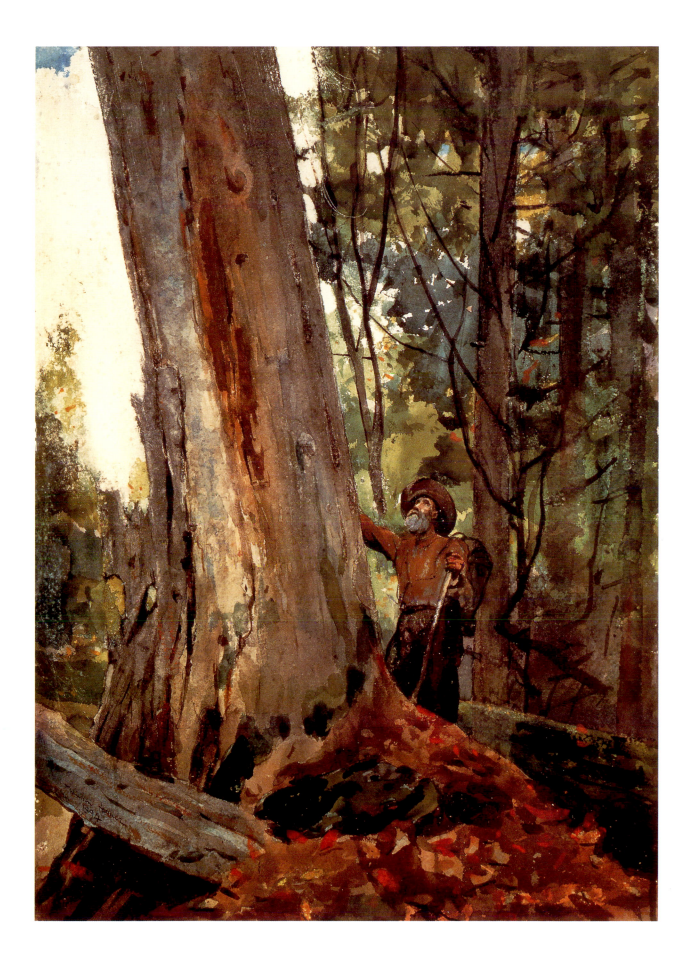

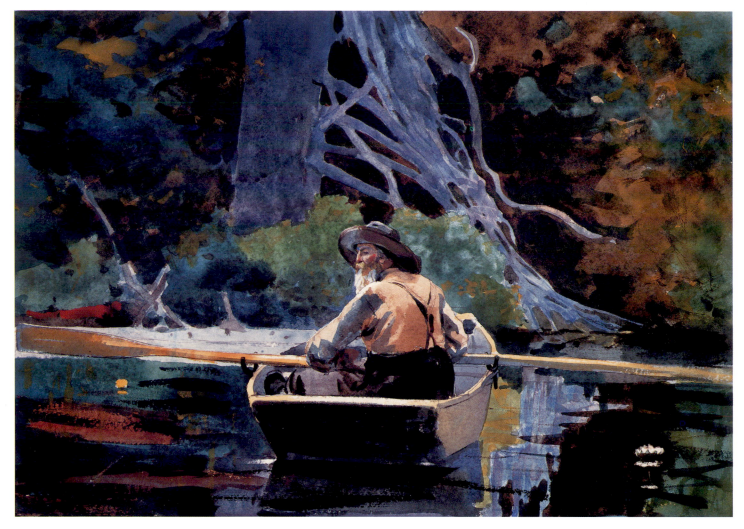

20. *The Adirondack Guide*, 1894. Watercolor, 15⅛ x 21½". Museum of Fine Arts, Boston. Bequest of Mrs. Alma H. Wadleigh. Courtesy of the Museum of Fine Art, Boston.

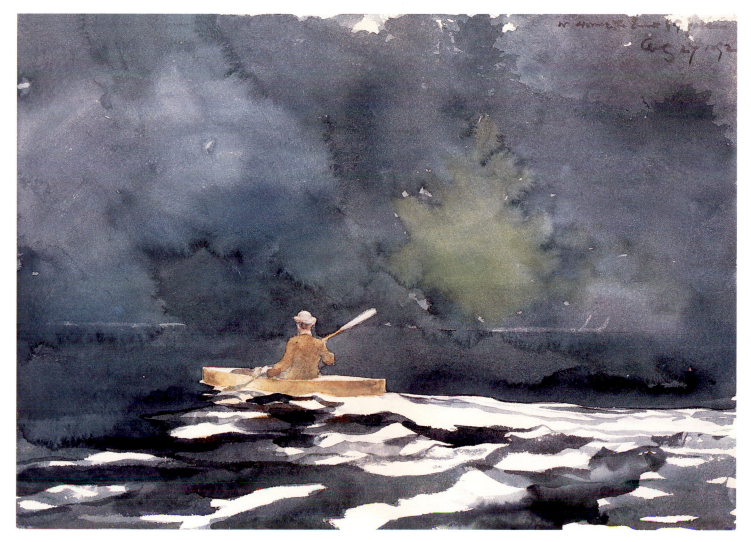

21. *Paddling at Dusk,* 1892. Watercolor, 15 x 21½". Memorial Art Gallery, Rochester, N.Y. Courtesy of the Memorial Art Gallery of the University of Rochester. Anonymous gift.

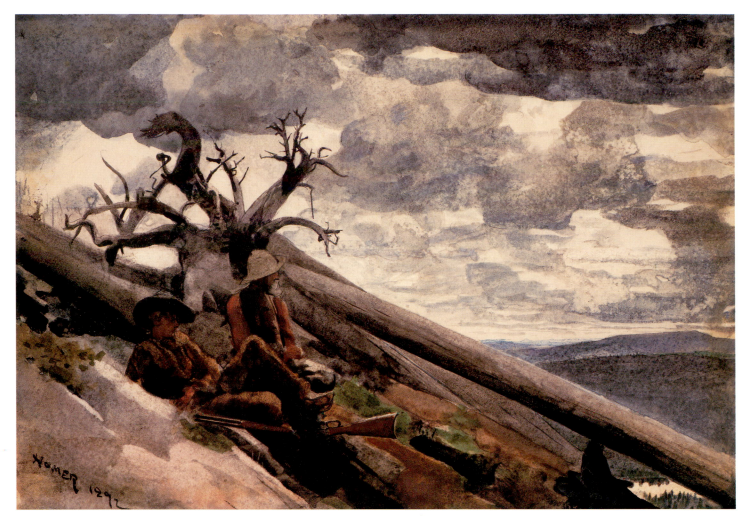

22. *Burnt Mountain,* 1892. Watercolor, 14 x 20". The Fine Arts Museums of San Francisco. Courtesy of The Fine Arts Museums of San Francisco, Achenbach Foundation for Graphic Arts. Gift of Mr. and Mrs. John D. Rockefeller, 3rd, 1979.7.55.

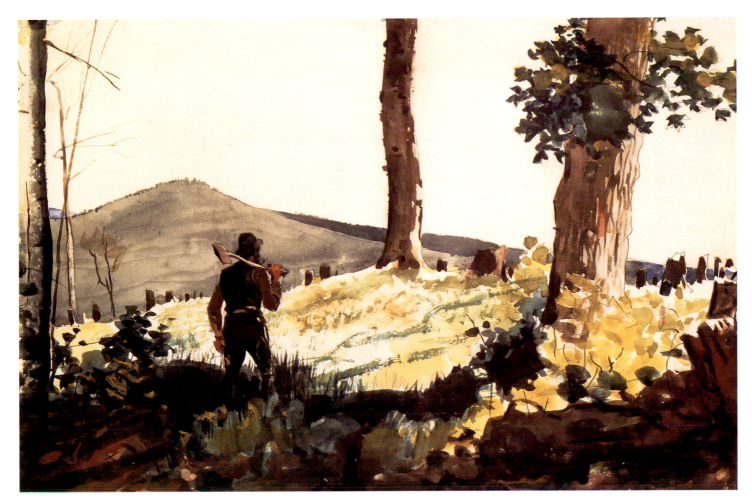

23. *The Pioneer,* 1900. Watercolor, 13⅞ x 21". Metropolitan Museum of Art. Courtesy of
The Metropolitan Museum of Art, Amelia B. Lazarus Fund, 1910 (10.228.2).

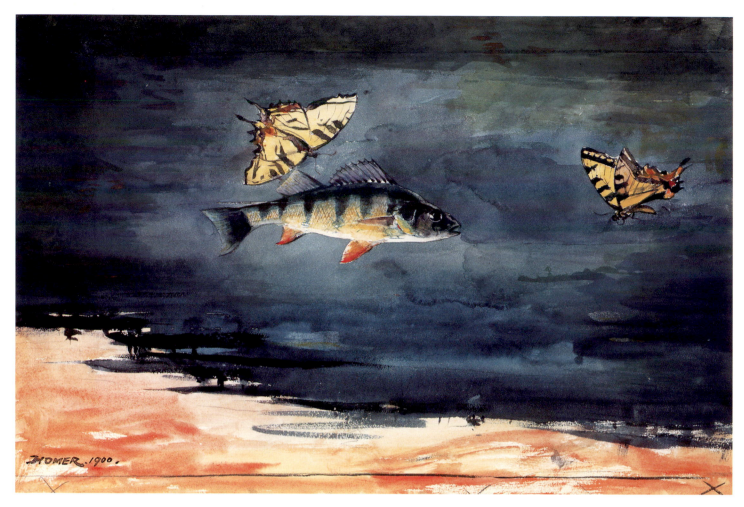

24. *Fish and Butterflies,* 1900. Watercolor, 14½ x 20¹¹⁄₁₆". Sterling and Francine Clark Art Institute. Copyright ©
Sterling and Francine Clark Art Institute, Williamstown, Massachusetts. Courtesy of the institute.

1870

The Trapper

WHEN HOMER went to the Adirondacks in 1870, he became part of a "rush" to the region. This influx of tourists, sportsmen, and sightseers had been occasioned in good part by the publication a year earlier of William H. H. Murray's best-selling account of his own visits to this land of forest, mountains, and lakes, *Adventures in the Wilderness.*[1] While Murray's ebullient prose may have encouraged Homer to make the trip, he undoubtedly also went at the urgings of a number of painters he knew in New York. These artists had already fallen under the region's spell; Homer had seen their Adirondack paintings in exhibitions in New York and doubtless heard their encomiums.

His initial visit to the region brought forth three magazine illustrations and one finished oil painting, *The Trapper, Adirondack Lake* (plate 1). This painting of a single figure in a landscape differed from the Adirondack pictures of his New York colleagues so thoroughly, and departed from his own earlier work in so many subtle ways, that it needs to be seen as a turning point in the development of his still-new career as a fine artist.

Before *The Trapper,* in his eight years as a painter, Homer had included two kinds of landscape settings as backgrounds in his figure paintings, those of war and those of peace. In each he had depicted the American land shaped for good or ill by the actions of people. In such paintings as *Inviting a Shot Before Petersburg, Virginia (Defiance)* (1864) and *Prisoners from the Front* (fig. 1, 1866) he had shown the land devastated by battle, with meadows and fields reduced to craters of blasted earth. As the war came to an end and in the years soon following, in *The Veteran in a New Field* (1865), *Croquet Scene* (fig. 2, 1866), *The Bridle Path* (1868), *The Dinner Horn* (1870) and others, he had shown through bountiful fields, manicured lawns, and graded paths that the land, and by extension the nation, had been restored through the cultivation of nature for peaceful ends.[2] In all of these paintings the figures and their settings stand in meaningful relationship; each comments on the other.

With *The Trapper,* he began to paint a third kind of landscape as background for figures, one of wilderness—wild nature unshaped by human action, unexploited for good or ill. Over the next third of a century he explored in his Adirondack work the implications that wild nature and its exploitation held for himself and his times. Outside the Adiron-

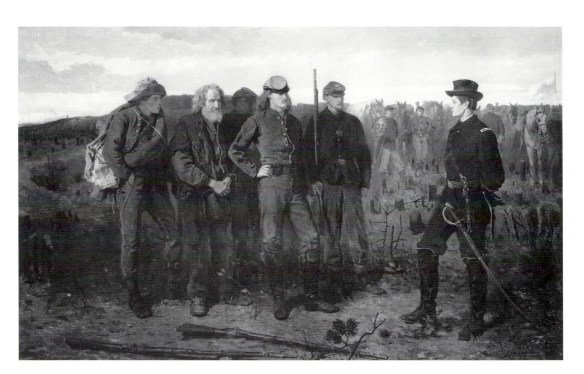

1. *Prisoners from the Front*, 1866. Oil on canvas, 24 x 38". Metropolitan Museum of Art.
Courtesy of The Metropolitan Museum of Art. Gift of Mrs. Frank B. Porter, 1922 (22.207).
All Rights Reserved.

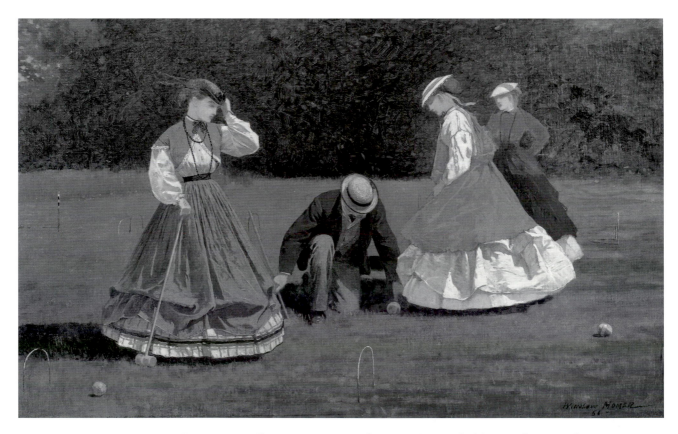

2. *Croquet Scene*, 1866. Oil on canvas, 16 x 26". Art Institute of Chicago. Photograph © 1995,
The Art Institute of Chicago. All Rights Reserved.

dacks he continued throughout the decade of the 1870s to paint peaceful scenes of rural and resort life, and achieve in them an understated yet captivating lyricism entirely new to American art, but wilderness remained a persistent undercurrent in his work, deepening in import as years passed and rising to the surface each time he returned to "the woods." In the 1880s his sharpened interest in the struggle inherent in wild nature led to the high drama of the epic marines that established him in many minds as the greatest American artist of the nineteenth century. The germ of this development from lyric to epic treatments of the natural world emerges first in *The Trapper,* a painting in which a solitary figure stands on a partially submerged log at the edge of a lake in the Adirondack wilderness.

This trapper turns, pivoting his torso to its left, giving his attention to something seen or heard by him, but unknown to us—a call, a movement, a splash. He balances himself on the arched surface of the log and holds his dugout canoe in place with a long-bladed paddle. Homer catches both the psychological and kinetic complexity of this maneuver. We infer what the trapper has done a few moments before—stepped from his canoe onto the log—and what he will do next—secure the canoe and move along the log—but we cannot tell from the visual evidence what has caused him to stop for this moment, turn, and look beyond his immediate surroundings. He may be doing nothing more than taking in for a long moment the quiet splendor of this summer morning. He sets an example, encouraging us to join him in looking at his world for the sheer sensual pleasure of it, for all that is glorious in these northern colors and shimmering reflections, for all that seems vibrantly alive in nature.

In catching the trapper's muscular action, the play of light and shadow on his clothing and the things around him, the "feel" of the warm, still atmosphere, the distinctive shapes and colors of the pickerel weed and water lily pads that enliven the foreground, Homer deals in pure naturalism—these things conform to nature as we know it through our visual experience. They constitute a report on what Homer has seen. The painting attests (as all his early paintings do) to his remarkable powers of observation, but these powers in themselves are only part of what is required to make a success of a subject as complex as that of *The Trapper.* As a good journalist, Homer needed to select from the plethora of things visible from his lakeside vantage point and give them a coherent design. Furthermore, as a good artist he needed to say in paint something of interest about what he had selected.

We can begin to comprehend what he meant to convey about this man and his Adirondack surroundings by noting that in selecting from what he saw at this waterside site, he eliminated a major feature of the landscape. This was the long triangular form of Beaver Mountain that, as seen from the painting's vantage point, West Bay on Mink Pond, is a powerful presence on the horizon (see fig. 17). Had he included it, the mountain's diagonals would have weakened his composition's horizontal emphasis and diminished his figure's significance. With the mountain removed, the trapper rises against bands of water, forest, and sky to surmount his surroundings. He becomes, despite his modest scale, a major element of the painting, an assertion of human presence within wilderness.

Like all mid-nineteenth-century realists, Homer valued verisimilitude but saw no reason to be imprisoned by it. The rearrangement and rescaling of details of the actual landscape for pictorial effect presented a problem to a realist painter only when it amounted to denial of place. Perhaps because a number of his friends and colleagues knew the view of Mink Pond that he painted in *The Trapper,* he gave a hint of the mountain's presence at the far left of the painting by faintly rendering one of its sloping ridges, obscuring the rest with haze. This distant haze heightens through contrast the sunny clarity of the air in the foreground, where light reflects brightly from the log and the boat.

Although he hid Beaver Mountain's form in this painting, Homer had recognized its pictorial strength. He incorporated it in his work repeatedly over the next thirty years, continually altering its scale and the pitch of its slopes. But here, when he might have included it in his first Adirondack painting, he banished it from sight to enhance the importance of the figure.

Homer's horizontal composition not only emphasizes the figure but also draws attention to water as a major presence in the Adirondack wilderness. Nowhere else in the United States did so much of it exist so close to mountains. Countless lakes, ponds, rivers, and streams served as routes for travel, as places for sport and recreation, and as sites for hotels, inns, lodges, and campsites. New Hampshire's White Mountains and New York's Catskills were by comparison lakeless. Those mountains, developed for the tourist trade a generation earlier than the Adirondacks, rewarded tourists who sought heights and gathered on summits and outlooks. When Homer had painted in the White Mountains in the summers of 1868 and 1869, he had placed most of his figures above treeline.[3] Attire and pastimes identify them as tourists. The figure in *The Trapper* differs from them in dress and activity; he is a man of the woods, not a visitor to it. Although the title of the painting specifies that he is a trapper, he is one by inference only. Nothing in the work attests to the particulars of a daily round of setting traps and collecting catch. Far from illustrating anything so specific as an occupation, the painting depicts instead a woodsman at lakeside.

For more than a decade earlier, Homer's artist predecessors in the region had presented the woodsman primarily as a rustic servant to sportsmen. Homer offered a new image. His *Trapper* departs from the stereotype to offer a woodsman admirable in himself, not dependent on an association with anyone else, and this is one reason why Homer isolates him. In paying respect to him and others of his kind, Homer paid respect as well to the natural world that had shaped this kind of man, given him meaning, and distinguished him from the "outsiders"—sportsmen, tourists, artists, scientists—who now arrived in the Adirondacks in increasing numbers each season. The woodsman's kinship with the natural world was precisely the condition that outsiders sought and hoped to find for themselves in the Adirondacks, in however small a measure, at least for a season, or a month, or a week.

Two versions of the painting exist. Colby College's *The Trapper, Adirondack Lake* is the smaller at 20 x 30". The Henry Art Gallery of the University of Washington's *Adirondack*

Lake (plate 2) is significantly larger at 24 x 38". Neither title may be original with Homer; he often left it to dealers and owners to affix words to his paintings.[4] Homer inscribed both versions "1870". No evidence has come to light to indicate conclusively which of them he painted first, but because he executed the smaller version for Lawson Valentine, a friend and patron, as well as his brother's business associate, and because Valentine also requested and obtained some replicas from the artist, the Colby painting may have come second.[5] In the Colby version Homer tightened the composition by eliminating a vertical strip of land-scape at left and heightened the color of the air. But whatever the order of execution, the fact that Homer bothered to repeat himself is a measure of his own regard for the work.

Nothing that Homer had painted prior to *The Trapper* offered quite so much that was delectable to the eye. The intricate weave of complementary color across the canvas, the confidently broad articulation of detail, the fine drawing of the figure, the intricate equi-librium of the composition, and, above all, the evocation of sensation—the feel of Adiron-dack air and light—these things made this painting, as Homer and Valentine surely knew, an early masterpiece.

The two versions differ in one significant detail. In the smaller work, a jack light stands at the bow of the canoe. In the larger, it reclines near the stern. The light consists of an open, half-cylindrical reflector of bark or metal with a base to support a candle or lantern, and a shaft to elevate it a yard or so above the bow. The trapper would light it at night after he had paddled his boat silently in darkness to a point near the shore where deer came to drink and feed on water plants. Once lit, the light dazzled and immobilized the animals. Unable to see the trapper (now a hunter) crouched behind the light, the deer became an easy target. This method hunting, known as "jacking" or "floating," was widely declared to be unsporting and became illegal, but for some woodsmen who depended on game for part of their subsistence, it was a way of life.

Because the jack light was useless in daytime, Homer in the Henry Gallery painting has quite rightly taken it down and put it out of the way. He may have placed it upright in the Colby version to draw attention to it and make clear to those who recognized its function that this trapper was also a hunter—as any genuine woodsman would be. Then, too, in the Colby version the nearly upright light contributes to the play of diagonals just to the left of the painting's center where Homer meticulously assembled branches, boughs, log, and paddle as counterpoint to the figure.

One branch in this assemblage forms a tilted rustic cross silhouetted against distant haze. Might Homer have meant this detail be more than a compositional device con-tributing to the array? Might it allude, however arcanely, to some aspect of Christian be-lief? American art, inheriting a Protestant aversion to established traditions of Christian iconography and allied in Homer's time with both the Barbizon School's distrust of overt symbol and the Realist movement's abjuration of old ideologies of pictorial expression, had little use for conventional iconography. Still, Homer must have understood that he

had put a rustic cross of sorts into his painting and tilted it in a way that would prove provocative to those who wanted it to be so. In any event, since he neither treated nor alluded to sacred subjects in other paintings and has come down to us as, if not an agnostic, then at least not a churchman, there seems to be little reason to read much into this depiction of a decaying branch.

Nominally a Congregationalist, Homer took some pride late in life in the fact that he had never attended a service in St. James Church, built by his family at Prout's Neck across the road from his studio-home.[6] But while he seems to have had little taste for overt religiosity, some of his remarks and a few of the books that he read and kept suggest that he found a benign pantheism agreeable.[7] Living in an age of conflict between religion and science, he was, as we shall see, drawn to the side of science. He may have alluded to some aspect of that conflict in this detail, but if so, his message has long been lost. As in most of his work, he avoided overt narrative, anecdote, and other literary programs, leaving them open to varied interpretations.

Who is this rustic figure atop the log? At one level he personifies the not-wholly-tamed Adirondack wilderness. At another, in his dignity and apparent self-sufficiency, he stands for American democratic man at home in the natural world. But beyond both of these allegorical roles he is an individual, a person whom Homer knew in the Adirondacks, who agreed to pose for him, and who appears in several of the artist's other paintings and prints. He is Rufus Wallace, trapper, hunter, and hardscrabble farmer who was also a guide affiliated with the summer boarding house at which Homer resided in 1870 and to which he returned repeatedly, a place that in the late 1880s became the home of the North Woods Club. Wallace was indeed a man of the woods, but he could also hold a pose.[8]

The condition of wilderness that Wallace represents is a concept as much as it is a physical state. A common definition holds that wilderness can be any place in wild nature at least a day's travel from society and its comforts. The presence of a road, buildings, or a few people makes no difference; wilderness exists so long as most of the amenities of life in town are not at hand and one is obliged to fend for one's self to a noticeably greater degree than townsfolk do. This was the benign type of wilderness sought by sportsmen and others who went to the Adirondacks in the decades after the Civil War. It amounted to a letting go of the safety of home without running much of a risk of endangering one's well-being.

Homer's *Trapper,* more than his other Adirondack paintings of the 1870s, offers a slightly riskier sense of wilderness, not only by isolating the figure but also by giving no hint that human society is anywhere nearby. In actuality, Wallace needed only to paddle to the lake's inlet, a few hundred yards along the shoreline, to reach a road that led in one direction to Homer's boarding house, a mile away, and in the other to the village of Minerva, nine miles distant, on the near side of which Wallace had a house. Easy access to town, and a reassuring juxtaposition of wild and tamed nature, made the Adirondacks a genteel rather than a raging wilderness.

$T_{HE\ TRAPPER}$ both perpetuated and enlarged on a tradition in American painting that characterized white rural folk and others who lived close to the land as individuals rather than types, and as people who were admirable rather than uncouth. Neither peasants nor boors from the European *genre rustique* populate the work of William Sidney Mount, Eastman Johnson, and the many other painters of American rural life. Even George Caleb Bingham's rougher-hewn Missourians possess an innate dignity that confirms the essential optimism of the nineteenth-century American trust in the worthiness of ordinary people. The democratic vision of these painters, and nearly all of their American contemporaries, broke from a European practice that tended to define a person's status in terms of class, wealth, family, or authority.

The intrinsic worth of the antebellum American citizen derived from his intimate relation with the Great Teacher: nature. This ideological foundation stone of democratic culture had been inherited from the Enlightenment and was then embraced as a wellspring of feeling by the back-to-nature strain of the Romantic movement. It exerted a powerful influence on American thought from Jefferson onward, even as the nation ceased to be primarily agrarian and the typical citizen became a city or town dweller rather than a farmer. It became an equally powerful influence in the arts beginning early in the nineteenth century when William Cullen Bryant, James Fenimore Cooper, and Thomas Cole came to the fore as the great poet, novelist, and painter of American nature. They celebrated a natural world that they believed to be wilder and purer than any in Europe. Cole gave this perceived difference between old and new societies a symbolic historical context in the five paintings of his *Course of Empire,* where he traced the rise of civilization from an ideal and idyllic nature-oriented pastoral condition to a high culture whose alienation from nature spelled its destruction. At a more prosaic level, Americans, eager to maintain their nation's pastoral condition, looked to nature to teach good citizens how to think and how to feel, even if the teaching needed to take place only in vacation time.

Homer would have had no argument with the view of his times that America was nature's nation, but in *The Trapper* he began to move away from the social and political implications of that concept as it had appeared in the work of other painters. In the pictures of Mount, Bingham, Johnson, and nearly all other painters of American life, a sense of community—of family, of fellowship, of work or play—can be felt if not seen. Homer's solitary trapper associates not with people but with wilderness. In setting his figure this way, Homer seems to have begun to show the early impact on American art of those newer ideas of scientific thought that had then begun to dislodge the human species from the privileged status in the natural world that centuries of religious and philosophical thought had accorded it. In the new order of things, the species became part and parcel of all nature. By not setting Wallace in the landscape so much as making him part of it, Homer shifted the sense of community in his painting from narrowly social to broadly biological.

The Trapper is also an outgrowth of an American, post-Civil War recasting of a vener-

able subject in the history of art: the pastoral. Since the Renaissance, and famously since Poussin's treatment of it in his two versions of *The Arcadian Shepherds (Et in Arcadia Ego)* in the seventeenth century, the painted pastoral has offered an Arcadian landscape in which shepherds live in evident harmony with nature. In their innocence of the ways of civilization, even of the ways of the ever-laboring peasant—for no Arcadian shepherd is actively at work or has any pressing business—they have regained some little part of what Adam and Eve lost at the Fall, but only a part, for they are mortal and Arcadia is not Eden. The shepherds in Poussin's paintings have only just begun to comprehend that death, too, lives in their world.[9]

The shepherd's condition of oneness with his beneficent natural world represented an ideal state of existence at least to the cultivated painters and poets who dealt with the subject. It was a state that they could never hope to realize as a lasting condition in their own lives, but they could approximate a sense of it by retreating to the country for a month, a week, a day, or even an hour, to be refreshed and restored before returning to the artifice of high culture. The retreat might be to a country villa, a park, a hunt, or, in Homer's time, to any of the resorts, country inns, campsites, and other places especially organized to accommodate a return to nature, that is, a return in the direction of one's presumed original state.

Watteau's *fêtes champêtres* of the early eighteenth-century idealize an aristocratic society's emulation of the pastoral condition. American genre painters of the first half of the nineteenth century democratized the subject, transforming the shepherd into the American farmer, and redefining the shepherd's innocence to democratic man's goodness. Homer's croquet scenes of the 1860s follow Watteau more than Mount or Johnson in showing the natural world as a park in which cultivated people play, although the middle class young men and women in his Yankee postbellum pastorals entertain themselves unattended by servants.[10]

In the works of Adirondack painters of the 1850s and 1860s, sportsmen assumed the role played a century and a half earlier by Watteau's aristocrats. Woodsmen guides became their attendants.[11] In *The Trapper* Homer recast this. He banished the sportsman and elevated the woodsman from the status of servant to the role of Arcadian shepherd, that is, a person who fulfills the pastoral ideal of living in perpetual intimate association with nature. Like the Arcadian shepherd, Homer's trapper is not escaping from civilization; he barely knows it. The Adirondack wilderness appears to be as beneficent to him as Arcadia is to its shepherds.

Because Homer did not impose a program of overt meanings on this work, he left it open to readings that have little to do with the pastoral tradition. It is possible to read the painting as one intimating that this wilderness is endangered by the trapper, that he is an intruder into pure nature who has begun a pattern of depletion of the land's riches and who, through his work as a guide to visitors such as Homer, has hastened the transformation of the wilderness into a vacationland. In this view Homer's delicate equilibrium be-

tween figure and setting masks the trapper's inherent (and self-uncomprehended) threat to his surroundings.

Of course, Homer may never have thought of *The Trapper* in any of these terms. His profession was painting, not the interpretation of art. Further, he surely agreed with Poussin that a painting's true subject is found in its delectation—its capacity to offer deep gratification to the senses. But Homer was hardly naïve about any aspect of art, including the history of its major subjects. Although his taciturnity allowed his early biographers to assume that he cared little about the intellectual side of painting, the artists closest to him, notably John LaFarge, did not characterize him this way. John Beatty, a painter and the director of the Carnegie Institute in Pittsburgh, who knew Homer in his later years, remembered that, although he had little interest in talking about art, from time to time he made a comment that revealed a surprising degree of sophistication. But one need look no further than the changing relationship of figure to landscape in Homer's Adirondack oils as they developed over twenty-two years to find evidence of a supple controlling intellect that by 1892 had transformed the quietly balanced Arcadian order of *The Trapper* into the dramatically violent Darwinian flux of *Huntsman and Dogs*.[12]

WILDERNESS HAD BECOME a subject of significance in American painting in 1825 with Thomas Cole's exhibition in New York of three oils inspired by his recent excursions into the then rarely visited Catskill Mountains. Theatrical in concept and presentation, for Cole was America's great puppet-master of landscape drama, these paintings and others that followed constituted a serious and sustained attempt to pictorialize and make comprehensible the laws that governed the natural world and those that ruled human society. Borrowing from a host of literary and visual sources, he divined a God-given grand design that controlled both the natural world and human nature, one in which human beings, although only tiny components in the grand scheme of natural history, nonetheless held a status superior to other mortal things. In the Great Chain of Being they were "just below the angels," closer to the Supreme Being and thereby more like Him than were any other living things. Cole's follower, Asher Durand, perpetuated this line of thinking, referring in his writings for the *Crayon* in the 1850s to the Almighty as the Great Designer, and continuing the metaphor of God as an artist, the natural world as His grandest work, and the landscape painter (or any realist artist) as His faithful copyist, a task which only the human species could fulfill.[13]

Durand and most of his colleagues in the Hudson River School made the most of this relatively passive role of transcribing the beauties of creation, but Cole had aspired to more. He moved in his own work from excited portrayals of the natural world in its wildest, God-given state, such as his grandly melodramatic Adirondack subject, *Schroon Mountain* of 1838 (fig. 3), to depictions of ideal worlds that comment elaborately on his own times. He attempted in all his works to address a fundamental question: what distinguishes

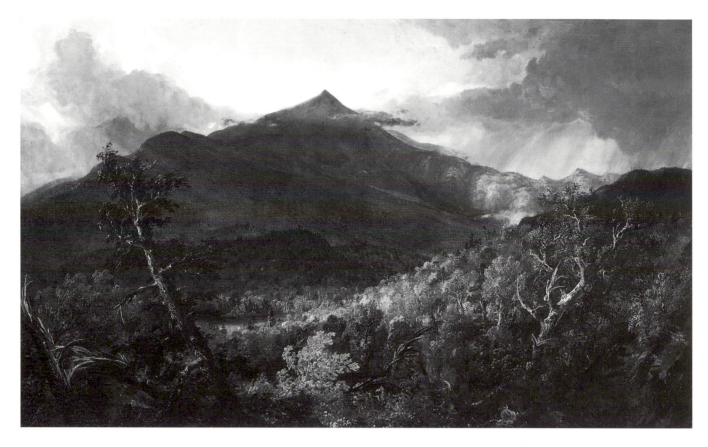

3. Thomas Cole, *View of Schroon Mountain, Essex County, New York, After a Storm,* 1838. Oil on canvas, 39½ x 63".
Cleveland Museum of Art. © The Cleveland Museum of Art, 1995. Hinman B. Hurlbut Collection, 1335.17
Courtesy of the museum.

human beings from the rest of living things? He never escaped the feeling that only the
Almighty knew the answer.

A generation later, Homer's *Trapper,* which eschewed Colean grand gesture, addressed
the same question. It arrived at an answer in harmony with the growing scientific thought
of the 1860s that denied a difference between humankind and nature. This trapper is an in-
trinsic part of the world he lives in; the same laws govern him that govern his surround-
ings. What we see from the edge of Mink Pond, looking past the trapper to the spruce-clad
islands and the forest-bound distant shore, all crowned by the haze that obscures Beaver
Mountain, is not Cole's world whose every change reflected the playing out of the Great
Designer's plan but rather a world of constant environmentally induced change, a world
always in flux. By 1870, Darwin and Helmholz had gone far to explain this world and with
The Trapper Homer had begun to paint it.

The new, modern, view of the natural world could be most clearly seen in nature in its
purest state: wilderness. The heightened interest of the 1860s in the Adirondacks as a place

of near-untouched wildness, and the fervent efforts in succeeding decades to preserve that wild state, owed something to both the older, Romantic, theologically derived worship of pure nature typical of Cole's generation and the newer, objective, scientific thought of Homer's time that valued wilderness as the essential state of all things, even ourselves.

This trapper is primordial. We recognize in him and his intimacy with the living world something of ourselves and our distant past, some echo of the archetypal hunter-gather, a being ever-old and ever-new. To regain some semblance of this elemental condition, thousands set out for the Adirondacks in 1870, to live near water under a canopy of trees, to renew the sense of well-being that comes from the sounds, smells, and sights of the forest. Homer was among them.

The Clearing

From its origins high on Mount Marcy, the Hudson River rushes headlong through the dense Adirondack forest of Essex County as a mountain stream, threading itself between ledges and coursing over and around the boulders that litter its bed. It gives little hint of the majesty it will assume when, deeper and broader near Glens Falls, it seems to sense its final goal and heads steadily southward to the sea.

Several dozen miles upstream, while still in wilderness near the boundary of Hamilton County, the river turns sharply to the east. A mile or so from this bend, a logging crew around 1850 cut an extensive clearing in the forest for its cookhouse, bunkhouses, stables, and logging equipment, and then, when their job was done, abandoned the site. A few years later the Reverend Thomas Baker left his congregation in Chestertown, twenty-odd miles to the south, and moved to the clearing. Perhaps he had been too fervent an Abolitionist to suit his fellow Methodists, but whatever the reason he withdrew from society with his wife, Eunice, and their daughter, Juliette, and took up residence in a rude log house on the cleared land. A second daughter, Jennie, was born there in 1855.[14]

The Bakers's clearing was nine miles from Minerva, the closest village, with much forest and few neighbors between. Aided by Rufus Wallace and one or two other hired men, they cleared more land, planted crops, raised buildings for livestock, sent poultry, eggs, and cheese to market, and struggled to make a go of their enterprise. By the end of the decade, when they had improved their home, they began to take in summer boarders. The earliest of these seem to have been old friends of the Bakers, cultivated people who in their early years had, like their hosts, known the literary, musical, and artistic life of New York. A painting of 1859 by Eliphalet Terry, an artist so captivated by the place that he visited it annually for decades, records both the log house and its surround of stumps, cultivated fields, pastures, and farm buildings, and a prospect of ponds and forest with mountains beyond (fig. 4).

Around 1860, Thomas Baker started work on a larger, three and a half storey log house to gain greater comfort for his family and to increase accommodations for boarders. His

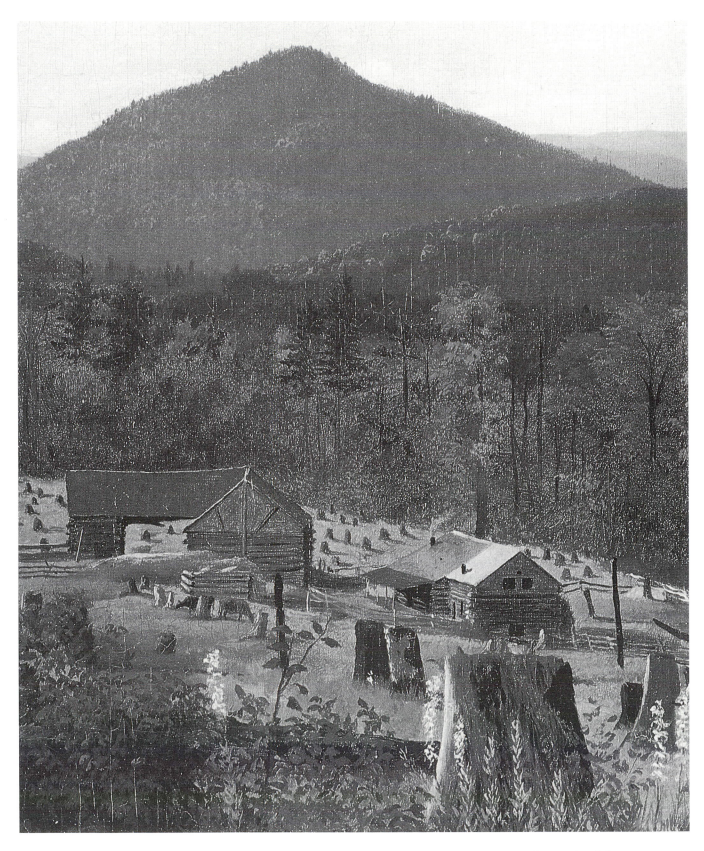

4. Eliphalet Terry, detail from *Baker's Farm (The Clearing),* 1859. Oil on canvas, 19 x 30". North Woods Club. Greatly foreshortened in the background is Polaris (Peaked) Mountain.

death in 1862 left the building unfinished. Eunice Harris Baker now became the motive force of the development. With the help of hired hands she completed the structure in 1863. Aided by her two daughters, Juliette, twenty-one, and Jennie, now eight, she welcomed that season's visitors to a sturdy, spacious building with a roofed veranda running along three sides (fig. 5). From the veranda the closest mountain, Beaver, displayed the long, low, asymmetrically pyramidal form that Homer had masked in *The Trapper* (fig. 6).

This was the log house that Homer came to in 1870 and saw for the last time in 1910. The open pastureland and fields around it, along with its barns and outbuildings, came to be known generally as "the clearing." The entire property, including forest land and ponds, took on the name "the woods." In 1887, a newly founded sporting club, whose original members were business and professional men chiefly from metropolitan New York, purchased the property. The club's name, the Adirondack Preserve Association, proved confusingly similar to those of other organizations, with the result that in 1895 the members changed it to the North Woods Club.[15]

While Murray's *Adventures* may well have sharpened Homer's interest in visiting the Adirondacks in 1870, it was probably his friend, and the Baker's regular summer boarder, Terry, who directed him to the clearing. On 20 June 1870 Terry had written to Eunice Baker to announce his intent to arrive early in the summer. He went on to report the travel plans of others whom he had encouraged to visit: "Mr. Homer will come up about the 1st of Sep-

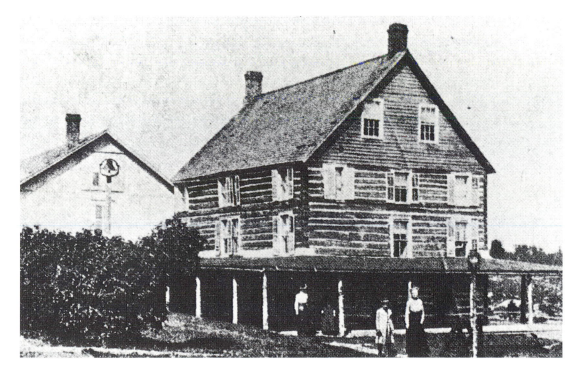

5. Thomas Baker's second log house, begun c. 1860 and developed after 1886 as the clubhouse of the North Woods Club. Courtesy Minerva Historical Society, Minerva, N. Y.

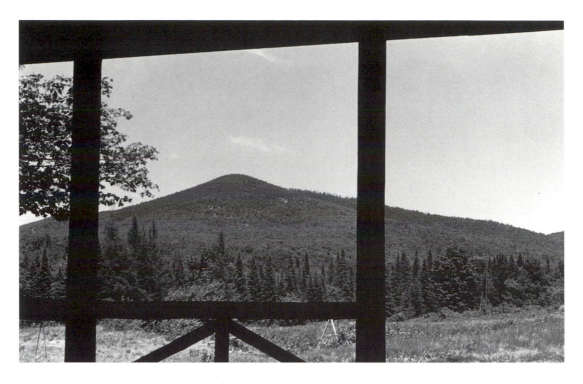

6. Beaver Mountain, photographed from the veranda of the clubhouse, North Woods Club, Minerva, N.Y. Photograph, Cleota Reed, 1986.

tember and Mr. Cott a few days later. They are both the kind of men you will like."[16] Homer had surely already heard of the place. John Lee Fitch, with whom he had painted in the White Mountains in the summer of 1868, had stayed at the Bakers since the mid-1860s, and would return occasionally through the mid-1870s. John Karst, a wood engraver who cut some of Homer's drawings, had been there in 1869.[17]

These artists went to the clearing partly because they were, like Homer, serious fishermen. Seven ponds of varying size and character lay within a mile or two of the log house, as did the Hudson River. Hired hands, doubling as guides, carried fishing gear to sites near and far, and rowed or paddled as needed, all at a wage of twenty-five cents an hour, or two dollars and fifty cents a day.

If Homer ever drew or painted Eunice Baker and her daughters or any of the buildings in the clearing, no evidence of it seems to have survived. Homer only rarely painted portraits, but he had constant need of models to pose for figures. At the clearing, he used the hired hands for this purpose, most often in their guise as guides. They were employable (as, by the proprieties of the era, the Baker women and Homer's fellow boarders were not).[18] More importantly, as men of the woods they had a greater natural kinship with their surroundings than did visiting sportsmen, and Homer found that kinship of figure and setting of constant interest.

Tourists to the White Mountains of New Hampshire, where Homer had spent the previous two summers, had little need for guides. The railroads that had arrived at the edges of the Presidential Range in the early 1850s within a few years entered the very heart of that region and soon disgorged their passengers virtually onto the piazzas of newly built, grand-scale hotels, full of the amenities of urban life.[19] The hotel keepers kept the wilderness at a safe distance, transporting their patrons to summits and scenic outlooks in mountain wagons on graded roads.

A hundred and fifty air miles to the west, in the Adirondacks, access to the few summer hotels that then existed was much less simple. The established routes of passage in northern New York had skirted the vast Adirondack region. Not until the mid-1870s did the long-planned rail line between Albany and Montreal reach completion through the Champlain Valley, within sight of the highest peaks.[20] Even then, most tourists who came by train, as well as others who made their approach from the east by Lake Champlain steamer, faced many miles of travel by coach, wagon, or boat—and sometimes by all three—to reach the hotels and inns set in the most scenic mountain valleys and by the innumerable lakes and rivers. Approaches from other directions of the compass took scarcely less effort.

Lacking the volume of business that train loads of tourists would bring, most Adirondack hostelries in the 1850s and 1860s tended to be smaller and simpler than those of the White Mountains. They made a virtue of these qualities by attracting a clientele that did not seek the comforts of resort life as much as proximity to wilderness. For those visitors, a "simple" life in wild nature seemed capable of restoring, or even revealing, fundamental truths about how life should be lived. As Thoreau had insisted in *Walden,*

> Most of the luxuries, and many of the so-called comforts, of life are not only not indispensable but positive hindrances to the elevation of mankind. . . .
>
> I went to the woods because I wished to live deliberately, to front only the essential facts of life, and see if I could not learn what it had to teach, and not, when I came to die, discover that I had not lived. . . .
>
> I never found the companion that was so companionable as solitude.[21]

Yet, in uncharted forestland, far from hotel wagons and roads, a companion who knew the way was useful, and sometimes necessary, and so the Adirondack woodsman-guide flourished.

The Reverend William Henry Harrison Murray, whose *Adventures in the Wilderness* instigated the rush to the Adirondacks in 1870, had recognized the growing mystique for wilderness. This Boston clergyman had come to know it in the course of fishing expeditions to the region in the mid-1860s. He wrote lively accounts of his trips for the Meriden, Connecticut, *Literary Recorder* and then put them together with new material to constitute his *Adventures.*[22] Little in this charismatic preacher's distinctly informal writing style iden-

tified him as a man of the cloth, or even as someone interested in overtly religious matters. His chapter "Sabbath in the Woods" might well have come from a layman. Writing as an enthusiast, he touted the restorative powers of Adirondack air, water, and food for the ailing. Presenting the region first and foremost as a sportsman's paradise, he took the time also to extol its aesthetic pleasures. He claimed that far from the hubbub of resort life, the "lofty mountain scenery and intricate meshwork of lakes," with its "wild grandeur," had no equal anywhere. He made it clear that in this wonderland of wild nature the best place to be was not on heights, as it was in the White Mountains, but at water level, or close to it. On the Racquette River, he said, "you can enter upon a voyage the like of which, it is safe to say, the world does not anywhere else furnish. . . . I have paddled my cedar shell in all directions . . . without seeing a face, but my guide's . . . through a wilderness yet to echo with the lumberman's axe."[23]

While Murray's *Adventures* reported the experiences of visitors (mainly himself) to the Adirondacks, Homer's four Adirondack works of 1870 reported something else, the life of the residents of the region—trappers, loggers, hunters, guides—woodsmen all.

ALTHOUGH ONLY one finished work in oil, *The Trapper,* came from his time at the clearing in 1870 (an oil sketch, *The Woodchopper,* is probably also a product of that season), Homer made a number of drawings, now lost, that served as the basis for three wood engraved illustrations published in the Boston-based pictorial weekly magazine, *Every Saturday.*[24] Earlier in the year, responding in part to the popularity of Murray's *Adventures,* this journal and other pictorial weekly magazines had published a number of Adirondack subjects. In September it included in its pages three landscapes from the region drawn by the painter Homer Martin; in other issues other artists treated tourist life.[25] Only Homer took as a subject the life of the woodsman. More than the work of any of the others, his three contributions amounted to reports about the region from an insider. This was further testimony to his instincts as a pictorial journalist.

Some useful documentation has survived concerning the first of the three prints. On 18 December 1870, Terry wrote to Juliette Baker Rice: "Homer is well and frequently speaks of you. His drawing of Rufus and Charlie trapping has come out in *Every Saturday.* He said that he should send you a copy."[26]

The "drawing" was Homer's *Trapping in the Adirondacks* (fig. 7), engraved by John Parker Davis, published in the 24 December issue of the magazine. Wallace paddles the canoe; his beard and hat correspond to those in *The Trapper.* The pipe in his mouth is perhaps the one Terry promised when, seven months earlier, he wrote to Juliette: "Tell Rufus I will remember his pipe. I suppose he means a meerschaum of medium size."[27] Terry thus responded to a request that Wallace had sent to him through Juliette's husband, Wesley Rice. Rufus had written to Rice: "Friend Wes—I have got me a dubbl barel shot gun—it is a ripper. The watter has been pretty hy. . . . Tell Mr. Terry to bring me a pipe and I will pay him. g. by. Rufus."[28]

The younger trapper is Charles Lancashire, also of Minerva, who worked as a hand and guide at the clearing. He holds a catch on high, a mink taken from Mink Pond. Beaver Mountain, rounded into a gentle, hill-like form, extends to the right. A rifle rests on the canoe, exemplifying here, as it would more than two decades later in *The Blue Boat,* and in other works as well, the woodsman's credo: always keep your gun within reach. The site is Mink Pond's inlet.

Homer had arrived at the clearing around the first of September, early enough to incorporate late summer light and color into *The Trapper.* He remained at least through the start of snow season in November. His second and third Adirondack subjects for *Every Saturday,* published in successive issues, those for 21 and 28 January 1871, are both early winter subjects.

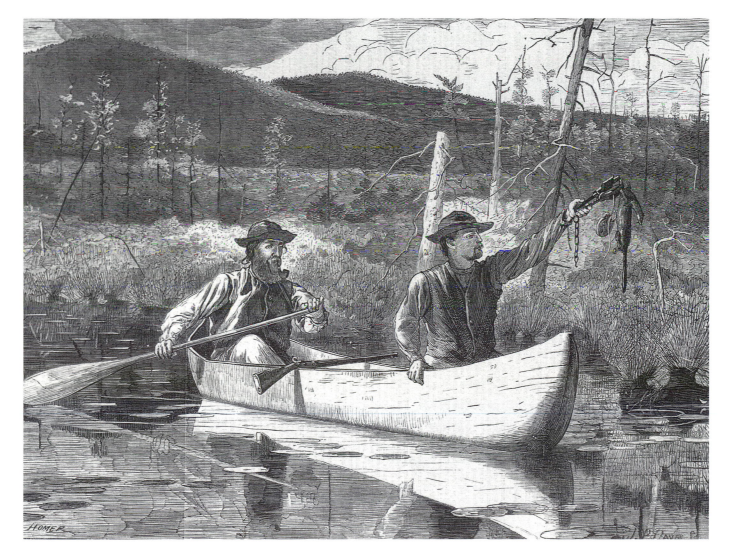

7. *Trapping in the Adirondacks,* 1870. Wood engraving after Homer by J. P. Davis, 8¾ x 11½" Published in *Every Saturday,* 24 December 1870. © Addison Gallery of American Art, Phillips Academy, Andover Massachusetts. Gift of James C. Sawyer.

In *Deer-Stalking in the Adirondacks in Winter* (fig. 8), two snowshoed hunters and a hound pursue a buck slowed by snow. The dog bounds over a crusted surface into which the deer sinks. Homer reports the subject objectively, without comment, but deer hunting was a subject that aroused passion. Later in the decade, in his satiric essay "A-Hunting of the Deer," Charles Dudley Warner opined:

> If civilization owes a debt of gratitude to the self-sacrificing sportsmen who have cleared the Adirondack regions of catamount and savage trout, what shall be said of the army which has so nobly relieved them of the terror of the deer? . . . The American deer in the wilderness . . . is very domestic, simple in his tastes, affectionate in his family. Unfortunately for his repose, his haunch is as tender as his heart. . . . If the little spotted fawn can think, it must seem to her a queer world in which the advent of innocence is hailed by the baying of the fierce hounds and the "ping" of the rifle.[29]

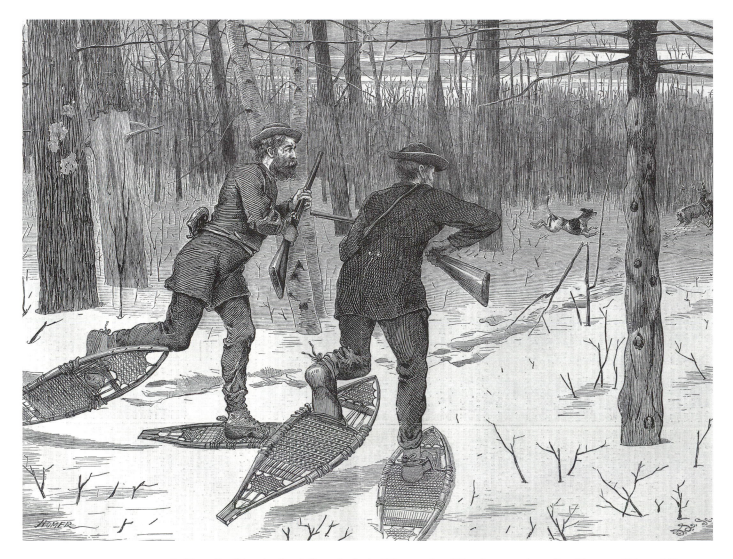

8. *Deer-Stalking in the Adirondacks in Winter,* 1871. Wood engraving after Homer, 8¾ x 11¾"
Published in *Every Saturday,* 21 January 1871.

and, turning to hunting in winter,

As the snow gets deep, many deer congregate in the depths of the forest, and keep a place trodden down, which grows larger as they tramp the snow in search of food. In time this refuge becomes a sort of "yard," surrounded by unbroken snow banks. The hunters then make their way to this retreat on snow-shoes, and from the top of the banks pick off the deer at leisure with their rifles, and haul them away to the market, until the enclosure is pretty well emptied. This is one of the surest methods of exterminating the deer; it is also one of the most merciful; and, being the plan adopted by our government for civilizing the Indian, it ought to be popular. The only people who object to it are the summer sportsmen. They naturally want some pleasure out of the death of the deer.[30]

What Homer had drawn for *Every Saturday* several years earlier is not quite the same subject—he set his scene too early in winter for a true deer yard to have formed. Further, the coarse dress of Homer's hunters makes them woodsmen rather than sportsmen (the bearded figure seems to be Wallace). Indeed, Homer's picture and Warner's text do not correspond on many points. Homer reports with little overt comment on what may be taken as Adirondack woodsmen hunting for subsistence. Warner, as we will see, is editorializing against deer hunting in general.

Homer's other illustration of early snow time at the clearing, *Lumbering in Winter* (fig. 9) requires a slight suspension of disbelief in one of its details. No colleague working nearby would be so oblivious to the approaching dangerous moment as the logger in the middle ground seems to be. If Homer had drawn this woodsman as an active onlooker awaiting the final swing and crashing fall, he would have increased the narrative content of the picture, making it the story of the felling of this particular tree and diminishing the greater scope of his subject: lumbering in winter. He has instead telescoped time to tell a different story; the logger in the background is demonstrating what happens after a tree has been felled.

In the Adirondacks, logging took place in winter. The trees on which these loggers work may be white pine (Homer had no need to identify them precisely), one of the species then of most value in the great Adirondack forest. The pine was the giant softwoods. It had already been cut extensively at the clearing in the 1850s and sent down the Hudson. The smaller but more plentiful spruce had also been cut, although not so early or extensively. Hemlock had been taken; its bark much in demand by the tanneries of the region. Hardwoods remained; clear-cutting made little sense to loggers in the 1870s. The operation Homer depicts is farm cutting, the felling of trees on the Bakers's land for their own use.[31]

The logger on snowshoes in the foreground resembles Lancashire. If he posed for this subject, it seems to have been his last appearance in Homer's work. Although Juliette Baker Rice Kellogg mentions him in her diary as late as the 1880s, he may no longer have worked at the farm, at least not as a guide.

These three wood engravings of Adirondack subjects differ from *The Trapper* in more

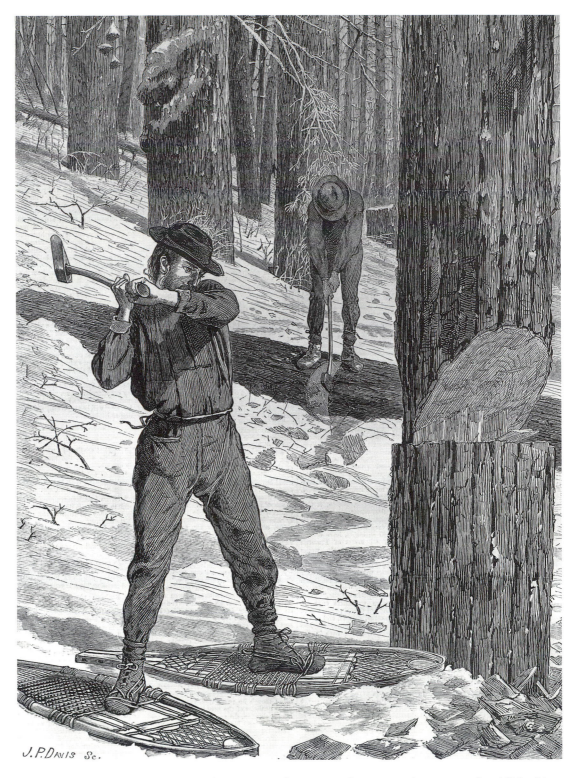

J.P.DAVIS Sc.

9. *Lumbering in Winter*, 1871. Wood engraving after Homer by J. P. Davis, 11½ x 8¾" Published in *Harper's Weekly*, 28 January 1871.

than medium. The prints show pairs of men working together; in the painting the trapper is alone. He is still; they are active. He is apparently in thrall, if only for a moment, to some sensation triggered in nature; they take no notice of anything other than the tasks in which they engage. Because Homer addressed these illustrations of Adirondack life to a mass audience, he incorporated in them a slightly greater degree of anecdote. *The Trapper* tells no story, offering instead such purely pictorial rewards as color, form, and an almost tactile envelope of light. All four products of Homer's first season in the Adirondacks—*The Trapper* and the three prints—departed from the work of other artists who included figures in Adirondack settings. Homer depicted no sportsmen.

The Artist

When Homer went to the clearing in 1870, he had been a painter for eight years. He had first taken up the brush and color in 1862, during the Civil War, after five years of free-lance work in black and white for pictorial weekly magazines in Boston and New York. Because he needed the income, he continued to contribute to these popular journals until the mid-1870s and to illustrate books until later in the decade. Although he quickly gained the esteem of some critics and most artists, his paintings sold slowly and at low prices. He could take some comfort from the distinct honor conferred on him at a relatively young age through his election to the National Academy of Design, first as an associate in 1864 and then as a full-fledged academician in 1865. In the spring of 1866 his *Prisoners from the Front* (fig. 1) was acclaimed in New York as the greatest painting to emerge from the national conflict, an assessment still widely held. Yet his work continued throughout the 1860s to realize modest little in the way of dollars.[32]

At this early point in his career Homer, like all American painters, depended on sales to private collectors. Not for another generation would the nation's art museums begin to purchase works by living artists in significant numbers. Homer's modern sensibilities (for the 1860s) brought forth paintings that failed to appeal strongly to the many American collectors whose buying habits had been formed by pre-1850s European taste. Further, as a hardshelled Yankee, he possessed scarcely any of the personal charm required for the cultivation of patrons or any of the flair needed for the promotion of his own work. Although these skills were extraneous to the making of art, they nevertheless counted for much in the success of a number of his American contemporaries. Nor did he have much of a talent for articulating what was original and important about his work; indeed, he seems to have expected the merits of his paintings to be self-evident to collectors and critics, and in this he was often disappointed.

Homer's work differed from that of most other American artists in the 1860s and 1870s in a number of ways. One was its straightforwardly reportorial manner, a manner that seemed to limit what he had to say in a painting to "this is what I have seen," although those who took the trouble to become well acquainted with his work found it full of sub-

tleties and quiet ironies. His work also differed from that of his contemporaries in its top-icality. No other American painter of his era had built an early career so exclusively on current events as Homer had done with the Civil War, and this, like his reportorial manner, owed much to his beginnings in the practical realm of pictorial journalism rather than in the more rarefied world of an art academy.

It would be a mistake, however, to think of Homer only as a consummate reporter. While the intensity of his involvement with the war—he had witnessed battle and its carnage—gave his *Prisoners* much of its power, the work's psychological, political, compositional, and iconographic richness came from introspection as much as observation. In this work he melded the immediacy of an eyewitness report with the intellectual complexity of a history painting. This was reportage of the highest order, informed by a thoughtful analysis that skirted the subject's possibilities for melodrama and offered instead not only a pictorial précis of the class, regional, and ideological divisions that underlay the national bloodletting but also a sense of the tedium and quiet anxiety that epitomized the typical experience of war for those who were in it.

The blasted landscape behind the figures in *Prisoners*—a desolation of craters and stumps—inverted the image of a beautiful and bountiful American land that had been the stock-in-trade of countless American landscape and genre artists before him. As *Prisoners* departed from earlier American depictions of war, so also, four years later, did *The Trapper* depart from earlier depictions of Americans in nature. And as *Prisoners* had been a topical subject, so too was *The Trapper*. It offered a visual report on the region that Murray's best-selling *Adventures* had just brought vividly to America's attention.

Homer's reportorial eye had undoubtedly been sharpened by years of drawing for pictorial magazines, but it had been formed earlier, in his youth in Cambridge, near Harvard University. His mother, Henrietta Benson Homer, a skilled amateur artist, undoubtedly played a vital role in this, but as great a formative influence on his visual intellect, one that determined what he chose to record and how he recorded it, probably came, directly or indirectly, from the great naturalist Louis Agassiz. The Agassiz and Homer households were not far from each other in Cambridge; Winslow attended public school with Agassiz's son Alexander; Winslow's brother Charles studied under Agassiz himself at Harvard's Lawrence Scientific School. At the outset of his first class, the charismatic professor routinely set his beginning students the task of describing a specimen, perhaps a leaf or a rock, as completely as possible with pencil and paper within several minutes. Most students attempted prose descriptions whose inadequacy Agassiz then demonstrated by drawing the object. This lesson on the superiority of visual over literary expression in describing many aspects of the material world was not lost on Homer, whether the precept came to him through his brother, from Agassiz directly, or from another source.[33]

The Cambridge of Homer's youth was a lively college town, a rather different place from the rapidly-growing city of Boston across the Charles River. An indication of both its small town pleasures and its quick accessibility to urban vitality survives in the recollection of Winslow's brothers that when the young artist was about nineteen and apprenticed

to the Boston lithographer John Bufford, he would often arise early in the morning and walk nearly two miles to Fresh Pond to fish for an hour, returning in time to catch an omnibus to carry him across Cambridge, over the Charles, and into the center of Boston to be at work at Bufford's shop on Washington Street by 8 A.M.[34] Even earlier evidence of his interest in the sport appears in a childhood drawing of a man fishing that he made on an endpaper in a book that he kept for the rest of his life.[35]

He became an inveterate fisherman. There can be little doubt that the promise of good fishing took him to the Adirondacks in 1870 as much as did the public's heightened interest in Adirondack subjects in art. Sport fishing was already a leitmotif of his life before he went to the clearing. There, beginning in 1874, it became a recurrent subject in his work, as it would later in Florida, the Caribbean, and Quebec.[36] His great companion on several of his fishing excursions was his brother Charles.

HOMER'S PAINTINGS of the 1860s and 1870s differed from those of his American contemporaries not only in their reportorial spirit but also in the variety of their subjects. Having painted war and then peace in his croquet scenes and other postbellum pastorals, he moved on to a sequence of other subjects, setting a pattern that persisted for much of the rest of his career. After exploring a subject in a group of paintings over a period of anywhere from a few months to a few years, he left it and turned to something new. This was less an abandoning of old interests than an annexing of new territory. In the decade of the 1870s alone, his subjects included children in rural and seaside settings; farmers in their fields; country teachers and other women at work outside the home; African-American life in Reconstruction Virginia; ships and sailing at Cape Ann in Massachusetts; and life in the Adirondack mountains. The work of no other American painter of the time embraced quite such a variety, and it was a variety unified by Homer's style and sensibilities. Of these subjects of the 1870s, only his interest in the Adirondacks continued past 1880.

Homer's uniqueness as a painter in the 1860s and 1870s came from exceptional powers of observation coupled to a distinctive style. In style, he has often been described as a self-taught artist, a homegrown product of Emersonian self-reliance, an exemplar in art of Yankee ingenuity. There is a kernel of truth in that characterization, although a greater truth lies elsewhere. As a painter he had allied himself from the beginning, more in spirit than in outright imitation, with the progressive trends in French painting of the 1850s and 1860s, trends best known in the twentieth century through the Realism of Courbet and Manet. His orientation had its roots in his home city of Boston. There, in the late 1850s, the painter William Morris Hunt, returned from years of painting in France, had argued for the superiority of modern French painting in general, and of *plein air* painting, the Barbizon School, and Millet in particular, over the Salon Academicism and the Ruskinian devotion to detail in nature that held sway in so much mid-nineteenth-century English and American art.[37]

Homer may have heard Hunt lecture or he may have comprehended this progressive

French taste and the arguments that supported it through his friend (and Hunt's pupil), John La Farge, although in the mid and late 1850s a preference for Frenchness in contemporary art was widespread among the artists and artisans with whom Homer worked in Boston. Frederic Rondel, a recent French immigrant to the city (and an artist who by the mid-1850s was already smitten by the Adirondacks), gave Homer his first instruction in the rudiments of painting.[38] The city's graphic arts shops employed as draughtsmen and engravers several other artists recently arrived from France, including Charles Damoreau, who cut some of the blocks for Homer's illustrations and critiqued his early drawings.[39] There were others as well, and while none of them were artists of the first rank, most had come from France as young men in the early 1850s when the power of the Barbizon School still persisted but the rising spirit of the times was for Realism. This "modern" outlook, which would congeal into print in Paris in 1855 with the publication of Courbet's "Realist Manifesto," arrived with them.

Neither these émigrés nor Homer found much in American painting of the recent past useful to their present Realist interests. Those interests centered on the life of their times as they experienced it, rather than on subjects imagined or idealized. Courbet urged that each artist according to his own sensibilities create a "living art" by painting the ideas, the appearances, and the events (even the most ordinary) of the age, but only as he or she knew them.[40] Homer's depiction of Civil War camp life was wholly in this spirit. In 1870 he brought this objective vision to the Adirondacks.

Courbet's second and wider-reaching statement of Realist principles appeared in December 1861.[41] He argued that great art cannot be taught, for it is ultimately a function of individuality of vision and "voice." It must arise from an artist's distinctively personal talent, sensibilities, and responses to tradition. Dismissing the value of academies, he proclaimed that "every artist should be his own teacher."[42] It may be more than coincidental that within little more than a year of the publication of this statement in a weekly journal known in New York's art community, Homer, essentially self-taught, embarked on his career as a painter.

At the close of the Civil War he seems to have been in no rush to see new French art on its home ground, but when at last the right opportunity to travel presented itself, he went. The occasion arose with the selection of *Prisoners from the Front* and another of his Civil War oils, *The Bright Side,* for inclusion in the American section of the painting galleries at the Exposition Universelle in Paris in 1866–67. He sailed in November 1866, and stayed for ten months. While he undoubtedly went to France to savor the presence of his work in this World's Fair and to sample the myriad pleasures of life in Second Empire Paris, he probably also made the journey to gain two other things. One was a first-hand knowledge of storied masterworks of art of the past. The most important of his contemporaries in American painting already possessed this background; Homer needed it too, if only not to seem parochial. He visited the Louvre Museum, although its collections had no appreciable impact on what he did as a painter while in France or later.[43]

The other and more important thing that Homer doubtless meant to gain in Paris was an acquaintanceship with the "advanced" work of the present, the still-vital spirit of the Barbizon School and the newer, more controversial, Realism. He undoubtedly saw recent painting in the studios of contemporary French artists (we do not know who they may have been) and perhaps engaged in plein-air painting sessions with them. He almost certainly spent time at the shed at the Place d'Alma where, beginning in May 1867, Manet, who had been excluded from showing at the Exposition, exhibited fifty paintings.

Homer went to Paris as an established painter, not as a student, but he seems to have spent at least a little time with younger Americans who were studying there. Among them was Mary Cassatt, who had arrived with Thomas Eakins and others from Philadelphia some months earlier.[44] He included her as the central figure in a drawing of the Louvre's Grande Gallerie (fig. 10) that he sent to *Harper's Weekly* for publication as a wood engraving.[45] This depiction of American students hard at work copying European old masters is

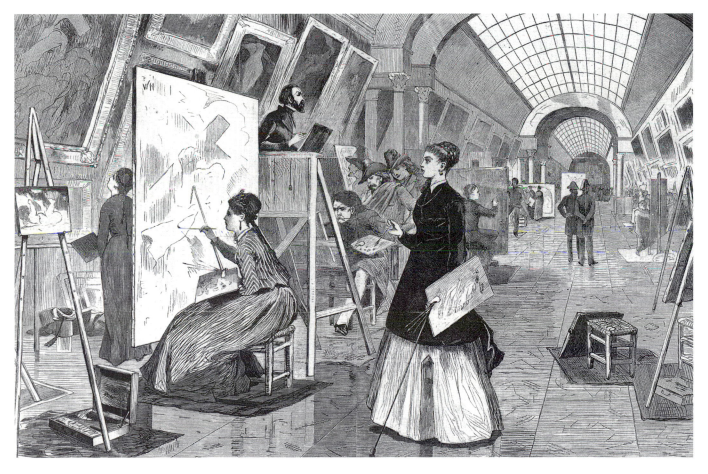

10. *Art Students and Copyists in the Louvre Gallery, Paris.* Wood engraving after Homer, 9 x 13¾"
Published in *Harper's Weekly*, 11 January 1868. © Addison Gallery of American Art, Phillips Academy, Andover, Massachusetts.

at one level straightforward reportage. At another, it is a charming *billet-deux* to Cassatt (who remains unidentified in the magazine's caption and commentary on the picture). A third level of meaning gives this work an ironic undercurrent. Having earlier said that anyone who meant to be an artist should "never look at pictures" (implying that nature was the better teacher), Homer here shows his younger contemporaries earnestly and intently doing just the opposite.[46] With characteristic understatement, he offers an emblem of America still in thrall to the European past in matters of art. Cassatt in due course freed herself from this academy mentality and made her distinguished career as a member of the Impressionist group in France. Homer had no need to escape academy mentality; he had never been burdened with it.

He differed from these students and their teachers by looking not to the past but to the present and not to any contemporary paintings as models for his own work, but rather to the strongly individualistic vision that separated the new Realism from mere reportage. Already empowered by Courbet's anti-academic spirit but not beholden to the manner of any Realist master, he had been recognized by American critics before going to France as being in the forefront of his generation's efforts to paint modern life in America. What he painted on his return affirmed rather than altered his direction. His ten months in France sharpened his understanding of what was essential in Realism: its distrust of history; its unsentimental regard for the worthiness of ordinary things and people; its emulation of photography's presumed objectivity; its recoil from Romanticism's open appeal to the emotions; its growing trust in the formal qualities of art as aesthetic ends in themselves; its fascination with the liberating qualities of design and color in the Japanese prints that had begun flowing to Europe and America in the 1850s; and its expectation that each modern artist's work express a distinctly individual "natural" voice. These things had already contributed to Homer's style in America; most of them can be seen in *The Trapper*. Though other ideas would join them, their presence would be felt in Homer's work for the rest of his life.

Although his stay abroad had reinforced what he had been doing before he crossed the Atlantic, it also refined it. His palette lightened for a few years, a greater delicacy of expression entered his figure work, and his already sure sense of design gained in both boldness and subtlety. He became a more skillful painter of faces. We can wonder whether either the figure or the landscape in *The Trapper* would have been quite so resplendently alive if he had painted them before going to Paris, but these modest modifications in his already distinctive style might well have occurred without the benefit of a trip to France. That no greater change entered his work testifies to his confidence in himself and in the course he had set for his art since he first put brush to canvas. The work of no other painter of the 1860s in America—and few enough in Europe—would develop so steadily in such impressive and consistent ways over so many years.

Chapter 2

1874

Waiting for a Bite

AFTER AN ABSENCE of three years, Homer returned to the Adirondacks twice in the summer of 1874. He went first to the Bakers at the clearing in Minerva. He arrived on 14 May with John Lee Fitch and probably remained through June. He then joined Lawson Valentine and his wife at their summer home in Walden New York, west of Newburgh near the Hudson River valley. Later in the summer he painted at Easthampton, Long Island, with Terry and others. Probably in September, he traveled back to the Adirondacks, this time to Keene Valley, some thirty miles north of Minerva as the crow flies, with much wilderness between. He was there amid the colors of fall foliage in early October, after which he may have made a late-season return to the clearing. This was a typically peripatetic summer for him. Like nearly all other painters who maintained studios in New York in these years, Homer left Manhattan with the arrival of warm weather and did not return until late summer or fall.[1]

Keene Valley (then Keene Flats) had become a favored summering spot for those who preferred rustic cottage life to either resort hotels or boarding houses. It attracted "mountain people" rather than "lake people," and this broad distinction between Adirondack summer subcultures is one that Homer took some notice of in his paintings. Although the clearing with its surrounding ponds and nearby mountains combined features of both, most of his Minerva works depict lake activities.

A tradition exists that Homer may have gone to Keene Valley four years earlier, in 1870, with his friend John Fitch. Since the mid-1860s, Fitch had divided his Adirondack visits between the clearing and Keene, but by the mid-70s he had begun to establish himself in that mountain hamlet as a summer resident.[2] After 1874 Homer seems to have returned to Keene only once again, in 1877. All evidence suggests that thereafter when he traveled to the Adirondacks he went only to the Bakers' clearing in Minerva. Of the two places, the clearing at the end of its forest-bound road was certainly the more remote, truly an opening in the wilderness frequented by few other than the Bakers, their boarders, and their hired hands. Keene Valley by contrast was a rural village with a church, store, cottages, and an inn along a road that saw a steady flow of tourists.

Two oil paintings came from Homer's time at the clearing in 1874, along with at least five watercolors and two magazine illustrations. A third oil, *Beaver Mountain, Adirondacks,*

Minerva, New York (fig. 17), may be a product of Homer's time in Keene Valley in the same summer, although the history of this work, which combines a Keene Valley figure with Minerva scenery, remains uncertain.

FIFTEEN YEARS following the summer of 1874, the critic Marianna Van Rensselaer wrote in a highly perceptive essay about Homer's work that, "the great value of America to the painter is that it is full of new things to be done. Many of them are not beautiful, or charming, or picturesque, or even possible, according to our accepted standards."[3] She probably had in mind paintings such as Homer's *Waiting for a Bite* (plate 3), painted at the clearing in 1874 and without question one of Homer's most serious attempts to find visual interest in a subject that was not conventionally beautiful, charming, or picturesque.

Two boys perch on the up-ended roots of a long-fallen giant of the forest whose bark has partly fallen away and whose trunk lies in shallow water. Perhaps a beaver dam raised the level of the pond and drowned the tree, or perhaps wind uprooted it. One boy sits with a thigh resting on a broken root, his torso turned to his right as he extends his fishing pole in that direction. Next to him the other boy lies prone along the top of the log, propping his upper body against a pair of decayed roots, and resting his head and hand on the saddle between them. Further down the log sits a basket; it carried lunch to this site and, with luck, will carry fish home. In the foreground water lily pads, their white blossoms, and elongated ovals of blue water break the blanket of reflected light on the water's surface. The arrow-like leaves of pickerel-weed shoot upward; their vertical thrust sends the eye back to the log and the boys.

Behind the boys stretches a low piece of land, its horizontal form echoing that of the log, but differing in its repeated uprights—blackened stumps and skeletal saplings. This land has burned in recent years. Blueberry and other low, post-fire shrubs blanket the area; fire as well as wind or water may have felled the great tree. Green new growth enlivens the shoreline and the area beyond the basket; a leafy spray reaches into the picture at right. The boys' heads rise above the long slope of the horizon line, but not far and not freely. The radiating roots and the boys' heads together form an interlocking complex of irregular dark and light shapes pulled downward not only by the apparent weight of the tree but also, and obviously, by the direction of the boys' gazes. That direction points to the unseen but understood subject of their hopes: fish.

Slouched, inert, unengaged in active communication, these boys are naturalistic almost to a fault. No academy life class would have posed models this way. Nothing here corresponds to the standard repertoire of stances, gestures, and attitudes taught in academies, seen in masterworks of painting since the Renaissance, and rarely departed from in the work of nineteenth-century American painters. A camera might document the truth of the inelegant postures of Homer's young fishermen, but only by chance; nineteenth-century photographers of the human figure tended to follow conventions of painting. In

any event, Homer used no photographs in painting this or any other subject in the 1870s.

The boys' inartistic postures have counterparts in the unpicturesque landscape, as well as in the harsh sunlight and even in the picture's very subject: boys angling with a sapling rod and tied-on line of string for fish unworthy of a sportsman's attention (sunfish, bluegills, suckers), and apparently encountering no success. The infelicitous alternate title of the watercolor variant of this subject, *Why Don't the Suckers Bite?* (plate 4) suits its mood. In its succession of parallel planes, the composition shared by both works offers little of the visual interest of the spatially more complex *Trapper*. Yet *Waiting for a Bite*'s directness and seeming avoidance of artifice is right for its subject, which concerns unsentimental American idealizations of childhood as much as Adirondack life.

Who are these boys? Sons of summer boarders at the clearing? Sons of guides? Figures that Homer sketched elsewhere and interpolated into this Adirondack landscape? No evidence survives concerning their identities, but their setting seems certain. According to tradition, the fallen tree lay near the marshy terrain around the Mink Pond inlet. A reduced remnant of the crown of roots survived as late as the 1940s.[4]

The identities of the models are of little consequence, since this young fisher and his friend are not so important as individuals as they are as specimens of the American Everyboy that Homer drew and painted throughout the 1870s. He is a stereotypical rural lad, homely (in the best sense), painted for pictorial interest and not for the sake of storytelling. He is rarely found in the presence of adults and never in active communication with them. His type appears famously in *Snap-the-Whip* (1872) but can be found as the primary figure in a number of Homer's other oils and watercolors of the 1870s.[5] He is at one level allegorical, personifying with low intensity such things as the innocence and wholesomeness of American rural society (compared to American urban life), the youthfulness of American society in general (compared to European), and the "new" America, reborn after the destruction of the old by war. At another level, Homer's boys follow his generation's widespread use of rural and small town children and adolescents, rather than adults, as resourceful and resilient protagonists in such works of art as Mark Twain's *Huckleberry Finn* and Louis May Alcott's *Little Women*. All of these works, pictorial and literary alike, keep the machine age with its industrial city at bay.

Homer's rural lad and his female counterpart contributed to the problem that Henry James found in Homer's work in the mid-1870s. Writing in *Galaxy* magazine about the 1875 art season in New York and expressing a taste shaped by European rather than American culture, and a dislike for children and youths portrayed outside the realm of adult-controlled relations, James see-sawed between praise and disdain for Homer's paintings before arriving at a judgment. In his first sentences he quite rightly assigns Homer to the Realist movement and then demonstrates his unfriendliness to the movement's precepts by oversimplifying them.

> Mr. Homer goes in, as the phrase is, for perfect realism, and cares not a jot for such fantastic hairsplitting as the distinction between beauty and ugliness. He is a genuine

painter; that is, to see, and to reproduce what he sees, is his only care; to think, to imagine, to select, to refine, to compose, to drop into any of the intellectual tricks with which other people sometimes try to eke out the dull pictorial vision—all this Mr. Homer triumphantly avoids. He not only has no imagination, but he contrives to elevate this rather blighting negative into a blooming and honorable positive. He is almost barbarously simple, and, to our eye, he is horribly ugly; but there is neverthe-less something one likes about him. What is it? For ourselves, it is not his subjects. We frankly confess that we detest his subjects—his barren plank fences, his glaring, bold, blue skies, his big, dreary, vacant lots of meadows, his freckled, straight-hair Yankee urchins, his flat maidens, suggestive of a dish of rural doughnuts and pie, his calico sun-bonnets, his flannel shirts, his cowhide boots. He has chosen the least pictorial range of scenery and civilization; he has resolutely treated them as if they were pictor-ial, as if they were every inch as good as Capri or Tangiers; and, to reward his audac-ity, he has incontestably succeeded.[6]

James' complaint that Homer had no imagination was a charge that he could have lodged against all other Realist artists and it was, of course, specious. Homer—and Courbet, Manet, Degas, Eakins, and many others—thought, imagined, selected, refined, and composed (to follow James' list of negations) in all his work, but in a new, Realist way to find the "truth" of modern life. In saying that Capri and Tangiers offered better sub-jects, James expressed not only his alienation from modern culture in general and Amer-ican life in particular, but also a determinedly old-fashioned taste in art. What subjects could these places offer a painter of modern life? Modern life in America existed not only in the pace, clamor, and materialism of its great cities but also in the cosmopolitan prim-itivism of the lake and mountain culture of the Adirondacks in the Gilded Age.

In 1883, Marianna Van Rensselaer recalled in an essay that she had shared some of James' reservations about Homer's work in the 1870s but now felt differently. First pub-lished in *Century* magazine in 1883 and then revised and enlarged for inclusion in her book, *Six Portraits* in 1889, her essay possessed none of James' graphic equivocations. She wrote:

As a youthful student of exhibitions and picture-papers, I remember to have hated Winslow Homer in quite vehement and peculiar fashion, acknowledging thereby his personal quality and his strength, and also his freedom from the neat little waxy pret-tinesses of idea and expression which are so alien to true art but always so attractive to the childish mind, whether lodged in a body childish or adult.

Looking back today at these early pictures they seem to me remarkable for their revelation of a bold, unguided effort to paint outdoor nature as it actually appears, and to translate its broad effect rather than its details. Crude, brash, and awkward though they were, there was the true breath of life in them all—the glint of actual sunshine, the swell of mother-earth, an accent in every line and tone which proved that they had been painted face to face with facts. . . . Today such characteristics might not seem remarkable . . . but in New York at that time even a picture which was painted out of doors was painted with reference to studio formulas. . . .

I think we must place Winslow Homer first in time among the many real outdoor painters of landscape whom we have today, and certainly he was first among our outdoor painters of the figure. He was a follower of Corot in spirit—though by no means in mind or manner—before he can ever have seen a Corot, a "realist" before the realistic school was recognized, an "impressionist" before the name had been invented.[7]

Homer developed his oil painting *Waiting for a Bite* from two watercolors. In addition to the watercolor of the same name, once known as *Why Don't the Suckers Bite?*, he worked from *Lake Shore,* which supplied the background of open, burned-over land. This watercolor includes a fallen tree, although one of a different character and orientation than that from which the boys fish in the oil painting. Homer placed two dark-coated mink near the fallen tree in *Lake Shore,* perhaps to suggest that Mink Pond was well-named. In his oil he synthesized and refined several elements from the two watercolors, incorporated both fallen trees, and brought to the canvas a new scheme of color and light. There can be little doubt that he painted the two watercolors in open air at the site. He may have begun the oil there but probably completed it in his studio in New York.

Homer adapted his watercolor version of *Waiting for a Bite* for publication as a wood-engraving in *Harper's Weekly* (fig. 11). It appeared bearing the same title as the painting in the issue for 22 August 1874. Of the five wood-engraved illustrations that came from his vis-

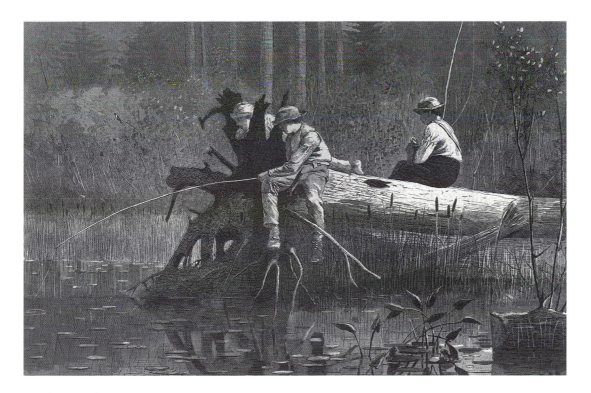

11. *Waiting for a Bite,* 1874. Wood engraving after Homer by LaGarde, 9¼ x 13¾" Published in *Harper's Weekly,* 22 August 1874.

its to the clearing in 1870 and 1874, only this one, the fourth, bears a close relationship to a known painting. In this regard it reflected a tendency in some of his late woodblock drawings for *Harper's Weekly*—the last appeared in 1875—to make use of compositions that he had recently painted in oil or watercolor. He seems to have thought of the published images as, in part, a promotional effort for unsold paintings. Nearly twenty years later, writing to his patron Thomas B. Clarke about his recently completed oil, *Hound and Hunter,* he said, "My plan is to have Harper publish it in the 'Weekly' to make it known."[8]

For the *Harper's* popular audience Homer retained the third boy from his watercolor, removed the basket, and brought the central group closer to the picture plane, increasing its scale within the composition. He rearranged and simplified the now-reduced foreground and included a touch of humor by adding two frogs perched atop lily pads who study the contemplative young fishermen. He took the background freely from the watercolor's dense forest. He may have done this to accommodate a general audience's expectation in his time that most fishing holes (and this seems nothing more) are found in or near woods, but he surely also did it to gain a rich variety of tone, shape, line, and texture that would offer as much in black and white to interest the eye as does the color of the scrub-covered open land and the sky in the oil painting.

In the *Harper's Weekly* version of the subject Homer broke the somnolent quiet of the painting by adding four things that hint at, if not anecdote, then at least a minor degree of change. The boy who baits his hook will shortly shift his position and begin to fish. The reclining boy, who only in the wood engraving has an animated face, will soon wear another expression. A bird perched on a twig at left will fly away. The frogs will leap. In these details Homer acknowledged the public's eagerness to find material for story-telling in pictorial art, but he stopped well short of gratifying that eagerness with full-fledged narrative.

In the same summer, Homer painted at the clearing a very different fishing subject in watercolor, a portrait of a friend: *Eliphalet Terry* (fig. 12). In showing Terry in an Adirondack guideboat about to net a fish, Homer painted a kind of *portrait d'apparat* of an artist who seems to have preferred fishing to painting. Terry may have requested this likeness, but he apparently never owned it; in 1876 Homer presented the work to the Century Association in New York, the distinguished club of artists, writers, and others associated with the arts to which both he and Terry belonged.[9] This watercolor's function as a portrait may have constrained Homer, for it is not as imaginative or vital as his other Adirondack work of 1874. The fluent brushwork of the water and the free washes of color that constitute the background enliven a composition that in its main figure is more dutiful than inspired, despite the presence of an interested dog.

Probably using the watercolor as a source, Homer painted an oil version of the composition, almost certainly beginning it at the clearing and finishing it in New York the next winter, dating it "1875." The figure in *Playing a Fish* (fig. 13) is more distant, its features less clearly defined, with the result that the oil seems not so much a portrait as a generalized

12. *Eliphalet Terry,* 1874. Watercolor, 9¾ x 12⅞". Century Association.

13. *Playing a Fish,* 1875. Oil on canvas, 11¹¹⁄₁₆ x 18¹⁵⁄₁₆". Sterling and Francine Clark Art Institute. Copyright © Sterling and Francine Clark Art Institute, Williamstown, Massachusetts, Courtesy of the institute.

depiction of a man fishing. In the 1890s, Homer reworked the painting, altering the bow and the stern of the boat, eliminating detail, and repainting the water and sky more broadly in a palette that evokes the soft colored light of early sunset.[10] In both works, fisherman's attire identifies him as a sportsman.

Wallace posed for two of Homer's Minerva watercolors in 1874. In *Man in a Punt, Fishing* (plate 5), the half submerged log, the boat, and the old-style fishing pole create a zigzag that leads the eye into the picture's space and connects Wallace to the viewer's world. Having no equivalent linkage to the viewer or land, Terry seems the more remote of the two fishermen. In *Trappers Resting* (fig. 14), which depicts a break taken on a carry (portage) between two bodies of water, a hand net in the canoe, and the shouldered gun allude to the activities of the unseen sportsman. Wallace sits at left, smoking his meerschaum pipe.

This was Homer's second season of working in watercolor as an expressive medium. Since the 1850s he had used monochromatic watercolor washes in the woodblock drawings he made for engravers, and he had also used the medium by itself to sketch from nature and to make preparatory studies for oils. But not until 1873 did he begin to use watercolor as an end in itself, as a medium requiring not only different techniques than painting in oils but also different treatments of subjects. The sun-drenched watercolors of children in the out-of-doors that he painted in the summer of 1873 in Gloucester were remarkable achievements, announcing (although it was not widely comprehended at their first showings) the arrival of a new approach to the medium in America. Instead of the delicacy traditionally associated with watercolor in both America and Europe, Homer's work revealed an expressive power rarely known in the medium except in the work of J. M. W. Turner in England and in Chinese and Japanese art. Homer's highly individual manner may have been inspired by such models, but it aped none of them.

His Adirondack watercolors of 1874 showed further advances in mastery, especially in his achievement of a modulated, forest-filtered light in *Trappers Resting* and *Waiting For a Bite.* Washes of color in these works and *Man in a Punt, Fishing* convey a sense of the forms and texture of dense woodland foliage without resorting, as Homer still did in his oils, to representation through the delineation of recognizable forms.

It somehow seems odd that a painter of American outdoor life who had been a committed fisherman since childhood should not depict that sport in his work until he was approaching age forty. Even in his illustrations, the subject arrived late. In the 1860s, as he embarked annually on summer excursions to the country throughout the Northeast, he presumably took with him not only the tools of his trade but also his fishing gear, yet he made no reference to fishing in the many depictions of outdoor pastimes that he contributed to pictorial magazines until the end of the decade. (A drawing of 1861 [Museum of the Rhode Island School of Design] depicting two speckled trout, one about to take a cast fly and the other already hooked and leaping, seems not to have been made for pub-

14. *Trappers Resting*, 1874. Watercolor, 9½ x 13⅜". Portland Museum of Art. Courtesy of the Portland Museum of Art. Bequest of Charles Shipman Payson, 1988.55.6.

lication.) Then, in *The Fishing Party* (fig. 15), published in *Appleton's Journal* for 2 October 1869, he reported something new about the activity. He showed that the sport had entered the sphere of the era's New Woman (of whom more in chapter 3) by presenting two women as the only active anglers in a group of fashionably attired young adults picnicking on the bank of a stream. This work, for which Homer's sketch of the four reclining figures survives, was perhaps the first work of art in America by an artist of distinction to reflect fishing's newfound status as a stylish sport.[11]

The elevation of fishing to a refined diversion occurred in the years immediately following the Civil War. It was the product of an American-led revolution that, beginning in the 1840s, thoroughly changed the design, materials, and methods of manufacture of fish-

15. *The Fishing Party,* 1869. Wood engraving after Homer by John Filmer, 9 x 13¾"
Published in *Appleton's Journal,* 2 October 1869.

ing tackle. Homer's women hold lightweight, hand-made, sectioned rods of split bamboo, probably with cork grips and presumably fitted with a reel and machine-braided, oiled silk line. The supple lightness and resilience of the rod, the strength and liveliness of the line, and other innovations and improvements of the era made possible the modern age of fly and plug casting, one in which the angler enjoyed greatly increased degrees of control within a vastly enlarged repertoire of tactics.

When Homer had painted boys still-fishing from a log and equipped them with trimmed green saplings for fishing poles and string for a line, he established a historical contrast to his depiction of Terry. This modern angler plays his fish with a flexible bamboo rod fitted with a reel. *Playing a Fish* records the transformation during the first half of Homer's lifetime of a largely static sport into one of rapid and complex motion.

While the portraits of Terry give us something of the appearance of the man and a glimpse of the paraphernalia of his favorite sport, they show nothing of that sport's visual excitement—the flashing color of a leaping trout, the sublime passage through space and time of a cast line, the tremulous wake of a boat's silent glide on a lake's still surface. Homer turned to these things in 1889.

IN THE AUTUMN OF 1874, Homer sent his last Adirondack illustration to *Harper's Weekly*. In *Camping Out in the Adirondack Mountains* (fig. 16), published in the number for 7 November, Wallace sits before a bark lean-to; his companion reclines nearby. A smudge fire keeps the bugs at bay, or some of them, anyway. The stock of a gun protrudes from the shelter, but a creel, a net, a disassembled fishing rod in its case, and a string of fish on the ground attest to angling rather than hunting as the day's activity. The birchbark canoe pulled up on the shore brought the two men across Mink Pond—variant traditions place the campsite either on one of the pond's islands or on a nearby point. Beaver Mountain occupies the horizon. The hound poking about behind the hut is as relaxed as the men. Their dress, rougher than Terry's tailored fishing outfit, suggests that they are woodsmen. Three years later in an oil painting Homer developed this subject of men camping out in a bark hut, but he treated it differently, setting the campsite in darkness rather than daylight and elevating the campfire from a subsidiary element to the work's chief subject.

16. *Camping Out in the Adirondack Mountains,* 1874. Wood engraving after Homer by LaGarde, 9¼ x 13¾" Published in *Harper's Weekly,* 7 November 1874.

Keene Valley

When Homer went to Keene Valley in late summer or early autumn of 1874, he may already have read the account of it in Seneca Ray Stoddard's just-published and highly engaging *The Adirondacks: Illustrated*, a hybrid travel book and guide book that soon became one of the classics of Adirondack literature. It passed through numerous revised editions in the course of more than a third of a century. Stoddard opened his chapter on the village with high praise: "Keene Flats undoubtedly possesses the loveliest combination of quiet valley and wild mountain scenery in the Adirondacks, if not indeed on the continent."[12] Yet, so far as is known, Homer drew or painted none of this scenery in 1874. The only work that seems to have a connection to his visit of that year is an oil painting whose title and landscape setting pertain instead to the clearing in Minerva, and whose assignment to 1874 remains conjectural.

Beaver Mountain, Adirondacks, Minerva, New York (fig. 17) is one of the rare problem paintings in Homer's oeuvre. Parts of it are thinly painted, leaving the impression that it is more an oil sketch or a work in progress than a finished painting. The figures of the women are ill-drawn by Homer's standard. The relationship of the three figures, two women and a man, is unclear, both among themselves and in relation to the landscape around them; this degree of ambiguity is rare in his work. The identity of the male figure, a noted guide, Orson Phelps, is certain, but he belongs in Keene Valley rather than in Minerva with Beaver Mountain as his background. Despite its shortcomings, Homer evidently had some regard for this work; a photograph shows it framed and hanging in the apartment that he shared with his cousin, Samuel T. Preston, in New York on his return from England late in 1882.[13]

Because the painting is undated, it has been assigned conjecturally to various years in the mid-1870s, chiefly on the assumption that it was a study for, or otherwise closely related to, Homer's much finer *The Two Guides* (plate 7), a product of 1877. While Homer may have painted it in that year (and it is conjecturally assigned there in appendix B, below), the dimensions of *Beaver Mountain* correspond closely to those of *Waiting for a Bite* and *Playing a Fish*. This suggests that in traveling to the Adirondacks in 1874 Homer took with him only a single stretcher with several pieces of canvas to fit. He seems to have the done the same in 1877, although in that year the stretcher was considerably larger.[14] If *Beaver Mountain* is to count as a study for *The Two Guides*, it is probably only in the sense that having failed to bring the earlier work to a successful conclusion, Homer reconceptualized the subject and began again. The two paintings make an provocative pair, one of them among the artist's weakest efforts, the other an unquestioned early masterpiece.

IN KEENE VALLEY, Homer resided in 1874 at the Widow Beede's Cottage, an inn with accommodations for twenty about two-and-a-half miles south of the village center, near the junction of the East Branch of the Ausable River and Roaring Brook. Seneca Ray Stod-

17. *Beaver Mountain, Adirondacks, Minerva, New York*, c. 1874–1877. Oil on canvas, 12 x 17⅛".
Newark Museum. Courtesy of the museum.

dard, who was as enterprising with his camera as he was with his pen in his travels through-
out the region, photographed the building's appearance, probably in 1873 (fig. 18).

On 5 October 1874, an unknown photographer recorded Homer as part of a group of
artists, some with sketch pads, posed on a bank of the East Branch (fig. 19).[15] The other four
men are the painters J. Francis Murphy, Calvin Rae Smith, Kruseman Van Elton, and,
bearded and hatless, Roswell Shurtleff. Homer, in profile at center, holds a pipe in his
mouth. Because he moved his head as the shutter snapped, his likeness is indistinct com-
pared to the others.

Shurtleff had known Homer in Boston in the mid-1850s when both were graphic
artists. He had become a devotee of Adirondack life in that decade and soon began an as-

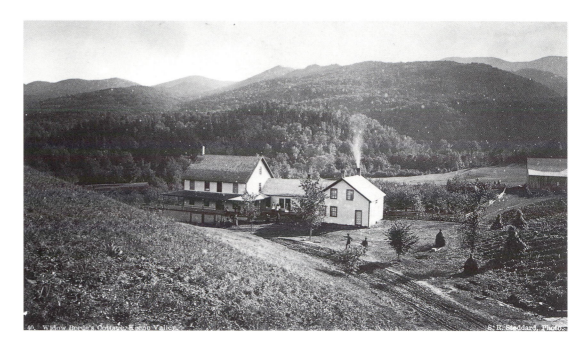

18. Seneca Ray Stoddard, *Widow Beede's Cottage*, c. 1873. Photograph. Keene Valley
Library Association. Courtesy of the association.

sociation with Keene Valley that lasted even longer than Homer's with the clearing. Unlike
Homer, who dressed fastidiously, Shurtleff "went native" in his attire. In the photograph
he is dressed as roughly as a guide while Homer is, as always, impeccably turned out in the
best fashion. The identities of the women and the boy are unknown.

Other than Homer, Murphy was the only painter in the photograph who became an
artist of historical significance. He would soon be a distinguished landscape painter in the
Tonalist style, but at the time of this photograph he was only twenty-one, at the beginning
of his career, and about to move from Chicago to New York. More than chance may have
placed Homer at the center of this group of painters. Most artists in America greatly ad-
mired his work, and those who knew him held him in great respect as a person, even
though his reserve, laconic speech, and austerity of manner did little to encourage close
friendship.

Critics, too, admired his work, but even as late as 1874, when he had been a painter for
a dozen years, some continued to express reservations about the "lack of finish" in his
paintings. Frequently, they were echoing the old Ruskinian-derived belief that truthful-
ness in depicting nature required the meticulous transcription of nature's details, but they
also reflected a persistent degree of discomfort with, on the one hand, the tenets of Real-
ism and, on the other, a growing interest in aestheticism, exemplified by Murphy's admi-
ration of Whistlerian Tonalism. Both of these styles, each in its own way, required viewers
to supply in their own minds not only "finish," but meanings as well. As an independent

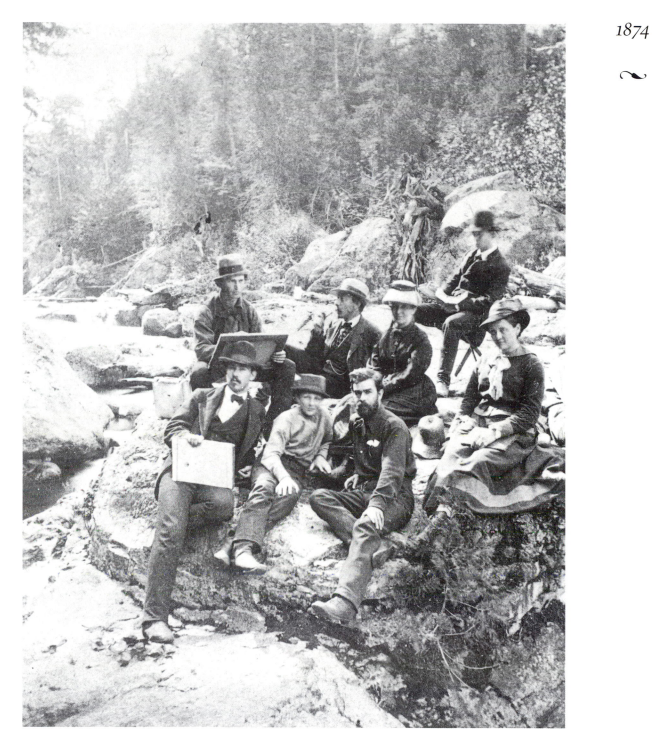

19. Photographer unknown, *A Group of Artists on the Bank of the East Branch of the Ausable River,* 5 October 1874. Courtesy of The Adirondack Museum.

Realist, Homer throughout his career had engaged his viewers visually not through story-inducing detail but through color, structure, nuance, memory, and allusion. He expected his viewers to be active rather than passive participants in the art experience. By the mid-1870s he had begun to grow impatient with critics who seemed to misunderstand what he was doing.

ORSON PHELPS, the bearded man who stands well to the rear of the women in *Beaver Mountain,* was a celebrated Keene Valley guide (of whom more in chapter 3). One of Phelps' daughters had married into the Beede family, and this assured his frequent presence at the inn. Since he made a practice of gravitating to notable visitors wherever they lodged in the village, it seems unlikely that he would have left Homer unaccosted for long, even if the painter had been at a camp site in the forest rather than at the Widow Beede's. Shurtleff would probably have effected an introduction of Phelps to Homer if the guide had not done so himself.[16]

Despite Phelps' role as a guide, in *Beaver Mountain* Homer placed him passively behind the women, too far away to be actively involved with them or to be imparting either wisdom of the woods or drolleries—he was noted for both. He may have led the women to this place; his presence is otherwise unaccountable. The women presumably look at the mountain scenery but he does not. Only in this work, of all his Adirondack paintings, did Homer leave a significant figure's relationship to wilderness so undefined. With Phelps alone in the painting he might have achieved something close to the oneness of figure and nature of *The Trapper,* and with only the women he might have enlarged on the subject of the outsider visiting wilderness, as he had done, however slightly, in *Eliphalet Terry.* By including both Phelps and the women, he needed to find a new subject, one that avoided the artificiality of earlier depictions of the relationship of guides to sportsmen by Arthur Fitzwilliam Tait and others. This he failed to do in *Beaver Mountain,* and never again did he attempt in an Adirondack painting to associate insiders with outsiders.

Who are the women? Could they be those who appear with Homer in the East Branch photograph? Or, if we are to trust Beaver Mountain as a clue to identities, might the women be Juliette Baker Rice and her mother, or perhaps two of Homer's fellow boarders at the clearing? Why did Homer, who tended to destroy works that did not meet his standards, keep this one? One conjectural answer to the last of these questions suggests that Homer painted *Beaver Mountain* as a study in 1874, but reinitiated the subject with major changes in 1877 when he embarked on *The Two Guides.* This left *Beaver Mountain* as a relatively independent work which he perhaps preserved for sentimental reasons, now unknown. Whatever its history, the work's chief significance is that it contained within it the seeds of two far more distinguished paintings, not only *The Two Guides* but also *In the Mountains.*

1877

In the Mountains

THREE OIL PAINTINGS and a brief newspaper item document Homer's presence in the Adirondacks in 1877. The *New York Tribune* for 13 October of that year, in an article titled "Reopening the Studios," reported that "Winslow Homer is back from the Adirondacks finishing two pictures of life in that region."[1] Although it does not indicate where in the region he had been, the evidence of the paintings suggests Keene Valley. The *Tribune* writer apparently saw only two paintings, but three came from this summer in the Adirondacks: *In the Mountains, The Two Guides,* and *Camp Fire.*

Each of the paintings treats a different subject. Water, which directly or by implication had defined so much of Homer's Adirondack work of 1870 and 1874, is absent in 1877. All three of the paintings reflect Homer's steadily increasing powers and his ability to find strikingly original subjects in commonplace events. The 1877 works are infused with an even more marked sense of self-confidence than before. Some of this had doubtless accrued from the critical and popular praise that a year earlier had greeted his *Breezing Up (A Fair Wind)* at both the annual exhibition of National Academy of Design in New York and the exhibition of American art at the Centennial Exposition in Philadelphia.[2] This painting of a man and boys in a catboat slicing through the waters of Gloucester Harbor enjoyed the most enthusiastic reception of any of Homer's works since *Prisoners.*

The three Adirondack oils of 1877 deal, each in its own way, with outsiders visiting the wilderness. They depart from *The Trapper* in this respect, and in other ways as well. Each of them, although begun in the region, required final work in the studio, and as the *Tribune*'s writer made clear, this was the common practice of the time. The column began:

> While the main body of the army of artists still lingers among the mountains or at favorite resorts along the sea-shore, a few detachments have already returned, and there is a little stir again in the studio buildings. These avant couriers are mostly figure painters. . . . The majority have a good account to give of their vacations, and some bring back a lot of happy sketches of life and scenery such as are not often seen, and which promise to form the basis of excellent pictures the coming winter.

If *The Trapper* is all horizontal stillness in its landscape, *In the Mountains* (plate 6) is all diagonal movement. Its long lines rise steadily upward toward the left, becoming a pic-

torial analogue of the experience of climbing a mountain trail. The bare ledge and surface-hugging scrub that dominate the painting's foreground may suggest arrival above tree line and an approach to a summit cleared by fire and erosion to sheer granite, but the higher, tree-clad ridge in the distance tells a different story. These four hikers, framed within roughly parallel diagonals, have reached only an outlook on the trail, and one of no great elevation. Two of them pause to take in the view; the other pair comes along behind them. The grandly rising ridge line reveals no beginning and no end. Few, if any, of Homer's contemporaries can ever before have seen an American landscape painting in which a diagonal of such beguiling boldness runs unbroken from one side of the painting to the other.

The ridge serves as a field of deep, densely dark green paint against which Homer plays the colors and reflections of the hikers' costumes. The red skirt and cuffs of the last hiker in the procession sounds a clarion note, virtually leaping from the canvas, echoed in touches on scarfs and headwear. We have seen the two frontmost figures before, in *Beaver Mountain*, similarly costumed and wearing the same hats, but without hiking sticks. Homer may have painted the women coming along the trail from the same two models, dressed and posed differently, but these four figures, configured as in the painting, also appear in Homer's drawing, *Study for "In the Mountains"* (fig. 20), probably of 1877.[3]

In neither the painting nor the drawing did Homer detail the women's faces. Facial detail would have been antithetical to the quick-sketch quality of the drawing, and it would have clashed as well with the reflected light that in the painting obscures detail in the costumes, clouds, and exposed roots—a light that emphasizes surface rather than substance. The more abiding things transmitted by sharply defined faces would be out of place here.

The four figures are New Women. If Homer did not actually invent the image of this entity in American culture, no other painter treated it so persistently and successfully during the 1860s and 1870s. He shows the type at closer range in his croquet scenes, at the seaside, and in the White Mountains; he reduces the scale here and paints her with more vigor to make a point of her self-assured presence without a guide on a trail in the Adirondack wilderness.[4]

The stereotypical New Woman is young or youngish, self-assured, independent, resourceful, urban, and removed from the domestic sphere. Nothing in any of Homer's depictions identify her as daughter, sister, wife, or mother. He shows her as relatively affluent, pleasure-seeking within the bounds of propriety, not overtly pious, keenly up-to-date in fashion, always decorous. She is not openly expressive and neither are the men who sometimes accompany her. She is unknown in American art before the Civil War, but by the mid-1860s, the Women's Rights Movement, the opening to women of some professions (teaching, medicine, editorial work), and the natural inclination of a younger generation to be different from its elders had begun to redefine the status of younger middle-class women in American society. Homer responded to this shift in identity sympathetically. He approached it from his Realist orientation as a vital subject in modern life.

20. *Study for "In the Mountains"*, 1877. Charcoal on paper, 8½ x 13". Private collection.

It is hard to think of any American painter before him who would have presented four women hiking for pleasure on a mountain trail unaccompanied by men. Surmounting a granite ledge, asserting their presence against the massive ridge looming behind them, these visitors to the wilderness almost certainly follow a marked trail. They are part of the movement that arose in the Northeast in the 1870s, and in which women participated actively, to give the public safe access to forests and mountains through the building of marked trails for self-guided hiking.

In its reductiveness, the landscape in which Homer sets the women departs from the Hudson River School's preoccupation with detail and from the practice of landscape painters in general to construct a gradual recession of pictorial space through a sequence of connected landforms. The landscape in *In the Mountains* consists only of widely separated vertical planes, those close together in the foreground—the rock faces and the ledge occupied by the hikers—and the single plane of the distant ridge, with nothing between them but a great gulf of mountain air. No individual trees soften the foreground. Exposed roots on the ledge hint at death and reinforce the idea that these women tramp in wild nature and not in a park. The brushwork that forms the serrated edge of the distant ridge

reads as dense conifer forest. Its precision complements the fluid painting of the clouds and the drier technique of the ledge. Slight modulations of tone here and there on the ridge hint at its volume, but in this work Homer for the most part turned his back on the landscape tradition that moved the viewer's eye gently from foreground to middle ground and on to background, a tradition he had followed in *The Trapper*. In *In the Mountains* he requires the eye to leap from foreground to background. He did this not for novelty's sake, nor only to dramatize the presence of this quartet of women within the colossal scale of the great forest, but also to set the viewer's mind to work constructing the lay of the land.

In 1959, Lloyd and Edith Goodrich omitted *In the Mountains* from their comprehensive list of Homer's Adirondack works because its title specifies no particular region, its landscape contains no Adirondack landmark, and Homer was not then known to have visited the Adirondacks in 1877, the year that accompanies his signature on the canvas.[5] These hikers could as well be on a trail in New Hampshire's White Mountains. Now that it is clear that Homer had a highly active season in the region in 1877, little doubt remains that this painting is an Adirondacks work. The locale is surely Keene Valley. No hiking trail in the vicinity of the Bakers' farm has an outlook backed by a ridge of this scale. The scenery is closer to what the hiker sees climbing out of Keene Valley toward high peaks, perhaps Mount Marcy, a common enough activity for Valley tourists.

The Two Guides

The unidentified writer of the *Tribune*'s "Reopening the Studios" column specified the two unfinished Adirondack subjects in Homer's studio as, "one of a campfire at night in the woods, and the other of a tramp to Mt. Marcy."[6] After an extended comment on the campfire painting (of which more below), the writer added, "'The Trail to Marcy' introduces Old Phelps, one of the well-known guides of the region."[7] While the women hiking in *In the Mountains* might well be on their way to the summit of Mount Marcy, Phelps' absence from their party argues against this work being the painting mentioned in the column. *Beaver Mountain* includes Phelps, but its landscape setting and title place him at the clearing in Minerva, far from Mount Marcy. Geographical disparity may also seem to argue against *The Two Guides* as "The Trail to Marcy," for Beaver Mountain is part of its scenic background, but in this painting Homer has made the mountain a peak in a massive range of high elevation, more in accord with Keene Valley heights and unlike Beaver's character in Minerva as a low mountain rising above a pond. Moreover, even in its unfinished state Homer would have been more likely to have shown a visitor to his studio the masterful *Two Guides* rather than the problematic *Beaver Mountain*.

The two men stand on a clear-cut slope, ferns and white blossoms beneath them. Sunlight glints off the taller man's axe handle and shirt buttons and off the blade of the axe foreshortened on the other man's shoulder. The shorter man (Phelps) wears an Adirondack pack basket; his companion carries a lunch pail. Homer has put Beaver Mountain to use

as a backdrop for these two, but the lesser summits at right and the distant range running into the distance at left have nothing to do with the landscape of the clearing. This synthesized mountain landscape gives Beaver as much Alpine character as it will ever have in Homer's work.

The mountain's greens reveal blushes of red. Like the greens of the underbrush they act with the reds of the shirts, flesh, ferns, and tree to offer an object lesson in how to intensify and unify a painting with complementary color. Banner-like clouds of gray mist, sometimes touched with green and pink, course through the notch that opens between the mountain and the men. Homer's bravura painting of these low-hanging strati presages the powerful brushwork of his marines of the next decade. At the left of the canvas, past the tops of white pines, the land falls away sharply into a an unseen valley. A bird flies high above this cleft, although still at a lower altitude than the two men. It reinforces a sense of height foreign to Minerva but just right for an ascent of Marcy. Phelps points; his companion follows his direction. Their dress and implements make them woodsmen.

In this respect *The Two Guides* differs from the century's other great painting of two men conversing in American wilderness: Asher B. Durand's *Kindred Spirits* of 1849 (New York Public Library). In that work the painter Thomas Cole and the poet William Cullen Bryant stand atop a ledge in the Catskill Mountains. They are visitors who have come to commune with wild nature as fact and symbol, but not to live in it. They are inspired by the wilderness but not part of it, as Homer's two guides so clearly are.

Like *Kindred Spirits, The Two Guides* is a double portrait. While Wallace's identity was incidental to *The Trapper,* for he was scarcely known outside Minerva and Chestertown, Orson Phelps was of central importance to *The Two Guides*. During the years immediately preceding this portrait, he had become a celebrated Adirondack personality. His younger and taller colleague, Monroe Holt, seemed in 1877 to have the potential to become the same.

The *Atlantic Monthly* had introduced Phelps to a national audience in its May 1876 number, more than a year before Homer painted *The Two Guides*. In that issue Charles Dudley Warner had made him the subject of his essay, "A Character Study." He wrote:

> I suppose the primitive man is one who owes more to nature than to the forces of civilization. What we seek in him are the primal and original traits, unmixed with the sophistications of society, and unimpaired by the refinements of artificial culture. . . I would expect to find him . . . enjoying a special communion with nature—admitted to its mysteries, understanding its moods, and able to predict its vagaries. He would be a kind of test to us of what we have lost by our gregarious acquisitions. On the one hand, there would be the sharpness of the senses, the keen instincts which the fox and the beaver still possess, the ability to find one's way in the pathless forest, to follow a trail, to circumvent the wild denizens of the woods; and, on the other hand, there would be the philosophy of life which the primitive man, with little external aid, would evolve from original observation and cogitation. It is our good fortune to know such a man.[8]

Thus, with tongue in cheek, Warner furthered the immortalization of Phelps. Warner may first have learned about Phelps two years earlier from Seneca Ray Stoddard. Stoddard had devoted more than a dozen pages to him in 1874 in his *Adirondacks: Illustrated*.[9] He described him as:

> a little old man, about five foot six in height, muffled up in an immense crop of long hair and a beard that seems to boil up out of his collar band; grizzley as the granite ledges he climbs, shaggy as the rough-bark cedar, but with a pleasant twinkle in his eye and an elasticity to his step equaled by few younger men, while he delivers his communications, his sage conclusions, and whimsical oddities in a cheery, cherripy, squeaky sort of tone—away up on the mountains, as it were—an octave above the ordinary voice, suggestive of the warblings of an ancient chickadee.[10]

Stoddard also photographed him (fig. 21) and drew his likeness for publication in *The Adirondacks: Illustrated* as a wood-engraving with a scenic background (fig. 22).

21. Seneca Ray Stoddard, *Orson Phelps,* 1876. Photograph. Adirondack Museum. Courtesy of The Adirondack Museum.

22. Seneca Ray Stoddard, *Mt. Colvin, Ausable Pass, Resagonia, and Orson Phelps,* 1873. Drawing, photomechanically reproduced as an illustration, 1⅝ x 2¼", in Stoddard's *The Adirondacks: Illustrated,* 1873.

"Old Mountain" Phelps, as he had come to be called by the 1870s, had in his younger years been among the early explorers of the Adirondacks. Around 1844 he married and settled in Keene Valley, where he made his home until his death in 1905. In the 1840s and 1850s he had charted the High Peaks and cut trails to several previously unscaled summits. Ranging more widely than most guides, in his younger years he had been a genuine explorer, and on this account he took a proprietary view of the entire High Peaks region. By the time Homer painted him in 1877, Phelps at sixty-one had limited his guiding terrain for the most part to the Ausable Lakes, where he maintained a camp, to Mount Marcy, and to various trails connecting them. At home in Keene Valley he held court for the sightseers who came in increasing numbers after the publication of Stoddard's and Warner's accounts of him. At this point in his career he guided tourists on scenic hikes to his camp and to Marcy perhaps more than he led sportsmen to wilderness sites for hunting and fishing.[11]

In the nonstop patter of his mature years he mesmerized the more willing of those who went with him into the forest and up the trails. He wove together lively commentaries on topography, botany, local history, politics, social issues of the day, forest exploits, famous people he had known or read about, and much more, although his primary subject was himself. He kept abreast of the events of the day outside the Adirondacks by reading

Horace Greeley's *New York Tribune* religiously; he must have been inordinately pleased to see his name in the "Reopening the Studios" column. His imperfect skills in spelling and grammar did not prevent him from contributing to the *Elizabethtown Post* and the *Essex County Republican* short pieces on natural history, local events, and other subjects.[12]

Homer portrays him wearing an Adirondack pack basket of his own making. Phelps claimed to have invented this kind of carrier, but it had long been traditional in Northeast Native American culture. He crafted the baskets during the winter months and sold them from his home during the tourist season. By the time that Homer painted him, Warner's primitive man had become an entrepreneur, an entertainer in the guise of a rustic philosopher, and pretty nearly a caricature of the man of the woods.

Like Phelps, Holt resided in Keene Valley, the village of his birth. His uncle Harvey Holt was a celebrated guide. Thirty-two when Homer painted him, Monroe Holt had acquired a local reputation as a brawny guide, quick-witted and humorous, and a man of integrity, although without a persona so distinctive as Phelps's. Years later a villager recalled him as "a large, powerful man . . . [whose] peculiarity was a red flannel shirt which he wore all summer as well as in cold weather," and this is how Homer portrayed him.[13] Holt's double-breasted fireman's shirt bears the heart insignia of a hose company, but the shirt came from outside Keene Valley, a place too small to have a firefighter's organization. Holt undoubtedly wore the shirt in summer from the belief that the color red repels insects. (Wallace apparently believed the same, for he appears in red in several of Homer's watercolors.) The shirt's color and the reflections on its breast buttons draw attention to Holt's finely delineated head, keeping the balance of interest from weighing too heavily on Phelps who, as the active figure, extending his arm to point, initially sparks our curiosity.

Lacking Phelps' talent for self-promotion, Holt never became an equivalently legendary figure. Before many years passed, he ceased to work as a guide. With his wife he established and operated the Spread Eagle Inn in Keene Valley. He later served as the village's Justice of the Peace. A photograph of him taken near the turn of the century shows him in a pose remarkably similar to the one he held for Homer (fig. 23), although his paunchiness speaks of life in town rather than in the hardier wilderness. He is best remembered through Homer's rendering of him, one that moved a critic writing in 1890 to say of it that "there is something free and audacious in his pose beside the weatherbeaten old guide with his grizzled beard and slouch hat, something finer and nobler than mere size and good health."[14]

Although *The Two Guides* shares with *The Trapper* the general subject of woodsmen in their natural setting—the wilderness—the two paintings differ in what they have to say about it. The trapper's wilderness is intact but the guides stand on a rise that has been cleared of trees. Both hold axes; a newly cut sapling lies by them. The trapper is engaged only with the natural world—he turns in response to something in it. The guides are engaged with each other—Phelps points and talks while Holt listens. The trapper's business is with wilderness. The business of these guides is with the sportsmen they attend.

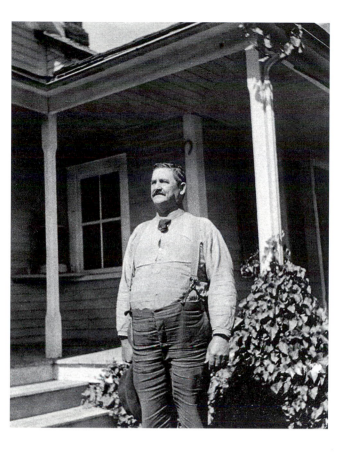

23. *Monroe Holt*, c. 1900–1910. Photograph. Keene Valley Library Association. Courtesy of the association.

In 1874 Stoddard said of guides that "they are, as a class, a noble set of men, who feel themselves the equals of their employer, and, to a great extent, reflect back their usage. . . . If you expect fawning servility the prospects are that you will soon be without a guide"[15] and "guides receive from $2.50 to $3.00 per day, furnishing boat, with every thing usually required for camping purposes, and doing all the work, although employers are expected to assist with the lighter articles over carries."[16]

Earlier, in 1869, Murray had treated the same subject with a touch of hyperbole:

I have seen the [guides] under every circumstances of exposure and trial, of feasting and hunger, of health and sickness, and a more honest, cheerful, and patient class of men cannot be found the world over. Born and bred, as many of them were, in this wilderness, skilled in all the lore of woodcraft, handy with the rod, superb at the paddle, modest in demeanor and speech, honest to a proverb, they deserve and receive the admiration of all who make their acquaintance. Bronzed and hardy, fearless of danger, eager to please, uncontaminated with the vicious habits of civilized life, they are not unworthy of the magnificent surroundings amid which they dwell. . . . Measured by our social and intellectual facilities, their lot is lowly and uninviting, and yet to them there is a charm and fascination in it. The wilderness has unfolded to them its mysteries and made them wise with a wisdom nowhere written in books.[17]

In revealing selectively the ways of forest life to outsiders, guides also defined themselves by elaborating on the stereotype already in place before Murray published his *Adventures*—one of the guide as a character larger than life. Stoddard describes an evening at Phelps's camp on Upper Ausable Lake, with ten sports, two or three dogs, and an unspecified number of guides who, "while the fire snapped and flickered, filling the shanty with dancing shadows," enchanted their captive and mostly rapt audience with story upon story. They told

> stories of personal prowess which culminated in one of a man who could pick up a two barrel iron kettle by the edge with his teeth, and the assertion by another that he knew another man who could perform the same feat sitting in the kettle himself when he lifted it, which was making light of serious subjects, and so Phelps told his bear story, how one day near the Boreas, he saw a big bear coming on the run after him and he, armed with only a little ax, then when the bear got within twenty feet of him he yelled "halt", which stopped the bear—he couldn't prevaricate, he did it with his little hatchet—he didn't feel scared any, only stirred up like, but the bear reversed ends and made off as fast as it could wabble.[18]

Phelps's audience would have caught his allusion to George Washington's apocryphal "I cannot tell a lie" answer to his father after felling a cherry tree.

Despite Stoddard and Warner's close knowledge of Phelps and Phelps' own proclivity for self-advertisement, nothing seems to have survived to explain the origins of *The Two Guides*. Perhaps an answer can be found in the painting's chief landscape component. Homer may have set Phelps and Holt, two Keene Valley worthies, in front of Minerva's Beaver Mountain not only because of his partiality to the mountain's shape but also to link together in art for personal reasons two places that in actuality were far apart. *The Two Guides* may commemorate a passage between the two locations in which Phelps and Holt worked as guides for a party of sportsmen that included Homer. No one knew the trails and fishing sites in the wilderness between Keene Valley and Minerva better than Phelps. He might have begun this journey by accommodating the party at his camp on Upper Ausable Pond. After the group had enjoyed a day or two's fishing, he might have led it on to Marcy, then descended miles of trail to Boreas Pond for more camping and fishing, and in time followed the Boreas River through deep forest to the point, a few miles from its junction with the Hudson, where it intersected the road from Minerva to the clearing. Holt would have provided much of the muscle needed to carry the party's gear. Such a trip would have taken a few days, and longer if the fishing were good.

Homer's characterization of both guides speaks more of an extended journey through wilderness than a day's hike on well-worn trails. Both men carry the axes needed for travel in wilder terrain. Phelps, the volubly knowledgeable pathfinder, points and talks. Holt, the campmaker, carries a food bucket. But the only evidence suggesting that such an excursion may have occurred is the painting itself. It includes everything needed to stand as a memoir of its maker's association with two remarkable people on a trip through the wilderness

from Keene Valley to the clearing. It may be a report on a happy time by a man whose primary means of eloquence was paint.

A common reading of the painting has been the allegorical one of age teaching youth. A descriptive entry in *The Art of the World,* an elaborate set of reproductions of works of art exhibited in 1893 at the World's Columbian Exposition in Chicago, observed:

> In Mr. Winslow Homer's The Two Guides the artist has painted one of the veterans
> of the Adirondacks whose acquaintance he made in the woods. The old man bears his
> years well, even by contrast with the stalwart young fellow who will take up the work
> so admirably done by the generation of guides and trappers now fading away.[19]

Later in the decade other writers, perhaps taking their lead from this, said, "the veteran seems to be pointing out to his companion certain landmarks in the vast wilderness," and, "the pioneer of the past is schooling his young successor, to whom he will soon abdicate his place, in some of the secrets of his crafts."[20]

Later generations would find other, less benign, meanings in this painting, some almost certainly not intended by Homer but powerful nonetheless. In these the work becomes through the axes and clear-cut land an allegory of the destruction of wilderness through the felling of the forest. At another level, the guides' significance rests on their central role in the development of the region as a center for sport and recreation at the cost of its purity as nature.

Kenyon Cox, writing in 1914, singled out *The Two Guides* as the first of Homer's masterpieces. Lloyd Goodrich in 1944 described it as "Homer's most mature painting to date, a new and more vigorous kind of subject, handled with impressive ability." Albert Ten Eyck Gardner in 1961 said that it was "a matured and measured statement of the artist's full powers. The composition is a masterpiece of restraint." Some of its earliest viewers may have held the painting in similarly high regard, but it did not find a buyer for more than a dozen years. About 1890, Thomas Clarke, the greatest collector of American art of his time and by then, with Valentine, one of Homer's two chief patrons, purchased it, probably for little more than five hundred dollars.[21]

Camp Fire

Of the two Adirondack paintings that the *Tribune*'s writer saw in Homer's studio, *Camp Fire* (plate 8) elicited the most comment. Having identified the painting as "a campfire at night in the woods," the writer went on to say that it

> brings out not only a pretty good thing in the way of a bark hut in which the artist's
> party bivouacked—a structure hardly to be seen in the New York woods other than in
> the Adirondacks region—but also a peculiarity in camp fires which every boy and
> man who has ever roved the woods much has seen in his own camp-fire, but perhaps
> never before on canvas. In stacking up branches and logs for a rousing fire, one occa-

sionally comes across a rare chunk of moss-covered wood which when thrown into the fire [fills] the flames above it with sparks which fly up in long, bright waving lines and lend to the fire a most fanciful [charm]. Not every campfire has those comet-like sparks. It is only when mossy branches are thrown in that they appear. Mr. Homer is trying to paint a campfire of this sort.[22]

Three triangular shapes lock the composition together: one of brilliance—the fire—pushed almost into the viewer's world, one in a much lower key—the interior of the shelter defined by reflections on its outer edges—and one barely emergent from darkness—the partially uprooted reclining tree meeting the shelter's sloping back. A figure sits between the tree and the hut, his head carrying the axis begun by the right side of the fire upward to the apex of the shelter, connecting the forms and giving human interest to this world of flying sparks, flickering light, shadow, and dark emptiness.

Soon after Homer's death in 1910, Roswell Shurtleff contributed a brief memoir of the artist to *American Art News* in the form of a letter to the editor. He recalled that Homer had painted *Camp Fire* in the course of one of his visits to Keene Valley. In his praise of the painting he, like the *Tribune*'s columnist, emphasized the sparks, saying that "a woodsman could tell what kind of logs were burning by the sparks that rose in long curved lines."[23] It is curious that the painting of the fire itself failed to elicit more comment. Its splendidly arrayed daubs of paint register faultlessly as glowing embers, smudge smoke, and leaping flames. As with the ribbon clouds of mountain mist in *The Two Guides,* Homer here used paint less as a tool of realism and more as an end in itself—color, texture, form, and autographic manipulation that pleases the eye.

In these things he may have been reflecting the new emphasis on painterly qualities—on fluent brushwork and rich impastos—that had arisen in New York around the time of the Centennial with the younger generation of American painters returning from study in Munich, led by Frank Duveneck and William Merritt Chase. Homer's darkening palette of the late 1870s, which distinguishes his 1877 Adirondacks oils from their predecessors, may reflect the same influence. But if he to some slight degree followed rather than led in these things, he was also a greater master in putting them to substantial use. The animated brushwork of the younger painters now seems superficially decorative; Homer's brushwork impresses the viewer as necessary for his subject. The dark tonalities of his younger contemporaries seem arbitrarily chosen; Homer's subjects call for his deepened palette, none more so than *Camp Fire.*[24]

In 1880, Homer told the New York critic and art journalist George Sheldon a little about how he had painted *Camp Fire.* He did so in the context of some remarks on why it was usually necessary for an artist to synthesize a landscape composition freely from sketches and studies of elements observed at different locations, rather than to record precisely what he or she saw in a single place. Sheldon wrote:

> Yet he admits that it is possible, sometimes, to find a picture—a complete one—outdoors; to meet with a combination of facts so happy that a sketch of it would deserve

to be called a picture—a rare case, of course, but not an impossible one. His "Adirondack Camp-Fire" is almost an example in point. He painted it out-doors; but the large tree on the left [i.e., right], the line of which answers to the line of the pole of the tent, is not in the original scene. He found it elsewhere, built a fire in front of it, observed the effect [of the firelight on the tree], and transferred it to the canvas. With this exception, the composition is a general transcript of the surroundings of a fire lighted one night while he was camping in the Adirondacks.[25]

CAMP FIRE IS Homer's sole painted contribution to the one subject in American art distinctive to the Adirondacks: scenes of camp life. The subject has two essential elements: sportsmen relaxing in a forest clearing, often accompanied by one or more guides, and a lean-to, tent, or other shelter. No one actively engages in sport. No women are present or, presumably, within miles. Arthur Fitzwilliam Tait's *With Great Care* of 1854 may be the earliest example of the genre; his *A Good Time Coming* of 1862 (fig. 24), reproduced as a colored lithograph by Currier & Ives, enjoyed much popularity in its time. Tait shows one guide cooking and another placed at a respectful distance from the sports, one of whom,

24. Arthur Fitzwilliam Tait, *A Good Time Coming,* 1862. Oil on canvas, 20½ x 30".
Adirondack Museum. Courtesy of The Adirondack Museum.

in concert with the gustatory spirit of the work, pours champagne into his tin cup. Part of the picture's appeal is olfactory, an evocation of the scents of the pine forest, wood fire, fish frying, viniferous effervescence, and campsite mustiness.

William J. Stillman's *Philosophers' Camp* of 1858 is perhaps the best-known specimen of the subject owing to its value as a not-very-enlightening pictorial record of the pilgrimage to wilderness (Folansbee Pond) undertaken by Ralph Waldo Emerson, James Russell Lowell, Louis Agassiz, and seven other distinguished men from Boston and Cambridge, all more at home in a lecture hall or laboratory than in camp.[26] More animated by far is Frederic Rondel's *A Hunting Party in the Woods,* also known as *Batkins Club in Camp in the Adirondacks* (fig. 25). It captures the sense of camaraderie in camp extolled by Murray and others but scarcely seen in Stillman's painting. Rondel's "sports" play cards, count their fish, clean weapons, smoke, imbibe, and dine. No guide seems present, and understandably so, since this painting is a group portrait of the members of a sporting club. Rondel depicts himself right of center, seated on a stump with a pipe in his hand.[27]

While Rondel served as Homer's first and only instructor in painting, by the time that

25. Frederic Rondel, *A Hunting Party in the Woods (Batkins Club in Camp in the Adirondacks),* 1856. Oil on canvas, 22 x 30". Adirondack Museum. Courtesy of The Adirondack Museum.

any instruction took place Homer already possessed superior drawing skills and a surer instinct for composition. Rondel's greater contribution to the painting of his era came from the enthusiasm that he, Tait, Shurtleff, and a few others generated in the 1850s about the Adirondacks as a place not only of scenic beauty but also of characterful campsites, rustic inns, and other places in which a return to nature brought the sojourner close to the wild.[28]

Homer departed from the thinking of Tait, Rondel, and other earlier painters of camp scenes by stripping the subject of nearly all anecdotal detail. He took the camp's fire, a minor detail in the work of other Adirondack painters, moved it to the edge of the picture plane and transformed it into a virtuoso passage of painting. His camp scene made the work of his predecessors in the genre seem contrived, valuable perhaps as documents of social history, entertaining sometimes in the stories they tell, but of minor interest as works of art capable of moving the viewer.

In *Camp Fire*, Homer developed, indeed transformed, his first thoughts on the subject as they had appeared three years earlier in his *Harper's Weekly* illustration *Camping Out in the Adirondack Mountains*. That work, set on Mink Pond, shares a few similarities with the painting, chiefly the bark hut and the placement of the creel and net on it. But Adirondack bark huts tend to look alike, and it seems best to accept these things as true: Homer's reported statement that he painted *Camp Fire* from life, Shurtleff's recollection that the campsite where this occurred was near Keene Valley, and the *Tribune*'s report that the painting was a product of 1877. In finishing the painting in his studio, Homer may have consulted his *Harper's* illustration to add such details as the fishing gear, but little else in it would have been of much use.

What Homer eliminated from the camp scene tradition in both works was not only active communication among sportsmen but also any relationship between sportsman and guide. Both figures in *Camp Fire* are certainly sportsmen; protocol required that, when practical, guides camping out have their own lean-to and fire. The fire in Homer's painting provides his campers with light, smoke to deter insects, and a source of aesthetic pleasure. Watching a campfire at night had always been a deeply satisfying part of the experience of being in the woods. Warner wrote of it in his "Camping Out:"

> Darkness falls suddenly. Outside the ring of light from our conflagration the woods are black. . . . The spectres, seated about in the glare of the fire, talk about appearances and presentations and religion. The guides cheer the night with bear fights, and catamount encounters, and frozen-to-death experiences, and simple tales of great prolixity and no point, and jokes of primitive lucidity. We hear catamounts, and the stealthy tread of things in the leaves, and the hooting of owls, and, when the moon rises, the laughter of the loon. Everything is strange, spectral, fascinating. By and by we get to our positions in the shanty for the night. . . . The shanty has become a smokehouse by this time; waves of smoke roll into it from the fire. The fire flashes up . . . [and] showers of sparks sail aloft into the blue night; the vast vault of greenery is a fairy spectacle. How the sparks mount and twinkle and disappear like tropical fire-flies.[29]

Homer himself was almost certainly the source for the *Tribune* writer's description of the bark hut as one "in which the artist's party bivouacked." Nothing is known of the size of this party, but a tradition has survived identifying the figure sitting by the shelter as Homer's brother Charles.[30] If these two avid fishermen camped together in the Adirondacks in the summer of 1877, perhaps as a party of two, they would surely have been attended by guides. If the guides were Phelps and Holt, then *Camp Fire* as well as *The Two Guides,* two paintings of approximately the same size, may be products of a tramp through the wilderness on which the guides carried not only the usual camping gear and provisions but also a stretcher with pieces of canvas to fit.[31]

Although Homer painted *Camp Fire* in 1877, he dated it "1880." Perhaps he put off adding the finishing touches until that year.

In "Camping Out," Warner observed:

> The stricken camp is a melancholy sight. . . . Man has wrought his usual wrong upon Nature, and he can save his self-respect only by moving to virgin forests. And move to them he will, the next season if not this. For he who has once experienced the fascination of the woods-life never escapes its enticement: in memory nothing remains but its charm.[32]

At one level, Homer's three Adirondack oils of 1877 constitute a Realist report on his experiences in the region. They record his hot-blooded response to things seen. But at another level the trio of paintings serves as a gloss on the direction that Realism had taken in America in the 1870s. In investing two woodsmen with as much dignity and importance as, say, Thomas Eakins had invested in his portrait of Dr. Gross a year earlier, Homer perhaps meant to emphasize an aspect of Realism that in France more than America had attempted to diminish social class as a factor in determining the worthiness of a subject. In placing his female hikers alone on a mountain trail he perhaps meant to press further one of the central arguments of his work as a Realist painter of postwar middle-class modern life that a New Woman had emerged in American society and deserved the attention of painters. In showing a meditative sportsman by a campfire at night he had perhaps meant to ask his viewers to contemplate the extent to which modern life had ceased to be lived almost exclusively in cities and at resorts and now had embraced the wilderness as well.

Like *In the Mountains* and *The Two Guides, Camp Fire* offers a view of the natural world that differs from that of *The Trapper.* Instead of the earlier painting's finely measured equilibrium between the figure and its surround and among all of the parts of the landscape, the three paintings of 1877 present a rougher balance of massive elements in a world of contrasts—of rolling slopes and sharp ledges, pitch darkness and blazing light, ridges that rise endlessly upward, winds that speed clouds through notches, and heat that explodes showers of sparks high into the air. The natural world in these paintings is less gentle, less accommodating, more mysterious than in *The Trapper.* By 1877, little remained of Arcadia in Homer's view of the Adirondacks.

The Hiatus

From all evidence, Homer was absent from the Adirondacks for eleven years beginning in 1878. When, in 1889, he renewed his association with the clearing he was a significantly different painter than he had been in the 1870s. His sensibilities remained intact, as did all his distinctive strengths, but a changed understanding of the natural world gave them new direction. In the course of the decade of the 1880s that world in his paintings had ceased to be a background for figures and became instead the primary subject.

Homer's reconceptualization of nature brought his work in line with Darwinian thought. While there is no reason to think that he read Charles Darwin's *On the Origin of Species* (1859) or *The Descent of Man* (1871) or to suppose that, if he did, their broader implications for society and the arts would have occurred to him on his own, those implications and the controversies they sparked were common knowledge among the educated professionals with whom he and his family associated at Prout's Neck. As a reader, at least on occasion, of *Appleton's Journal, Scribners', Century, Harper's Monthly,* and perhaps *Scientific American,* he encountered Darwinian-derived discussions of the natural world as a place of constant struggle for survival.[1] Struggle became a major theme in his work early in the 1880s, and it grew steadily in importance thereafter.

Beyond what he may have gained from the popular journals of his day, his comprehension of the implications of Darwin for an understanding of both the natural world and the place of humans within it may well haven taken form, or been refined, through, conversations with his brother Charles. Charles was a scientist, a devotee of fishing and the wilderness, and, Homer's closest friend. As an industrial chemist, he had built his career around color theory and its applications, first in the textile industry and then, with Lawson Valentine, in the development and manufacture of paints and varnishes. In matters of color usage, Charles was as sophisticated as Winslow, and he seems to have been the person with whom the painter talked most freely about his work.

By the 1880s, the Darwinian reconceptualization of nature's processes had redefined the essence of wilderness. It had altered it from a place in which stability and change were both explained as part of the Almighty's grand plan, and even as evidence of His interventions, to a place where stability and change were functions of local environmental circumstance into which no supernatural force intruded and where all living things, humans among

26. *Fresh Air*, 1878. Watercolor, 20¼ x 13¼". Brooklyn Museum. Courtesy of the Brooklyn Museum. Dick S. Ramsay Fund.

them, struggled to survive in a world of constant flux. This reordered the relation of people to the natural world; it seemed to diminish the importance of humans. These things may have registered on the Homer brothers with special pertinence as they camped and fished in wilderness, but however it came about, the new Darwinian-inspired understanding of nature as a place of constant struggle for survival left an enduring mark on Winslow's work.

During the hiatus in Homer's association with the Adirondacks, the clearing twice changed ownership. Juliette Baker Rice, widowed since 1873, and her mother, Eunice Baker, had run the farm and boarding house through the season of 1877. In 1878, they sold it to Juliette's sister Jennie and her husband Robert Bibby. Juliette remarried in 1879, to William Kellogg of Minerva, and settled at the village end of the club road. In 1887 Robert Bibby sold part of the Baker property to the recently founded Adirondack Preserve Association. This sporting club soon purchased the rest of the five thousand acres. Bibby worked as the club's superintendent for two years, and then in 1889 he and Jennie left the property, but not the region, to pursue other interests. In 1895 they returned to the clearing, he once again as superintendent. In that year the Association renamed itself the North Woods Club.[2]

Homer's absence from the Adirondacks for eleven seasons came about at least in part from his need to be elsewhere. He spent part of the summers of 1878 and 1879 at Houghton Farm, Lawson Valentine's new country home, near Mountainville, New York, a few miles west of West Point. In the lyricism of the watercolors he painted there, he achieved something quite original in American art, a fusion of delicacy and solidity, directness of statement and elegance of expression, economy of means and splendor of effect.[3] These works touch the heart without resort to sentiment. The rustic dress and unself-conscious innocence of many of the figures, set on rail fences, among sheep in pasture, and in the shade of fruit trees, puts them securely in the pastoral tradition. In some, such as his *Fresh Air* of 1878 (fig. 26), he dressed his model not in plain country clothes but in a decorative costume suggestive of the eighteenth century. It suits the artless elegance of the figure while it also reveals the physical presence the girl's body, something left hidden by both country dress and the tailored finery of 1870s high fashion. This is the last group of Homer's paintings in which the landscape possesses a pre-Darwinian stability, a stasis superb as design but false as a report on how nature works.

He had a different agenda for the summer of 1880, which he spent at Gloucester Harbor on Cape Ann in Massachusetts. The figures in the watercolors he painted there have little of the presence of those at Houghton Farm. Light rather than people acts as the protagonist. He played moonlight, sunsets, fireworks, fog, the palpable moisture-laden air of muggy days, and other conditions of light and air against still or rippling surfaces of water. The range of technique and originality of concept in these watercolors had no precedent in his own work or that of any other American artist and had no close counterpart in Europe. A piece such as *Sailboat and Fourth of July Fireworks* (fig. 27) departed radically from the conventions of watercolor practice in his time in both technique and subject, with free-

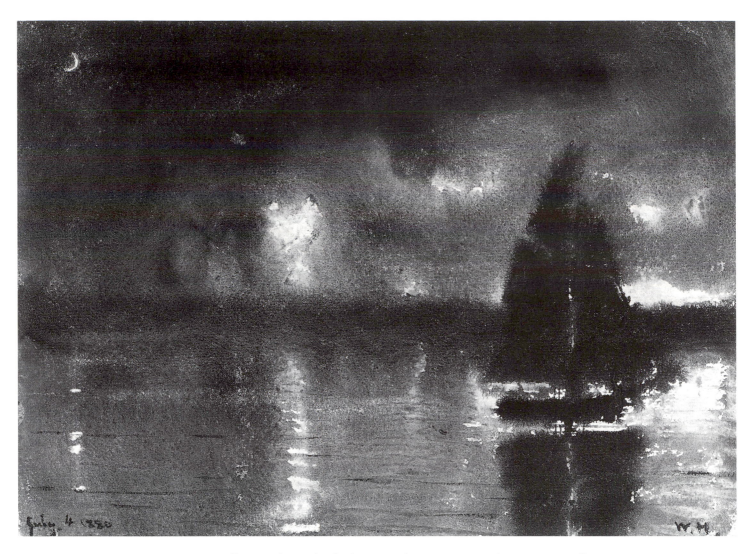

27. *Sailboat and Fourth of July Fireworks*, 1880. Watercolor, 9⅝ x 13¹¹⁄₁₆". Fogg Art Museum, Harvard University Art Museums. Courtesy of the Fogg Art Museum, Harvard University Art Museums. Bequest of Grenville L. Winthrop.

dom and control always in delicate balance.[4] He dissolved the stable structure seen in his Houghton Farm landscapes to achieve an almost palpable flux, one that serves as a visual analogue of a natural world in constant change, a crucial step toward the pictorialization of a Darwinian world.

In England in 1881–82, he resided for eighteen months in the North Sea fishing village of Cullercoats, near Newcastle-upon-Tyne. There the figure returned to center stage as he painted fisherfolk in an extensive series of watercolors. They constitute his most illustrative (in a documentary sense) work in the medium, although each is as much a transformation as a transcription of what he saw. For the first time he painted women toiling, making a major subject of their near-constant labor and their moments of rest. The placid

weather and benign natural world of his earlier paintings gave way to heavy gray skies and a relentlessly threatening sea that controlled the lives of the fisherfolk even when it was not seen. Although nature's power had been implicit in his Adirondack works of the 1870s, only with his English watercolors did it become explicit as an epic force that can destroy as easily as it can nurture.

The figures in Homer's Cullercoats watercolors are the most active and interactive of any he painted. He depicts them talking and touching, holding children and sharing burdens. His *Four Fishwives* of 1881 (fig. 28) has, in addition to its striding main figures, illuminated on the wet sand by a ray of sunshine breaking through the cloud-clogged sky, more than a dozen and a half other people in the distance, all busily engaged in the day's labors. The warm humanity of Homer's Cullercoats paintings is virtually unseen in the rest of his work. Its open expression complements the touchingly muted feeling of his Houghton Farm watercolors.[5] But the more important quality in his English work is the energy that he gives to both the figures and their natural settings. This energy is obvious

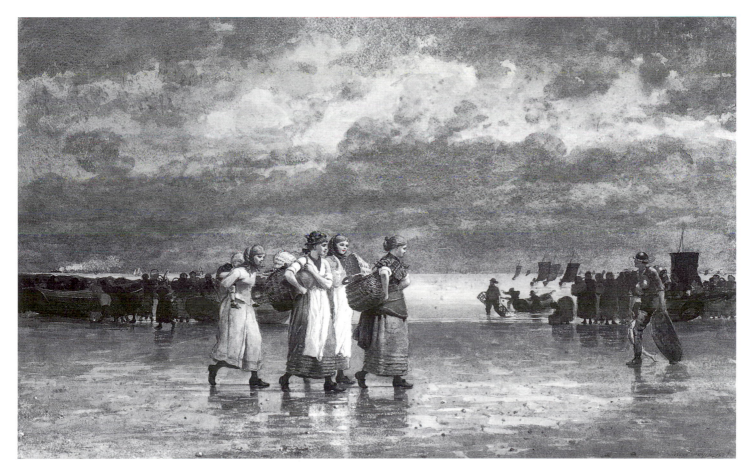

28. *Four Fishwives*, 1881. Watercolor, 18 x 28½". Scripps College. Courtesy of Scripps College, Claremont, California. Gift of General and Mrs. Edward Clinton Young, 1946.

in the surging sea and scudding clouds, in the movements of the working fisherfolk, and in the emotions of those who watch and wait for the return of boats from a storm-tossed ocean. It is an undercurrent in the scenes of rest where he sets rare moments of peace against ledges, bluffs, cliffs, heavy walls, and other places that speak of nature's rigors.

In the five years from 1878 through 1882, Homer ranged more widely in subject, technique, and feeling than ever before or after in so brief a span of years. He did this almost exclusively in the watercolor medium. Where France had provided, through the Barbizon School and Realism, a foundation for his highly individual style as a painter in oils, England was the great source for his even more individual, still evolving, style in watercolor. First in Boston and New York, and then in London, he had access to the work of Turner and others who since the late eighteenth century had placed England in the forefront of the expressive use of watercolor. While he undoubtedly learned much about technique from this British work, its greater influence probably came from the example it set for an innovative spirit in the medium, for the enlargement of the medium's possibilities for original painterly expression in treating distinctly American subjects.

His watercolor paintings from these years embraced the lyric and the epic, pastoral idyll and seaside drama, some of the finest figure drawing of his career and its most experimental, nonlinear work as well. For those attuned to it, the later paintings in the five-year progress—the struggle of the Cullercoats fisherfolk to make a living from the sea—revealed the first, still-tenuous, coherent impact of Darwinian thought on American art. Perhaps reviewers sensed this without knowing how to articulate it, for while these watercolors sold only moderately well, even at low prices, they earned high critical praise.[6]

HOMER WAS NOW (in 1882) forty-six years old. In the more than a quarter of a century of creative life that remained to him, he would move on to other achievements that, while they owed much to the years 1878–1882, also reflected his constant search for new subjects and new means of expression. His powers of renewal and his capacity for growth had no equal among American artists of his time. At the same age, forty-six (in 1890), America's other great realist painter, Thomas Eakins, had already reached his prime as a painter, and while many deeply moving works were yet to come from his brush, they added relatively little to what he had already said. In his ability to assay human nature and probe individual character, Eakins had no peer in America, and he could in a single work such as *The Gross Clinic* reach greater intellectual profundity than Homer would ever attempt. But neither he nor any other American artist of the time had quite Homer's instinct for innovation, his ability to find visual interest where others saw none, his boldness of direct statement, or his skill in reducing a subject to its essentials.

Around 1882 critics and connoisseurs could speak with confidence about the identifying hallmarks of the work of such other leading American painters as Eastman Johnson, George Inness, Elihu Vedder, and even Eakins and rightly expect that their descriptions

would still be valid a decade later. But even as early as 1882 they would have hesitated to try to nail down the essence of Homer's work; indeed, any summation of his achievements as a painter in 1882 would have required major emendation every few years. Among other American artists perhaps only John La Farge possessed anything approaching Homer's capacity to remake himself as an artist continually. This may have been one of the reasons why La Farge, alone of all artists in New York, could engage his friend in serious discussion about the problems of art, and why Eakins, interviewed in 1914, named Homer as the greatest American painter of their time.

After his return from England late in 1882, Homer embarked on a sequence of oil paintings that treated a range of human engagements with the sea. In varying degrees they depict Darwinian struggle in nature, in some cases the struggle of human beings to survive in death-threatening circumstances. Homer treated these subjects dispassionately; he offers no suggestion of what the outcome of the struggle will be or that it is even important.

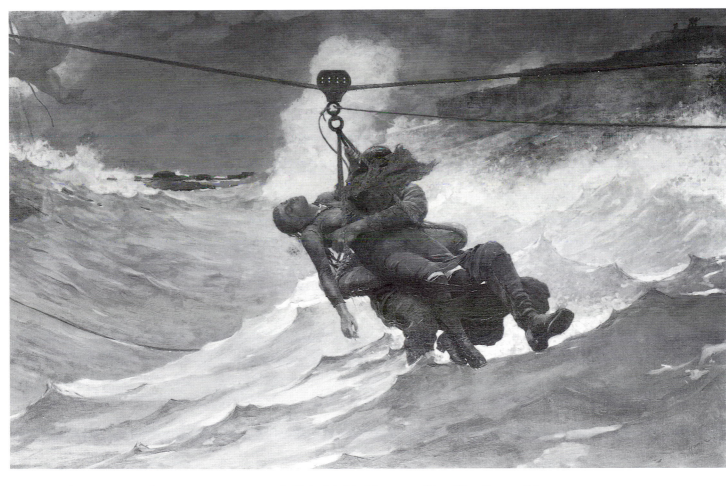

29. *The Life Line,* 1884. Oil on canvas, 28¾ x 44⅝". Philadelphia Museum of Art. The George W. Elkins Collection. Courtesy of the museum.

The sea that he painted in these oils of the mid-1880s was a far cry from the placid, decorative ocean in his beachside subjects of the 1870s. He now portrayed it as a thing of tremendous power in constant motion, and he painted it in oil in a vigorous manner that built upon his experience of rendering it in watercolor in England.

The first of his sequence of American marine subjects, and the most openly illustrative of the struggle for survival, was *The Life Line* of 1884 (fig. 29). It brought high praise from critics and sold immediately for $2500, a price considerably above anything that he had previously earned from a single canvas.[7] At about the same time, Marianna Van Rensselaer published in *Century* magazine her essay on his English work.[8] This was the most thoughtfully intelligent piece of sustained criticism of Homer as an artist to appear in his lifetime, and it left no doubt that she considered him a great master of American painting. The essay apparently pleased him—for many years he kept a copy of it in his studio—even if, as is likely, he found its recognition of his accomplishments overdue.

With the success of *The Life Line* and the publication of Van Rensselaer's essay, Homer's career seemed to have entered a bright new phase, one that promised not only to enhance his already considerable stature in his profession but also to bring the one measure of professional success that, consonant with the spirit of the Gilded Age, he prized most highly: financial reward. It now seemed that his work might sell for prices approaching those obtained in the past by such celebrated painters as Albert Bierstadt and Frederic E. Church, and in the 1880s by such younger artists as John Singer Sargent. Homer considered the achievements of none of these painters superior to his own.[9] This expectation of greater income from sales brought bitter disappointment. Of the other major oils that he painted over the next two years, including *The Fog Warning, Lost on the Grand Banks, Undertow, The Herring Net,* and *Eight Bells,* only the last found a buyer within two years and that at $400, less then one-sixth of what *The Life Line* had realized.[10] Beginning in 1887 he abandoned painting in oils for three years.

Encouraged by the vogue for etchings that had arisen in America a decade earlier, in the mid- and late 1880s he made seven large intaglio prints, all but one reproducing with modest change the images of recent paintings—subjects from Cullercoats and later. Each of these dealt with the sea except for the one original composition in the series, an Adirondack subject, *Fly Fishing, Saranac Lake* (of which more in chapter 5), which proved to be his last etching. Like most of his paintings of the 1880s, Homer's etchings met with disappointing sales.[11] He survived in these years through the sale of his watercolors.

Geographically, he entered new territory in the winter of 1884–85 when he traveled to Cuba and Nassau. Some of the products of this trip, such as his *Sponge Fishing* (fig. 30), shared with his Cullercoats watercolors the subject of people working on the sea but differed not only in the different light and relative calm of their settings but also in his broader, freer, more painterly technique. Overt struggle rarely appears in these works, but their natural world is often one of transience.

Through his trip to Cuba and Nassau, which began a long association with the

Caribbean, Homer became the first American artist of stature to examine this subtropical realm closely. He went there—and later to Florida and Bermuda—to gain relief from winter in Maine, to fish, and perhaps for another reason, one that may have arisen from accounts published in popular journals describing a recent scientific exploration of the Caribbean. The articles noted the intensity of light and color on land and water alike, qualities that Homer had not encountered in the north and which, in view of his analytic interest in color and light, may have intrigued him. The team of scientists aboard the USS *Blake* who conducted the study had been led by Alexander Agassiz, Homer's childhood schoolmate in Cambridge.[12]

In 1884, a year and a half after his return from England and before traveling to the Caribbean, Homer settled at Prout's Neck on the coast of Maine. This put him about ten miles south of Portland. He had left New York in part because he had no very good reason

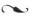

30. *Sponge Fishing*, 1885. Watercolor, 14 x 20". Canajoharie Library and Art Gallery. Courtesy of Canajoharie Library and Art Gallery, Canajoharie, New York.

to remain in the city and in part because Prout's Neck and its elemental landscape of sea and rocks had begun to assume growing importance to his work and his life.

Having ceased working as an illustrator in the late 1870s, he no longer needed to be near publishers in New York. His presence in the city had never seemed necessary to the sale of his paintings. His association with other artists had rarely been more than social; he had little to learn from them. Although his many admirers in the profession stood in awe of his skills and found him an agreeable enough personality, his personal independence, individuality of style, and belief that an artist should be essentially self-taught insured that he had no students or close followers likely to feel that he had abandoned them when he left for Maine. The new generation of painters who had appeared on the scene with a Hals-like painterly realism (from Munich) and, by the early 1880s, intimations of Impressionism (from Paris) drew the avid attention of critics, dealers, and collectors. They breathed new life into the old belief—antithetical to Homer—that European taste and style were superior to American. Homer found himself cast, with some suddenness, into the role of an Old Master, an artist to be venerated as part of the past rather than embraced as part of a movement. And so, because he found himself comfortably at home at Prout's Neck, where he and his family were much engaged in the development of a summer community, he remained in Maine. He was hardly isolated there; a rail line with a station four miles from his house ran directly to Portland, Boston, and New York.[13]

At Prout's Neck he lived by the sea, as he had in England. In time he took it as his primary subject in oil. In the waves breaking against rocks close by his studio-home, he had a continuous reminder of struggle as a given in nature. While he came to paint this subject often, he did not limit himself to it. Life about him was too varied. Each summer he was among his brothers, their wives, his nephews, and, for many years, his widowed father, as well as, year by year, increasing numbers of other congenial seasonal residents. His year-round neighbors—mostly farmers and artisans—became friends at least as good as any that he had known in New York. Although the press characterized him as a recluse apparently for little better reason than his departure from New York and his unwillingness to give interviews, this independent, laconic Yankee probably felt no more alone at Prout's Neck than he had in Manhattan.

To explain the departure of a major figure from the center of the American art world, the press constructed an image of him that has persisted for more than a century. It cast him as a great painter of nature, drawn to a hermit-like life of contemplation in isolation by the sea. In characterizing Homer as a solitary recluse, writers went wide of the mark, for in addition to his warm, neighborly association with his year-round neighbors in Maine, he traveled often and widely from Prout's Neck, staying in good hotels, maintaining regular contact with dealers and others in New York, and, beginning in 1889, renewing old friendships and making new ones at the clearing.

There are better reasons to explain Homer's choice to live by the sea and to take it as a major subject. To the extent that he had begun to think seriously about Darwin's implica-

tions for painters of the natural world, he could hardly have found a more telling symbol of it than the constant flux and perpetual struggle of the sea breaking against ledges not far from his studio. If he saw struggle in nature as his great subject, and most of his paintings since 1881 pointed in that direction, then he would be far better off studying it at Prout's Neck—and in the Adirondacks—than in New York City.

Homer's move to Prout's Neck may also have been in part an outcome of what seems to have been his growing move away from the precepts of mid-century Realism. As a painter of modern life in the 1860s and 1870s, he had produced a body of work whose topicality had now begun to make its subjects seem outdated. Even his idiosyncratic choice of such subjects as camp life in the war, croquet following it, country schools in New England, and African-Americans in Reconstruction Virginia seemed diminished in relevance. The power of his composition, drawing, and color gave these earlier works staying power, but their nuances of meaning, tied so closely to the events, fashions, and political and social sensibilities of their times, had begun to fade. By the late 1880s he seems to have elected no longer to paint modern life, or even distinctly national subjects. He turned instead to more timeless, universal things and chose the most universal subject of all, the sea.

He spent five summers at Prout's Neck becoming intimately acquainted with its people as well as its rocky shore and sun-baked meadows. Then, having painted his great marines of humans in contest with the sea and having found new colors and light in the Caribbean, in 1889 Homer returned to the Adirondacks.

Chapter 5

1889

Annus Mirabilis

In June 1889 *Undertow,* an oil that had come from his brush two years earlier, sold for $2400, although he did not learn about the purchase until he had returned from the first of his two visits to the clearing that year. But it was the reception of the three dozen watercolors that he painted in the Adirondacks during the summer and fall that made the year an *annus mirabilis,* one that continued on into 1890. In these new Adirondack watercolors he brought together and synthesized everything that he had learned in the medium since he had adopted it sixteen years earlier and made this group the most brilliant in execution, subtle in structure, and varied in subject of any he had yet painted. When in February 1890 his dealer put thirty-two of these new works on view in New York, they met with critical praise and robust sales; twenty-seven found owners within a month.[1]

Homer had painted them during two periods at the clearing in 1889. The club's register records his arrival for the first visit on 6 May and his departure on 13 July, a stay just short of eleven weeks.[2] He returned on 1 October and remained until 24 November, almost nine weeks.[3] In staying so late into the autumn, he repeated what he had done in 1870 on his first visit to the clearing, although this time no winter subjects resulted. He renewed old friendships with the Baker women and their husbands, probably with Charley Lancashire, and certainly with Rufus Wallace, whose beard was now white.[4] Wallace resumed posing and would do so for the rest of Homer's time as an active artist in the Adirondacks. Sometime in the summer of 1889 Homer portrayed him in *The Guide* (plate 9).

The background of Homer's oil painting *Camp Fire* of 1877 consists of the all-encompassing darkness of nighttime, a blind drawn on our vision. The background of *The Guide* includes something different, the localized darkness of daytime, light in the forest's interior so low in intensity that it reveals nothing to the outside. Only after we enter into it do we see cool, almost shadowless color in a low key and textures unknown in brighter light. Homer would paint this distinctive quality of light at various levels in several works, including *Mink Pond* in 1891 and *Hunter in the Adirondacks* in 1892. Here, Wallace, his guideboat, and its wake divide the darkness of the forest from its reflection on the water's surface and become a part of both. More than in any of Homer's earlier depictions of him, he seems less a figure in a landscape than part of the landscape itself.

At first impression, this watercolor strikes the eye as a visual moment seized and quickly executed, a product of intuition more than planning, but in fact Homer structured the work with precise calculation. The tip of Wallace's extended oar and its closely mirrored reflection define the edge of a square whose width measured from the sheet's right margin corresponds to the watercolor's height. This square constitutes the fundamental component of a golden proportion composition, a type that Homer used often; his layout of details within the square is as precisely determined as is the proportional relationship of the square to the rest of the sheet.

In the background a massive hemlock rises into dim light, its age echoing Wallace's. Down-sweeping limbs pick up the repeated diagonals of the foliage at left and carry them toward the sheet's upper right margin. A yellow water lily blossom, sharpened by adjacent touches of violet and green, enlivens the lower right and balances the mossy gray twig forms at left, while it also anchors the diagonal axis established by the washes behind Wallace's head. The variety and organic flow of this and the other greens that range across the work above the water suggest the lush greenery of summer without showing a delineated leaf.

In this picture of an older man guiding himself through quietly resplendent nature, all the things that reward the eye and move the emotions represent the maturation of a watercolor style that had already demonstrated remarkable strengths in Adirondack subjects fifteen years earlier. At that point he had used color with more restraint and controlled it with drawn detail. Effective as this early manner was, it lacked the unifying bigness of form and expression that developed steadily in the years leading to 1889. By the time he returned to the clearing he had developed unerring judgment in fitting technique to subject. The fluid washes in *The Guide* reinforce sensations of a boat in motion and branches gently moving. *The Guide*'s quietly elegiac mood returns in many of Homer's depictions of woodsmen for the rest of his active career in the Adirondacks.

The Guide offered nothing new in the way of an Adirondack subject for Homer, except perhaps in its minimalization of visible action. He had already painted Wallace in a boat in 1874. In that work the guide fished; here nothing visible explains his presence on the water. But such other watercolors of 1889 as *Casting, A Rise* (fig. 31) depict at a greater distance a man in a boat, each a solitary angler actively fishing. Homer invests these dark works with the low light of dusk or dawn, a tenebrity deepened by surrounding mountains and forest, a light good for fishing. While these paintings share a subject with *Eliphalet Terry* of 1874, they represent a distinct advance in the evocation of atmosphere and richness of color. The earlier work had not broken so completely from the traditional belief that a watercolor was a colored drawing; Homer's 1889 watercolors, and those that followed, are in all essentials paintings.[5]

New subjects arrived. Some, such as *Casting in the Falls* and *Waterfall, Adirondacks* (plate 10), put the fisherman on solid ground and change the water from horizontal stillness to vertical rush. Homer may have painted the latter work from the cataract that occurs on Mink Outlet as it flows through the forest to the Hudson. New, too, were Homer's watercolors of dogs. The keenly observed *Waiting for the Start (Dogs in a Boat)* (fig. 32) is

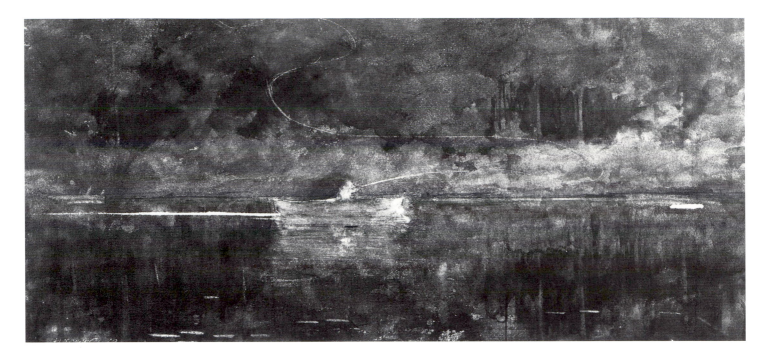

31. *Casting, A Rise,* 1889. Watercolor, 9 x 20". Adirondack Museum. Courtesy of The Adirondack Museum.

remarkable in its naturalism; confined to the boat, the hounds made good models. *Dog on a Log* (plate 11) strikes the eye as a quicker study of an animal not likely to remain long on this perch.

The dogs in the punt are gathered for a day's hunt and will in time be dispersed as guides take them away into the forest to rouse deer. In three seasons at the club, those of 1889, 1891, and 1892, Homer painted most stages of this use of the hounds. While there is no reason to suppose that he intended these watercolors to be shown as a sequence that surveyed the hunt systematically from start to finish, he nonetheless painted a near-comprehensive account of the subject in which *Waiting for the Start* comes first. *Dog on a Log* represents a later stage, when a fleeing deer has taken to water and the hound that has driven it from the forest waits and barks, shifting its location along the lakeside to keep the deer from reaching shore until the hunter in his boat draws close enough to shoot the animal and secure it before it sinks.

An October Day (plate 12) shows the hunt at high pitch on Mink Pond. A hound on the shoreline barks while a buck swims, altering his direction as a hunter in a boat approaches. Yet this narrative seems wholly secondary to the splendor of the fall foliage, its reflections on the pond, and the sublime sweep of Beaver Mountain's slope. So too, in *Waiting for the Start* and *Dog on a Log,* Homer's sympathetic feeling for these hounds, and his admirably naturalistic rendering of them, commands our attention and makes superfluous any explanation of them in terms of the hunt (of which more in chapter 6).

32. *Waiting for the Start (Dogs in a Boat),* 1889. Watercolor, 14 x 20". Museum of Art, Rhode Island School of Design. Courtesy of Rhode Island School of Design. Gift of Jesse Metcalf.

Many of the watercolors that Homer began in the Adirondacks and elsewhere in his travels undoubtedly reached completion in his studio at Prout's Neck. There he had the time and conditions to create effects that have ever since kept viewers in rapt wonder. In *Dog on a Log* Homer almost certainly first drew the hound in graphite and then from observation at the site added with brush, the log, the log's reflection, part of the water, and an over-all wash as background, all the while hewing in his composition to the general principle of structuring the essential part of the image in a square, and treating the remainder of the rectangle in a slightly different fashion. Later, probably at Prout's Neck, or possibly in a makeshift studio space in a building at the clearing—a place that offered controlled conditions of light and where he had ample time to work undisturbed on a sheet of watercolor paper—he used a remarkable range of techniques, some of which required extended drying time. In these sessions he worked extensively on the background. He carried its grays into the spaces between the dog's legs and added flecks of red to denote the early autumn time of the hunt. The painting of the water—he probably added the dog's reflection at this point—further work on the background, and numerous other details required in sum more time than he had available at the original painting site in a single day. He preserved in his watercolor style an overpowering sense of rapid, spontaneous, on-the-

spot execution, but the finished work usually amounted to more than this. It synthesized quickly recorded observation, images retrieved from visual memory, compositional design, and painstaking elaboration, all under the control of an artist who, it had now become clear, ranked among the century's great masters of the medium.

During his midsummer weeks at Prout's Neck, Homer presumably completed some of the watercolors that he had begun during the first of his two Adirondack visits in 1889. Those that he initiated during his second stay, including the dogs and other autumn subjects, he must have completed soon after his return to Maine in late November. From both groups came the thirty-two sheets that went on exhibition in New York in early February. Others, finished after the new year had arrived, he dated "1890."[6]

Within the 1889 group of Adirondack watercolors, no subject was more strikingly original than the depictions of leaping fish. While sporting magazine artists had often drawn fish in midair pursuit of an insect or a fisherman's fly, Homer transformed the subject from anecdotal popular illustration to a more abstract consideration of the appearances of fish in which sensuousness of color and texture shunt aside narrative. By placing the fish close to the picture plane, he created a sense of intimacy with a living thing that is close to unique in his work. In making the vantage point of *Jumping Trout* (plate 13) and his other leaping fish perhaps a foot above the water's surface, he put the viewer in the place of another airborne trout. The angle of vision of a person seated in a boat would be too high to see just what Homer has painted; a swimmer would be too low and would in any event tend to inhibit a nearby fish from leaping. But whatever the angle of vision, a fish leaps in a flash, altogether too quickly for the human eye to capture in any detail. Although Homer depicted an event that his viewers had never seen with any clarity, they nonetheless insisted on praising the veracity of his images. One of the four watercolors of jumping fish that he painted in 1889, *Leaping Trout* (plate 14), contains two fish set among lily pads (one in pink, gracefully articulated) and reflections from the water. A black-grey-blue background reads simultaneously as dimly seen forest forms, as nonrepresentational brushwork, and as deepest darkness against which the brilliantly illuminated trout seem to radiate light from the varied and vibrant colors of their skins.

Homer knew from years of observation how fish leap and how newly caught fish look, with their radiant wet color intact. Within minutes after death, that color begins to lose its lustre and fades. Working quickly from just-caught specimens, he captured the glistening wetness and soft color of the arched form and later washed in dark backgrounds. The resulting images transcend considerations of sport, biological fact, and even apparent motion to make an impact through things that have not always been associated with fish: sensuousness and mystery. For more than a century these watercolors of vibrant life propelled into our sight have brought aesthetic reward to countless viewers who knew or cared little about fish or the sport of fishing. John Ruskin may have touched on one aspect of their appeal when he wrote in 1859, "No human being was ever so free as a fish."

There were no real precedents in art for these stunning images. All of them are lateral

views of leaping fish in a single plane, most of them set against a background also limited to a single plane. It has been tempting to wonder whether Homer may have been inspired in these works by depictions of fish in Asian art, and perhaps he was, but not to the point of adapting existing images. All evidence shows his highly original depictions to be products of observation in nature, introspection, trial and error, and much hard work.

The life that surges in Homer's leaping trout is missing in his watercolors of fish hung as trophies. His *Two Trout* (fig. 33) speaks of sport ended and action past, of death rather than life, and for all the aplomb with which Homer rendered it (and it is a splendid cre-

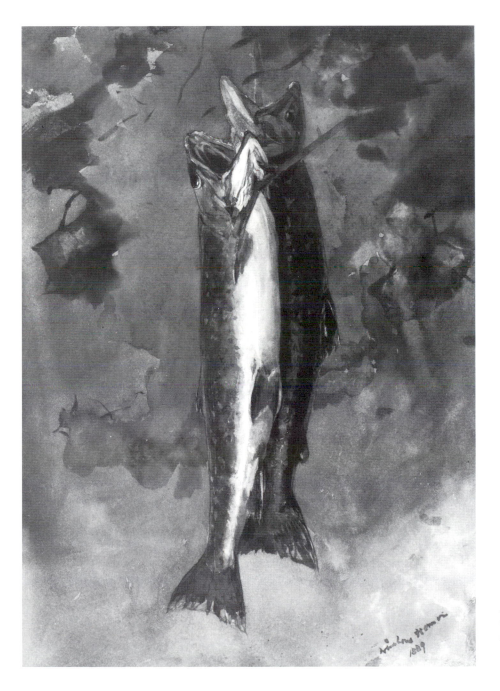

33. *Two Trout*, 1889. Watercolor, 19½ x 13¼". Private collection. Courtesy of Sotheby's New York.

ation), it has none of the mystery and little of the sensuousness of his leaping fish. This still life is unable to tell us anything that we want to know about the living thing that bursts from depths to dazzle for an instant, an instant prolonged for our delectation through Homer's suspension of time.

Critics warmed to these works. An admiring review of the Adirondack watercolor exhibition appearing in New York's *Commercial Advertiser* said: "He has caught the movement of the waters, the elusive scintillations of the gaudily scaled fishes, and the constantly changing tints of the growth along the lakes and rivers."[7] The *New York Times* reviewer wrote:

> Two trout [are] leaping together from the flat discs of the lily at the same dragonfly—and missing it. . . . They . . . sweep through the air like tropical birds, with their brilliant spots and ruddy fins fully displayed. The surface of the lake is wrought with a rare sense of color. Lily leaves overturned by the wind show their pale pink and violet undersides, and one feels, rather than distinctly sees, the background of sombre forest.[8]

In taking fish, dogs, and deer as subjects at least as often as people and in incorporating people pictorially into the wilderness rather than showing them as visitors to it, Homer in 1889 seemed to be painting, consciously or not, that aspect of Darwinian thought that minimized long-held distinctions between humans and the rest of the animal world. He persisted in this direction. It seemed to some of his contemporaries that he had stopped painting people altogether. He had not, although he had very largely stopped painting social life. He had turned his powers of observation to more universal things closer to his own life as he had now arranged it.

Although he had fished since childhood and occasionally treated the sport as a subject in the 1870s, only in 1889 did it become a major theme in his work. He returned to it repeatedly in the Adirondacks over the next three years and treated it in other regions as well. Beginning in early 1890, when he was barely home from the Adirondacks, he made fishing an important subject on the warm rivers of Florida. In 1895, he began to paint it on the grander waters of Quebec. While fishing as a sport had from time to time briefly captured the attention of other American artists, until Homer it had no important place in the annals of American fine art. Even his earlier attention to it in 1874 seemed unpromising of further development. Still, a sharply observant watercolorist who was also a knowing fisherman could find meanings in a solitary angler casting in a wilderness lake or river that the casual observer missed.

For centuries before the mid-nineteenth century revolution in tackle, the art of fly casting, even with rudimentary gear, had enjoyed a premier status among other kinds of sport fishing—indeed, among individual sport of any sort. It continues to do so, at least for persons of a philosophical bent. In the minds of its devotees, fly fishing epitomizes a near-perfect union of the active and the contemplative modes of life, an endeavor that has few equals as a means of taking measure of the fisher's intellectual and manual powers as

they operate in close alliance, with little of real import put at risk. The intellectual aspect of fly fishing derives in part from the fisher's need to conceptualize accurately the behavior of fish and the conditions of fishing, taking into account the implications of stillness and motion, surface and depth, time and space, all the while intent on catching life in a submerged world and bringing it captive into the fisher's own. In his or her oneness with nature, the fisher rivals the Arcadian shepherd.

The image of the thoughtful angler has a long history. It appears in numerous books popular in Homer's lifetime, some of which he may have known, although they can hardly have had any direct influence on what he painted. Izaak Walton shaped his essay of practical philosophy, *The Compleat Angler* (1653)—a book much reprinted in Homer's time— as a conversation about fishing, defending the simple pleasures of a life lived quietly in solitude close to nature. John Bunyan began his *Pilgrim's Progress* (1678), a ubiquitous book in nineteenth-century America, with a metaphor about angling to justify his allegorical manner. Closer to Homer's time, Henry David Thoreau introduced a self-absorbed fisherman alone on the bank of the Concord River early in his *A Week on the Concord and Merrimack* (1849), "fishing with a long birch pole, its silvery bark left on," noticed but unnoticing in his preoccupation as the author and his brother row by at the start of their week's journey by stream to explore the natural world. "Thus, by one bait or another, Nature allures inhabitants into all her recesses."[9] Fishing has always seemed full of significances, meanings, and imports easier to feel than articulate, some running to primal man and some to things as new as the tackle or the intellectual currents of the day.

But contemplation alone catches no fish. Success in the sport requires action. Casting, the most elaborate of actions, calls for near-virtuoso manual skills. The tying of flies and preparation of lures, clambering along stream beds and maneuvering boats, are but practice for the dexterity required in casting, not to mention the hooking, playing, netting, and landing of a fish. All these things and more depend for their success on the experienced, fine-tuned interplay of hand and eye. So does painting in watercolor. At some level Homer doubtless found parallels between what he did as a fisherman and what he did as a watercolorist.

He painted one of his Adirondack watercolors in 1889, *Netting the Fish* (fig. 34), as preparation for an etching, and it is, accordingly, a monochromatic study of values. He presumably painted it on Mink Pond, although the resulting etching bears the title *Fly Fishing, Saranac Lake* (fig. 35), probably in the hope that reference to that much-visited Adirondack locale would enhance the print's sales. Of Homer's six published etchings, in only this one did he make extensive use of aquatint. He achieved through it something akin to the free effects of his watercolor technique, notably in the reflections of trees on the water. This was the only one of his etchings issued in a numbered edition. The edition apparently was to consist of a hundred impressions, but because only a small fraction of this number seems to have survived, the printing may have stopped at midpoint owing to poor sales.[10]

34. *Netting the Fish,* 1889 (dated 1890). Watercolor, 14 x 20". Art Institute of Chicago. Photograph © 1995, The Art Institute of Chicago. All Rights Reserved.

It was rare of Homer to depict a sportsman at such close range, close enough to include details of his features and sporting costume. He perhaps thought that in the print market such an image would be more salable than one of a guide. The fisherman in his guideboat, legs apart for balance, uses a state-of-the-art rod and reel to net his fish. The identity of the model is unknown.

The wholehearted praise accorded the 1889 Adirondack watercolors at their first showing, and the group's rapid sale, marked the acceptance of Homer's painterly style. Critics who had resisted that aspect of his work now accepted as strengths what they had earlier described with exasperation as the "sketchy" and "unfinished" nature of his work. Critical admiration for the vigorous brushwork of the younger Munich-trained painters made

35. *Fly Fishing, Saranac Lake,* 1889. Etching, 17½ x 22⅝". Courtesy of the Museum of Fine Arts, Boston.

Homer's own, more secure, painterliness at last seem part of the mainstream. So also by 1889 did the growing acceptance of French Impressionism, both as a style and a theory of perception. The looseness of Homer's brush, his life-long interest in painting the effects of outdoor light, and his consistent preference for ordinary subjects made him seem a painter whose work, despite a different palette and technique, could be enjoyed on the same grounds as that of the Impressionists. When Marianna Van Rensselaer wrote that Homer had been an Impressionist before the name had been invented, she meant these shared qualities.[11] Other critics had recognized the same congruences and distinctions with modern French painting and were even more explicit about it. One, in a review of the Adirondack watercolor show of early 1890, allied him with the great masters of Impressionism

while separating him from that style's basis in the physiology of perception. The critic wrote: "Mr. Homer's watercolors are in fact impressions. But Mr. Homer has not found it necessary to copy Manet or Monet, or Renoir or Degas; he has means of his own, very simple means, artistic rather than scientific, and he uses them frankly."[12]

The Club

Homer returned to the clearing in 1889 as a member of a club that had come into being in 1886 for reasons implicit in its original name: the Adirondack Preserve Association. Its members meant to preserve at least a small part of the Adirondack wilderness at a time when it was endangered. By the early 1880s those well acquainted with the region had come to understand that a burgeoning lumber industry was moving rapidly to fell large tracts of the great forest. Murray had expected the forest to endure forever, but what he had described with not too much exaggeration in 1869 in his *Adventures* as "a wilderness yet to echo to the lumberman's axe," seemed, only a dozen years later, to be slated for large scale devastation by lumbermen.[13]

The circumstances were complex. Private land owners sold logging rights to gain cash to pay land taxes. Lumbering firms bought land outright at a price so cheap that once they had logged it they abandoned it. State land holdings increased as owners defaulted on taxes, but the state had no adequate means to police property deep in the forest and to prevent loggers from cutting its trees. As rail lines entered deeper into the region, they made it possible to remove hardwoods, trees previously left uncut because they were too heavy to float down the rivers that moved the softer pine, spruce, and cedar out of the forest. As the fast-growing pulp paper industry began to make use of nearly any kind of wood in its mills, the selective cutting of the recent past gave way to a logging practice that promised to denude vast expanses of the land.[14]

Outdoorsmen and others who had come to use and revere the region responded to this state of affairs by organizing themselves into clubs and purchasing tracts of the forest to save them from the saw and the ax. While the clubs intended to preserve woods, lakes, and streams for the pleasure of their members, more broadly altruistic goals also motivated them. They sensed the truth in Thoreau's claim that "in wildness is the preservation of the world."[15] Even beyond the very real ecological concerns of their day, they knew that the forest's aesthetic and cultural value exceeded its value measured in board feet.

The group of enthusiasts from greater New York who formed the Adirondack Preserve Association in 1886 wasted no time in scouting for suitable property. In 1887, having begun the purchase of the Baker Tract from Robert and Jennie Bibby, the club set out to pursue its objectives. It had stated those as the encouragement of "boating, fishing, athletic and all manly, lawful sports and pastimes, and the preservation of game and forests." The last word was the most important, for without the forest, none of the rest was possible in any way that resembled a wilderness experience.[16]

Although the newly founded clubs—the Tahawus, Kildare, Morehouse Lake, Wilmurt Lake, and Adirondack League, among several others—served only a relatively few people, their action in acquiring land for preservation rather than exploitation became part of a broader movement. Public opinion led by enlightened civic leaders pressed the State of New York to acquire more Adirondack land and to preserve its holdings in the region for the protection of much of the state's water supply, for the prevention of forest fires, and for recreational use by the public at large. In 1885 the State created the Forest Preserve of the Adirondacks and Catskills. This consisted of only a patchwork of tracts and parcels of state-owned land, but it was a major first step toward protecting the forest and encouraging the regrowth of what had been cut. The legislation specified that the Preserve "shall be forever kept as wild forest lands." [17] Enforcement of this provision proved difficult.

Seneca Ray Stoddard, who was a leading voice in the preservation movement, argued vividly for greater protection of the entire forest, both public and private in ownership. In the 1891 edition of his *Adirondacks: Illustrated* he wrote:

> The preservation of the forests is a question of vital importance not only to the Adirondack region itself, but to the state and country as well. About one-third of the mountain and wilderness region is drained by the Hudson. This section is being gradually stripped of its valuable trees far up into the rugged Indian Pass and around its wild head waters, except where a narrow belt is left untouched around the more important lakes. All this section . . . should be under the control of the State, and would be cheap at any price, now, before irreparable injury is done. The lumberman, engaged in an honorable (and profitable) business, is not to be blamed for making what he can out of it. It is a matter of pure business with him as with dynamite and powder, he clears away obstructions in mountain gorges and wilderness streams, and with dams, floods and drains the valleys until the retiring waters leave behind them [nothing] but decay and death. Following him comes the wood pulp fiend who strips the hills of the softer wood, which the lumberman has pointed to with pride as show-ing that he did not cut away the forests, until finally the "duff" [decaying organic matter] which through ages past has slowly climbed the mountain sides affording support to the compensating vegetation that in turn deposits more duff higher up—opened to the sun becomes tinder; then comes fire, and after that deluge.[18]

In 1892 the State created the Adirondack Park, within whose boundaries (the "blue line") privately owned land and the land of the Forest Preserve existed side by side, all now subject to state controls. Some privately owned properties, such as those of the clubs, were to the eye indistinguishable from the Preserve, but the public had no access to them. Stod-dard, who through his guide books and photographs had a stake in the business of tourism for the public at large, urged the State to increase the public's holdings. In the 1892 edition of *The Adirondacks: Illustrated,* he editorialized:

> The State Park as proposed encloses an area of about 4,000 square miles . . . [of this,]

1,000 square miles are owned by lumbermen who make no apologies for following a legitimate business, and over 2,000 square miles by clubs and corporations, set aside as reserved for the preservation of forests and the propagation of game and fish, and, of course, held for their owners' private use. To such ownership the public can have no reasonable objection, although the restrictions may prove unpleasant to individuals at times, but the public has the right to demand that the forests shall be preserved for the public good, whoever may own the land, and will fall short of a duty to coming generations if it fails to insist on that right.[19]

In 1894, the people of the State of New York amended their constitution to strengthen the stipulation of 1885 that the Preserve be kept "forever wild." The amendment specified that the timber of those lands "shall not be leased, sold, or exchanged, or taken by any corporation, public or private, nor shall the timber therein be sold, removed, or destroyed."[20] More effective enforcement began.

Issues of forest conservation may have been close to Homer's heart but they seem not to have entered his work other than in indirect ways. His watercolors of fishing and other outdoor sport, all with richly painted evocations of the forest as backgrounds, may be taken as images of things threatened and worth saving, although if Homer intended this as a meaning, it was only at a secondary level of significance. Indeed, these watercolors celebrate the sensations of the present so well that other messages scarcely register.

The Adirondack Park in 1892 consisted of nearly three million acres, about 20 percent of which was state-owned land. A century later it had grown to almost six million acres, 42 percent of which was state land. It remains the largest public park in the United States.[21] In its mix of public and private land, of wilderness and towns, campsites and resorts, all embraced by the great forest, the park is much as Homer knew it, although fires, blow downs, and the continuous natural succession of tree species alter its appearance from year to year. Automobiles now travel the spare network of roads that predate the establishment of the Park, including the one from Minerva to the clearing.

Access was more arduous in Homer's time. After 1870 he had probably arrived by train at North Creek and then traveled by buckboard or wagon to the village of Minerva and then another nine miles on the rocky, often muddy, road from the village to the Bakers. This journey in 1889 occupied the better part of a day even in good weather, but for Homer and the others who made the trip, the rewards they found at the clearing far outweighed the rigors of getting there.[22]

The founders of the Adirondack Preserve Association may have heard about the clearing and its surrounding ponds and forest in New York from Terry or others who had boarded at the log house over the years. They may even have heard it praised by Homer on one of his visits to the city from Prout's Neck. In becoming a member of the Association in 1887, Terry continued an affiliation with the place that had he begun more than a quarter of a century earlier. He had been absent from it only for five years in the late 1870s.[23]

Although both Homer and his brother Charles have long been described as charter

members of the association, they were not. Homer was elected to membership on 28 January 1888, in the club's second year and a month before his fifty-second birthday.[24] When he made his first visit to the clearing as a member in May 1889, he was entered in the club's register as the "guest of George W. Shiebler," a Brooklyn manufacturer and founding member of the association.[25] Shiebler may have covered the cost of Homer's lodging and board on the first of his two stays at the clearing that year. Perhaps this hospitality was required to persuade the artist to return to the clearing at a time when he had reason to complain of reduced income; he did not learn of the sale of *Undertow* until July.[26] Charles Homer seems never to have been a member; the club's register places him at the clearing only twice, in 1902 and 1904, each time as his brother's guest, although one supposes that he may have also visited the clearing years earlier.[27] In 1889, the annual dues were $30.00 and board at the clubhouse was $1.50 a day. The next year, the dues increased to $50.00 and board to $1.75 and remained at that level for some years.[28]

Homer and Terry were the club's only artist members, but Charles Brush had a feel for architecture. In 1894–95 he erected to his own designs a large rustic cottage of genuine charm (fig. 36). From its spacious veranda Homer may occasionally have studied Beaver Mountain. Six years earlier, in 1889, Terry had built the first separate cottage at the club, be-

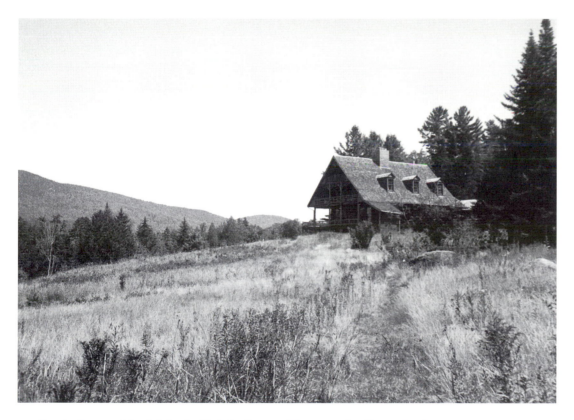

36. *Brush Cottage, North Woods Club,* Built 1895. Photograph, Cleota Reed, 1994.

ginning a line of rustic structures of modest scale that ran from near the clubhouse to the rise of land on which the Brush cottage would be built. With these, and other cottages on another axis, the membership increased. Homer stayed at times in the clubhouse, at times in the Terry cottage, and perhaps at times elsewhere.

Life at the club was a far cry from the camp life that Rondel, Tait, and Stillman had painted in the 1850s. The most striking difference was the presence of women and children. Having played a prominent part in the life of the clearing since the arrival of the Bakers, women continued without interruption to do so. Wives, daughters, sisters, mothers, and other women frequented the clearing during all of Homer's years there. In 1887, the club's first season at the clearing, women accounted for four of the twenty-eight registrants.[29] In 1889, Homer's first season, they accounted for sixteen of seventy-two, not counting the staff at the clubhouse.[30] Not until 1912 did the club formally admit a woman to membership, but their influence in club matters had been great from its early years.[31]

Most members of the club came from the professions—law, medicine, the church—and the world of business. They were, like Homer, cultivated people, at least moderately affluent (a condition that Homer would have denied as applicable to himself in 1889) and devotees of the outdoor life. Henry Clay Frick (a man of somewhat more than moderate affluence) joined the club in the late 1890s; his daughter Helen, later the founder and benefactor of the Frick Art Reference Library, made her first visit to the clearing in 1897 just before her ninth birthday. She returned for a few more seasons, although never at a time when Homer was in residence. The club maintained a place in her affections; her financial support assured its survival through and immediately following the difficult years of World War II.[32]

The club sustained the Adirondack spirit of a simple life in the midst of wilderness, a life without luxury or pretense. Communal dining in an addition built onto the log house in the late 1880s continued even after kitchens began to appear in cottages. Docks and boathouses came into being at Mink, Beaver, and Split Rock ponds. In 1895 the road to the clearing was relocated to pass by the southern rather than the northern edge of Mink Pond, and with other improvements reduced the usual travel time from the village of Minerva to the clearing from over three hours to about an hour and a half.[33] Despite these improvements, life at the club must have been in most respects quite similar to what Homer had known on his first visit to the clearing in 1870: good air, good food, good fishing, and something left unemphasized by Murray in his *Adventures*, good company.

It is easy in retrospect to see how much good company meant to an artist who, despite evidence to the contrary, has been saddled with a reputation as a recluse. The most innovative and productive periods in Homer's career always coincided with his close association with trusting, supportive friends. This had been true in the Civil War camps where he resided with his cousin, Frank Barlow, and others; in the White Mountains in the late 1860s when he vacationed with his brothers, cousins, and painter friends; at Houghton Farm in the 1870s with Lawson Valentine and his family; at Cullercoats among the fisherfolk; and,

of longest duration, at the clearing in the Adirondack forest. There in 1889 with Wallace, the Bibbys, and others he had known since the 1870s, with Terry (whom he had probably seen from time to time in the intervening years at the Century Association in New York), and with new friends, he was daily among people whom he seemed to like and who evidently liked him. When, in 1910, the club memorialized their recently deceased member as a person of a "singularly simple, kindly, courteous, and gentle nature," it undoubtedly gave a more accurate description of the man than the journalists of his later years who presented him as a misanthrope.[34]

Homer left the North Woods Club on 24 November 1889, and did not return until 9 June 1891, nearly a year and a half later. His revived interest in oil painting—an interest that had lain dormant since 1887—kept him close to his studio at Prout's Neck during the months in 1890 when he might have gone to the Adirondacks. Five canvases came from his easel in that year, all marine or coastal subjects. When his dealer exhibited four of them in New York early in 1891, the critic Alfred Trumble described them as the achievement of "a great American artist, in the full greatness of an art as truly American as its creator."[35] Homer found an even better measure of his newfound success in the fact that two of the four paintings, *Sunlight on the Coast* and *Winter Coast,* sold immediately and at good (for him) prices.[36]

The catalyst for this sustained creative outburst in oil was almost certainly the satisfaction he had realized from the three dozen watercolors that he had painted during his visits to the clearing in 1889. Whether the subjects were lake or forest, fish or fisherman, guides or hounds, the 1889 works conveyed with stunning effect an instantly recognizable sense of place—of Adirondack color, weather, texture, light, and life. He knew better than anyone the artistic worth of what he had done, but now, as had rarely been the case earlier, buyers in the art market shared his high esteem for these watercolors and acted on it. Adirondack subjects must have presented themselves to him as good prospects for oil paintings, but being in Maine and not at the clearing, he turned to subjects at hand. His audience of collectors, critics, fellow artists, and the art-oriented public all held painting in oils to be the more substantial medium, not only materially but also in its traditional status as a medium that required more forethought in conceptualization and execution than watercolor. Further, oil painting on canvas lent itself to work on a larger scale. Homer had gone far to diminish watercolor's reputation as a lesser medium, but there can be little doubt that he shared the near-universal view of his times that a reputation as a major painter needed to be founded and sustained through oil painting. And so, after the glowing critical assessments of the marines exhibited in New York in February 1891, just a year after his highly successful watercolor show, Homer was ready to return to the Adirondacks and to paint there again in oils.

Chapter 6

The 1890s

The Hunt

I<small>N</small> 1891 Homer first arrived at the club on 9 June and remained until 31 July, a stay of just over seven weeks. After spending the rest of the summer at Prout's Neck, he traveled back to the club in early fall, arriving on 1 October in time for the hunting season. Because he neglected to sign the register on departure, the duration of this second stay is not known, but it amounted to at least fifteen days, and probably considerably more.[1]

On 15 October, after little more than two weeks at the clearing, he wrote to his brother Charles in New York: "I am working very hard & will without doubt finish the two oil paintings that I commenced Oct 2nd & great works they are. . . . The original ideas of these paintings are in water-color & will not be put on the market but will be presented to you with the one I made expressly for you."[2]

Perhaps because he was engaged in painting these two oils, *Huntsman and Dogs* (plate 15) and *Hound and Hunter* (plate 16), he seems to have completed and dated only seven watercolors before the end of the year. He may have started others at the club in 1891 and finished and dated them in the next year. Well before the end of 1891 he had completed one of the oil paintings, *Huntsman and Dogs*.

The huntsman rests his raised foot on the bleached, barkless root of an old stump. His gun and shoulders support the pelt of a recently killed deer. His right hand grasps the buck's head by its antlers. His two hounds leap and bark, still excited from the kill. Clouds blanket most of the sky; with the sere colors of the foliage they speak of autumn chill. The long diagonal of Beaver Mountain's slope, echoed in a line of red-orange foliage and in the largest of the exposed roots, as well as in the dogs' torsos, encounters an opposed axis running across the tops of the stumps to meet at the hunter's head. This stolid figure stands motionless against these dynamic diagonals while his frenzied dogs circle around him.

Huntsman and Dogs holds in common with *The Trapper* of 1870 an image of a solitary woodsman in wilderness, but while the earlier painting radiates a quietly pastoral mood, the newer one conveys the aftermath of struggle and death. Where the trapper surveyed his watery domain on a morning full of light and life and responded to it with a turn of his attention, the hunter, resting for a moment by decaying stumps on a dull day, seems to be

only passing through this landscape of dead and dormant nature, insensitive to anything in it. His rifle and the folded pelt give his figure a block-like form, one that repeats the shape of the stumps that stand before him. His closeness to the picture plane bring him, his newly gained pelt, his deerhead trophy, and his howling hounds as near to the viewer's world as comfort allows.

Alfred Trumble, the critic who had so eloquently praised Homer's marines a year earlier, wrote of this painting in *The Collector*:

> It is one of the least attractive pictures which the artist has painted—a bit of cold, uncompromising realism. . . . Every tender quality of nature seems to be frozen out of it, as if it were painted on a bitter cold day, in crystallized metallic colors on a chilled steel panel. The type of huntsman . . . is low and brutal in the extreme. He is just the sort of scoundrel, this fellow, who hounds deer to death up in the Adirondacks for the couple of dollars the hide and horns [*sic*] bring in, and leaves the carcass to feed the carrion birds. . . . Throughout, the picture—albeit well composed and firmly drawn— is a cold, unsympathetic work, entirely unworthy of the artist.[3]

By conventional standards of taste in polite society, Trumble's complaints had some merit, although his bias against deer hounding would probably have prejudiced him against any treatment of the subject. But in describing *Huntsman* as "unsympathetic" (to what, is not clear), he overlooked the possibility that Homer's sympathies in this work sided with a determinist, Darwinian view of nature. To have made the figure a sportsman or a guide would have been more agreeable to popular taste and more in accord with Homer's past practice, but it would not have carried the painting's implication that the killing of the deer was not sport but rather a way of life. This huntsman sees deer as a commodity. He kills them as a means of sustaining himself.

Homer had preceded the oil with a watercolor study—in his terminology, a "sketch": *Guide Carrying a Deer* (fig. 37). The differences between the two works include, in the watercolor but not the oil, the entire carcass of a deer rather than only its pelt, a prominent tree rising to the top of the sheet, brilliant fall colors, and high values throughout. The splendidly drawn dogs, one impressively foreshortened, and the hunter's rifle appear only in the oil. The hunter's features are less coarse in the watercolor.

If Homer recalled his sequence of work correctly in his letter to his brother, then by the day after his arrival at the club on the first of October he had not only painted this watercolor and begun work on two oils, *Huntsman* and *Hound and Hunter*, but he had developed both of them to the point where he could be confident that they would be "great works." By this he probably meant, among other things, that they were distinctly original in concept. This they were, certainly within the context of his earlier Adirondack work. That, as much as anything, may have unsettled Trumble.

On the upper edge of the sheet Homer inscribed with his watercolor brush, "Sketch for the oil painting of this subject" and "To C. S. H., Jr., with the comps of Winslow Homer, Christmas 1891." If Homer had thought of his subject in Darwinian terms and had articu-

37. *Guide Carrying a Deer,* 1891. Watercolor, 14 x 20". Portland Museum of Art. Courtesy of the Portland Museum of Art. Bequest of Charles Shipman Payson, 1988.55.10.

lated them to his brother, then this watercolor might have carried special meaning to a man who, as a scientist, would very likely have brought to the work sensibilities quite different from Trumble's. He would probably have recognized in it Homer's relocation of the subject of struggle from sea to forest, and his recasting of human players from people who fight against the natural world to survive, as in *The Life Line,* to people who, like the huntsman, are part of that world. More than the guides and fishermen he had painted in the Adirondacks, this huntsman is as much a denizen of the wilderness as was the deer he has just killed.

Huntsman and Dogs is the earliest, and perhaps the most powerful, manifestation in American painting of the complex of ideas that brought forth Naturalism in American literature. Taking the implications of Darwin to heart, and with Emile Zola as a model, Stephen Crane, Theodore Dreiser, Frank Norris, and others cast their characters as products of biological determinism. Having no control over their lives, these characters epito-

mized the animalistic aspects of humankind; they behaved and thought as functions of heredity on the one hand and environmental pressures on the other. By implication or otherwise, the authors left such traditionally "humane" qualities of advanced human society as free will, reason, and morality as little more than illusionistic constructs that mask the crude actualities of human instinct. They spun out their narratives with a considered objectivity that neither praised not condemned the behavior of their characters, behavior that was, they made clear, a product of circumstance rather than choice.

This literary Naturalism, full of struggle in and against society, conformed to a Darwinian understanding of nature, just as earlier naturalisms had conformed to other understandings of the natural world. It resulted in powerful works of fiction, including, among the earliest, Crane's *Maggie* (1893), Norris's *McTeague* (1899), and Dreiser's *Sister Carrie* (1900). *Huntsman and Dogs* precedes them all and encapsulates in a single image the gripping essence of their aims.

Huntsman and Dogs, set near Mink Pond's inlet, portrays a "pot hunter." The term had originally referred to a man of the woods who hunted to fill the pot on his stove, that is, to feed himself and his family at a time when to live in a remote Adirondack location meant living off the land. But as the demand for artifacts of the hunt and for deerskin manufactures grew, pot hunters increasingly killed deer not so much for their value as food as for their less perishable, saleable parts, such as a rack of antlers and a pelt, and this is what Homer's huntsman has done. By the 1880s the term had also come to include persons who were not hunters at all but who raised deer as stock animals and slaughtered them to supply Adirondack hotel kitchens with venison. In the same decade the term in its original meaning of a subsistence hunter gained sharply negative connotations within the newly founded sporting clubs as pot hunters poached deer on the clubs' properties, often out of season, and thus depleted the supply of animals available for the weeks of hounding.[4] When Homer wrote on the verso of his 1892 watercolor, *The Fallen Deer,* "just shot—a miserable pot hunter", his ire had surely risen more from resentment over the hunter's trespass and the club's loss of game to an outsider than from any feeling against hunting as a sport. A perception of the hunter as an intruder may have been part of Homer's program in *Huntsman and Dogs,* but even if not he undoubtedly meant to represent a true woodsman and not, as he had painted in his hounding watercolors, a club guide assisting in the hunt.

Trumble read this figure as "brutal in the extreme," but it is difficult to identify anything in the painting that merits that description. Trumble seems to have transferred his own discomfort concerning a presumed act of brutality, the killing of the deer (although it in fact might well have been a "clean" kill) to the well-groomed huntsman's block-like, near-expressionless visage. Perhaps it was the absence of any kind of feeling in the face, even an expression of satisfaction over a successful kill, that bothered the critic. He may have recalled that, in Homer's earlier paintings of guides, some slight expression, or at least an appearance of thought in the features, contributed a humane touch that is missing in *Huntsman.*

MICHAEL FRANCIS FLYNN posed for the huntsman, as well as for some two dozen other works by Homer, and he was far from brutal. He had been born in or near Minerva in 1871, a descendent of Irish settlers who had arrived in northern New York in the first decades of the nineteenth century. His father, Patrick Flynn, had worked for Juliette Baker Kellogg at the clearing in the 1880s. The year after his death in 1888 at age forty-three, his son Michael, then seventeen, began working as a guide at the club to help sustain his mother and siblings. He continued at least through the 1892 season, the last year in which he appears in Homer's work. A photograph (fig. 38) shows him in 1894 with a sportsman and his string of fish on the grounds of a small summer hotel, the Mountain View, in the village of Minerva. After holding jobs elsewhere in the region and in Vermont, he returned to Minerva and in time with his team of horses worked for some years on the construction of the state highway through the eastern margin of the mountains. Later serving for many years as Commissioner of Roads for the Town of Minerva, he helped to bring his corner of the Adirondacks into the age of the automobile. Knowing every road, lane, and house in the township, he made it a point to check on the welfare of people who lived in remote locations, sometimes barely subsisting, and to help them when needed, although his own resources were modest. Far from being a solitary man of the woods, Flynn was a much-respected member of a rural community.[5]

38. *Michael Flynn, second from right, photographed with others on the grounds of the Mountain View Hotel, Minerva, N. Y.,* ca. 1894. Private collection.

As a youth he gained the nickname "Farmer" in jest following an unsuccessful attempt to grow a crop unsuited to the region, and it stuck. Although in his maturity he maintained a garden for his household and raised fodder for his horses, he never farmed as an occupation. Nor was he, as some viewers have surmised from the evidence of Homer's paintings, a person of few words. Rather, he was a gregarious, generous-spirited man of good humor, a singer of Irish and country songs and, until his marriage, a country dancer. Except for his summer employment as a young man at the North Woods Club and the Mountain View Hotel, he was not a professional guide. As an adult and the father of five children, he had little interest in fishing, did not hunt, and forbade firearms in his home.[6] The activities, stances, and all else that we see in the paintings for which he posed are Homer's concepts, not his own.

Like Wallace, he could take and hold a pose. In later life he said tongue-in-cheek to one of his sons that when he was young he had been so handsome that "a famous artist" had chosen to paint him.[7] In a more serious vein, he recalled to his wife that sustaining the poses Homer specified was a challenging task and hard work, but one that he undertook not only for the wages but also out of respect for "Old Homer."[8]

A tradition long existed at Prout's Neck that Wiley Gatchell, a local young man, posed for the figure in *Huntsman and Dogs*.[9] He undoubtedly did, but only after Homer had returned to his studio from Minerva with the unfinished painting. The figure he had begun with Flynn he completed with Gatchell. Flynn alone posed for *Guide Carrying a Deer*.

A NUMBER OF VISITORS to the Adirondacks in Homer's day found in hunting an essential part of the primitive condition they sought. It had been the "natural" activity of their predecessors in the wilderness—the Native American, the pioneer, and the woodsman. For the atavistically minded who sought to distance themselves for a while from the manners and mores of middle-class society, hunting stood as a return to authentic forest life. It mattered little that skeptics drew distinctions between hunting for subsistence and hunting for sport; sport hunters knew that only in the excitement of the chase and the kill could they become one in emotion with their primitive forebears.

Deer were the great quarry. Although not so plentiful as they would become in the second half of the twentieth century, enough existed to give fair hope of reward to the persistent hunter. Deer were fleet enough to challenge the hunter's quickness of thought and action and large and strong enough to represent (as grouse and squirrels did not) a worthy opponent. Since to shoot deer blinded by a jack light or impeded in deep snow hardly amounted to sport, the self-respecting Adirondack sportsman and sportswoman of Homer's time engaged instead in those methods that called for greater skill and allowed the deer some chance of survival. The most exciting of these methods was hunting with dogs—hounding—the method that Homer had depicted in 1889 in *An October Day*. In 1891 and 1892 he examined the subject further.

In the hounding season at the club, guides sent dogs into the forest toward deer paths or "runs," most of which led to water. Homer depicts Flynn preparing to release two hounds in *On the Trail* (fig. 39) of 1889. The barking of approaching dogs roused deer from their cover, scattered them, and drove them to water. At a number of the club's ponds a hunter waited with a boat. When a deer fleeing from the sound of the dogs emerged from the forest and plunged into the water to make for the opposite shore, as in *Deer in the Adirondacks* (fig. 40), the hunter at that location set out in his boat. His hound moved along the shoreline to deter the deer from landing, all the while tiring it. In time the hunter drew near and shot or otherwise dispatched the animal. He then quickly secured it to the boat, as Homer depicted with Flynn as his model (in a taxing pose) in the watercolor *Sketch for "Hound and Hunter"* (fig. 41) and the oil he developed from it. The hunter, or a guide, then pulled the deer into the boat and rowed it to shore; these moments provide the subject for *The End of the Hunt* (fig. 42), a work which includes both Wallace and Flynn. The deer was taken to a dock or landing by a road where the animal could be loaded onto a gig and wheeled to the club's ice house. There, after dressing, it was put into cold storage until the club's kitchen saw fit to use it. As with all other game and fish shot or caught by members and their guests, the deer became the property of the club.[10]

39. *On the Trail*, 1889. Watercolor, 12⅝ x 19⅞". National Gallery of Art. Gift of Ruth K. Henschel in memory of her husband, Charles R. Henschel. © 1996 Board of Trustees, National Gallery of Art, Washington.

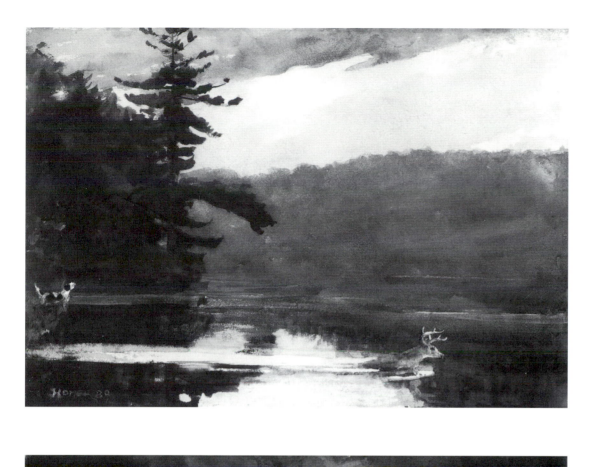

40. *Deer in the Adirondacks,* 1889. Watercolor, 13⅜ x 19⅜". Copyright © Fundación Colección Thyssen-Bornemisza, Madrid.

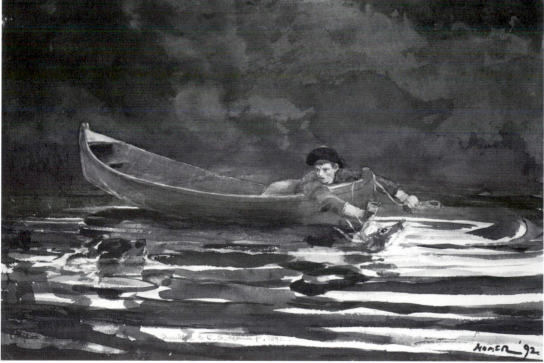

41. *Sketch for "Hound and Hunter,"* 1892. Watercolor, 13¹⁵⁄₁₆ x 20⅞". National Gallery of Art. Gift of Ruth K. Henschel in memory of her husband, Charles R. Henschel. © 1996 Board of Trustees, National Gallery of Art, Washington.

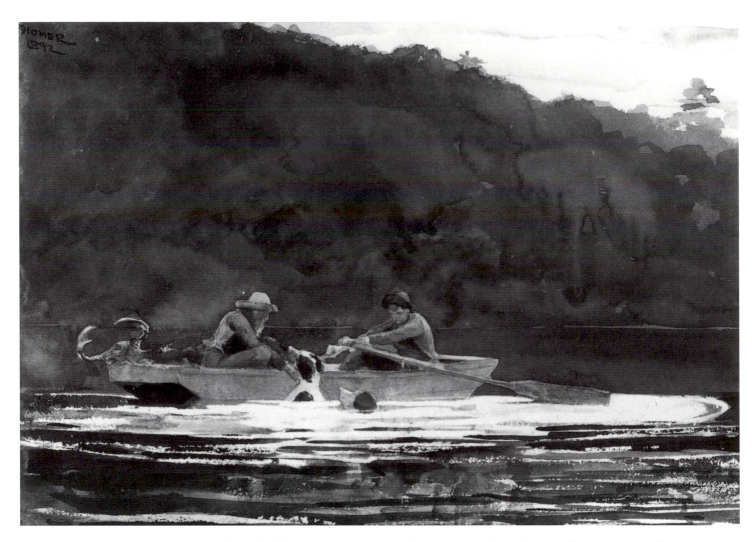

42. *The End of the Hunt,* 1892. Watercolor, 15⅛ x 21⅜". Bowdoin College Museum of Art. Courtesy Bowdoin College Museum of Art, Brunswick, Maine. Museum purchase.

During the years in which Homer painted it, the deer hounding season in the Adirondacks ran for three or four weeks each autumn, the dates varying from tract to tract. By the mid-1880s, a growing body of public opinion held this method of hunting to be unsporting, and the State of New York banned it, although it had no good means to enforce the ban very widely. In 1889, responding to requests from hunters who pointed out that hounding left no wounded animals to die slowly in agony in the forest, the State reallowed hounding for a limited season in early autumn. In 1896 the state again prohibited hunting with dogs, and the ban has remained in force ever since.[11]

Another method of hunting deer was still-hunting. The hunter took a position by a deer run or at some other location where deer might be expected to appear and waited. Because a deer shot in deep forest needed to be carried out, which was always an arduous task,

hounding with its boat and gig transport had clear advantages over still-hunting's wood-land carry. A combination of the two methods flourished at the North Woods Club when, in deer hounding season, a hunter took up a position on the Hudson River, which in early autumn was often a fordable mountain stream, and waited for a deer to appear in flight from a hound. As in still-hunting, the deer offered a target only briefly as it emerged from the forest, crossed the river, and disappeared into the forest on the other side. But deer taken on the river could be moved by water to a trail leading to the club road. In *A Good Shot, Adirondacks* of 1892 (fig. 43) Homer depicts the successful outcome of a hunter's wait on the Hudson, but he shifts the vantage point from the hunter to that of a companion deer, much as he had done in his paintings of leaping fish in 1889.

Although only members of the club and their guests participated in hounding as hunters, Homer shows none of them. In dress and comportment, sportsmen would have appeared as outsiders in the wilderness, which indeed they were. Much as did the women in *Beaver Mountain,* sportsmen would have broken the unity of figure and nature that

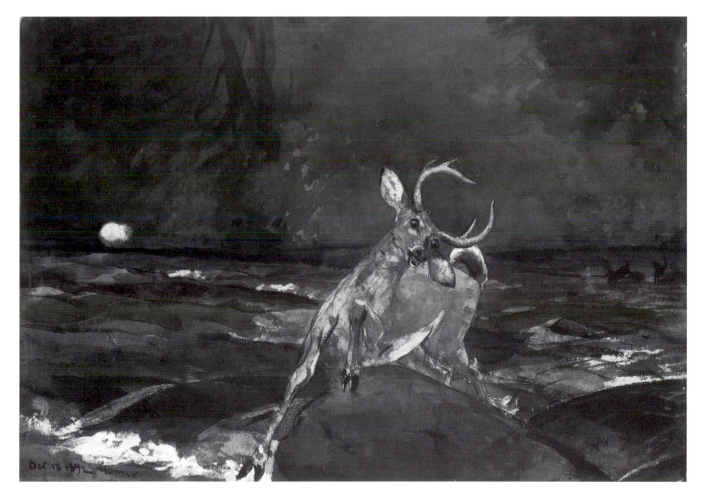

43. *A Good Shot, Adirondacks,* 1892. Watercolor, 15¹⁄₁₆ x 21¹¹⁄₁₆". Gift of Ruth K. Henschel in memory of her husband, Charles R. Henschel. © 1996 Board of Trustees, National Gallery of Art, Washington.

Homer achieved when he used guides. Even if some of his fellow sportsmen at the club had looked sufficiently rustic and had a talent for holding a pose, protocol argued against inviting a fellow member to undertake a task that the artist routinely paid guides to perform. While he might render a fellow sport fisherman at a distance casting from a boat in a subdued light that made identification unlikely, he tended to paint only guides when a face could be seen. He made exceptions to this rule chiefly in the case of his brother Charles.

But there is another consideration as well. In his art, as in his life, Homer felt an affinity with workers. Foot soldiers, farmers, teachers, mill workers, fisherfolk, lifesavers, guides—these are the people Homer painted more than the members of his own class, and these are the people among whom he lived happily at Cullercoats and Prout's Neck. It is curious that in the first decades of the twentieth century, the age of *The Masses,* when issues of social class and themes of labor provoked sharpened attention in the world of American art, this precoursing aspect of Homer's work went largely unnoticed.

In his depictions of hounding Homer avoided both sentiment and heroics. The extent of his attention to the sport—more than a dozen paintings in four years—leaves no question that he found hunting with hounds intensely interesting. Even observing it engendered an excitement difficult to explain to those who have not experienced it. But he almost certainly sensed that his hunting subjects worked not only as records of observed events but also as allegory. If *The Trapper* represented democratic America at home in the wilderness—free people in free nature—*Huntsman and Dogs* offers a less sanguine national spirit. It intimates a coarser American society that has ravished the wilderness and come to treat nature as a commodity. This huntsman seems immune to all that is fine, beautiful, and nurturing in the natural world.

For many generations people have attributed some degree of human-like intelligence and emotion to deer, admired the color of their coat and their movements, used them, because of their peaceable mildness, as symbols of innocence, and, accordingly, abhorred their seemingly wanton destruction in the hunt. Subsistence hunters viewed deer differently, of course, seeing them as sources of food and other products necessary for survival. The perceptions of sport hunters have been different still. Knowing that their sport was one of aristocratic lineage, limited in Great Britain to the few but democratized in America, they found in it not only a test of one's mettle and quickness of mind in nature but also a release, however dimly recognized, from class restriction. More vitally, they also found in the hunting of deer a powerful ritual of life and death whose origins are lost in prehistory and whose meanings remain forever ineffable.

Ineffable, too although often vocalized, have been the instincts of those who deplore hunting. While Homer did not editorialize against the sport of in his work, his very objectivity has allowed viewers to read his paintings as statements against the hunt. All great paintings are multivalent, and it is a measure of Homer's success that *Huntsman and Dogs* has sustained so many levels of meaning, some of them diametrically opposed. Nonetheless, Homer's own views on the matter are no small matter of historical interest, and we can gain some insight into those views from his actions as well as from his work.

During Homer's stay at the club in early autumn of 1892, he not only painted deer hounding but participated in the sport. We know of this because beginning in 1892 a fellow member, the New York lumber merchant Edwin Adams, maintained a daybook of the season.[12] As the hunt's captain he assigned participating members and guests, undoubtedly with their assent, to stations on the club's ponds and on the Hudson. Mink Pond was large enough to offer three or more positions. On the Hudson River there would be no chase in a boat. Because the number of positions needing to be filled usually exceeded the number of active sportsmen and sportswomen available to fill them, an extra element of chance came into play—a fleeing deer might enter an unattended pond and swim to the other side and safety, the pursuing hound unwilling to swim after it without human direction.

On 22 September 1892, Adams entered the following in his daybook:

Hunted today—

Below Huntley, on Hudson	J. Yalden
Huntley outlet	W. Homer
Mink	Mr. Terry
Upper Hudson	E.W. Adams

He then described the outcome.

Small doe came into Mr. Yalden but he missed. Large doe or buck in above me but out of gunshot. Small yearling doe came in below me; fired three times but without result. While going to my station, started a 2 year old buck near the Hudson; fired at it as it ran and killed it first shot. This is the first deer I ever killed while running in the woods. This makes 4 deer seen today—rained last half of day.[13]

Since no deer appeared at Huntley Pond, Homer probably passed the time fishing. The opportunity to shoot a deer during the club's hounding season evidently never presented itself to him. Indeed, the evidence of his work in 1892 suggests that he spent more time painting the hunt than participating in it. The deer hounding season, coinciding as it did with weeks of brilliant fall colors, provided him with ample company in posthunt social gatherings. The club register records four deer killed during the 1892 season.

Hounding and other recreations sometimes coincided. On 11 September 1893, the first day of the hounding season (Homer was not at the club), Adams recorded what happened when a hunter and his guest positioned at Thumb Pond took a break from their station to visit a friend at Mink Pond.

In the afternoon while Bloodgood and friend and Len Lawson were swimming from the rock in Mink a yearling doe came in from [Mink Pond's] South Bay. They hurriedly partly dressed, rowed to shore for the purpose of letting Mr. Bloodgood's friend (Mr. Sheffield) run to the house [a mile distant] for a rifle; in the meantime, Jessie and Mrs. Lawson in one boat and Grace and Mrs. Griffen in another boat came down from the other end of the lake and these three boats by hand rowing kept the deer out in the lake by heading it off continually for nearly three-quarters of an hour,

by which time Mr. Sheffield had returned and rowed out in the lake and shot the deer. Quite a feat for the ladies as they were the principal actors in the game and without them the deer would have escaped.[14]

But women participated more actively than this. On 15 September 1894, Adams recorded assignments to six stations including: "South Bay [Mink Pond]—Miss Cooley." Only one of the six hunters had a successful day: "A year old doe ran into South Bay, which Miss Cooley shot."[15]

Although Homer completed *Huntsman and Dogs* first, his pictorial concept for *Hound and Hunter* preceded it. The deep greens and blues of the washes that make up the cavelike space of the background in his *Sketch for "Hound and Hunter"* are products of midsummer observations during the earlier of his visits in 1891. He dated the watercolor in 1892, apparently not bringing it to completion until after he had finished work on *Huntsman.* Like *Guide Carrying a Deer,* he inscribed it to his brother: "Original Sketch for Oil Painting—Presented to Charles S. Homer, Jr."

In both the oil and its study, Flynn, prone in a guideboat, struggles to fix the boat's painter to the antlers of a recently killed deer. He shouts to his swimming hound to keep him from interfering with the task at hand. Viewers unacquainted with the events of hounding tended to assume that the deer was alive, for its eyes were open. In a letter to his patron Thomas Clarke, Homer expressed impatience with this reading, and in the process he displayed the intimate knowledge of a subject that always underlay the sense of truthfulness in his work.

> The critics may think that the deer is alive but he is not—otherwise the boat & man would be knocked high and dry. I can shut the deer's eyes & put pennies on them if that will make it better understood. They will say that the head is the first to sink— that is so. This head has been under water & from the tail up has been carefully recovered in order to tie the head to the end of the boat. It is a simple thing to make a man out an Ass & Fool by starting from a mistaken idea. So anyone thinks this deer is alive <u>is wrong</u>[16]

Some years later, in conversation with Bryson Burroughs, later curator of paintings at the Metropolitan Museum of Art, he made a comment of a different sort about another aspect of the painting. Burroughs recalled Homer saying: "Did you notice the boy's hands—all sunburnt; the wrists somewhat sunburnt, but not as brown as the hands; and the bit of forearm where the sleeve is pulled back, not sunburnt at all. That was hard to paint. I spent more than a week painting those hands."[17]

It was characteristic of Homer to speak of his work only in terms of problems of making. On matters of interpretation he tended to remain silent, presumably from the conviction that words could not adequately encompass what he expressed in paint.

All three figures are contained, the hound by the water, the hunter by his tasks, and the deer by death. The deer's struggle is past; the other two will soon rest in success. The

hunter's visage reveals more feeling than does the face of the pelt-carrying huntsman, but it is feeling of a kind that suits the mood of literary Naturalism more than the "higher" mood, full of intelligence, that enlivens the faces of Phelps and Holt in *The Two Guides.*

Homer built *Hound and Hunter* around tilting horizontals suggestive of the imperfect stability of the activity he depicted: the hunter, the fallen hemlock, the swimming dog, the emanating ripples, the guideboat. But it is the boat that redeems the subject from Naturalism, for if at one level this painting records the culmination of a many-staged day of hunting, at another it pays homage to a vessel, the Adirondack guideboat, that was already a hallmark of the Adirondacks. Light enough to be carried by a single person, spacious enough for plenty of camping gear and provisions—or a deer—fast moving and easily controlled, ideal for the shallow waters of lakeside, and a marvel of craftsmanship, this boat symbolized through its design and construction acts of human creation that refuted notions that humankind was little different from other animals.

To adopt a Darwinian view of the world in Homer's time called into question the belief in progress that had held a central place in the Western world since the Enlightenment. Darwinian thought undermined especially the spirit of optimism that had accompanied the belief in progress and that had been so central a part of the character of nineteenth-century American life. In a quiet-spoken way, optimism had infused Homer's sun-filled paintings of the 1860s and 1870s. It also had shaped Murray's notion that the Adirondacks wilderness existed essentially to benefit humankind. Made accessible and comfortable (through progress) it revivified the mind, body, and spirit of those who visited it and made them better able to move ahead with society's altruistic aims. Homer's *In the Mountains* and *Two Guides* capture some of this belief in the power of nature to improve those who visit it.

But the optimism of the 1860s and 1870s had become contained by the end of the century, at least in much of intellectual and artistic life. While the shattering experience of the World War I and Spenglerian gloom were still half a generation distant, a mood of late Victorian melancholy had already begun to appear in the arts. It could be seen in Homer's work by the mid-1880s. As a mood of profound seriousness it seemed to portend an age coming to its end. We can find this mood in Matthew Arnold's "Dover Beach," Brahms' third and fourth symphonies, Eakins' late portraits, and, among countless other works in all the arts, Homer's oils after his move to Prout's Neck. The antidote to this pessimism would prove to be modernism, but that new view of the world arrived in America only as Homer's career ended.

It is possible, of course, to attribute some of the gravity of Homer's late oils—his subjects of danger, isolation, and death—to personal matters rather than to see them wholly as his conscious or unconscious response as an artist to powerful ideas. Psychobiography is a notoriously subjective branch of conjecture, however, and a mode of inquiry that of necessity reflects as much about the sensibilities of its authors and their era as it reveals of

the mind of its subjects. The evidence of Homer's paintings is that his subjects reflected the mood of their times at least as much as they reflected his own mood. While in his late years he probably meditated upon his own mortality—people who reach old age tend to do so—and this may have encouraged him toward grave subjects, he executed those subjects with the bracing bravura of a young man. The vivacity of his technique, the constant inventiveness of his compositions, and the vitality of his expressiveness all transcend his subjects to affirm life triumphantly.

Paddling at Dusk

Any attempt to generalize from *Huntsman* and *Hound and Hunter* that Darwin, deer, dogs, and death dominated Homer's mood in 1891 is put to rest by the nonhunting subjects that he painted at the club in that year and later in the decade. They constitute a group as remarkable as those of 1889 and represent a further development in his thinking about subjects and in his mastery in executing them. None of them is informed by the brooding Naturalism that appeared with *Huntsman and Dogs* and *Hound and Hunter* and was rarely seen thereafter.

Mink Pond (plate 17), one of his greatest watercolors of any year, is full of distinctly Homerian grace, charm, and even a touch of dry humor. A sunfish and a frog both eye a pair of moths that flutter between them; simultaneous leaps will end in a collision. One can find an elementary Darwinian subject here, but it is a minor consideration compared to the work's sensual appeals, its splendid color, line, and form. The waterlily blossom, precisely drawn in graphite and exquisitely painted to near luminescence, is a stunning presence; the uprising leafs of pickerel weed in the background, delicate in half-light, and the downward serpentine flow of the lily pad fronds, provide a subtle accompaniment.

This watercolor has sometimes been cited as an example of Japanese influence in Homer's work, for in its delicacy of subject and execution, its loosely defined pictorial space, and its intimacy, it summons up seemingly similar things that are common in the art of China and Japan but rare in Western art. Homer had been acquainted with at least bits and pieces of Asian art since his youth in Boston, a city with countless Spice Trade artifacts, and he had known a few specimens of Japanese wood block prints since at least as early as 1857.[18] Like La Farge, Whistler, and a few other American artists of his generation, he had found in the model of Japanese prints a freedom from rules of academic art that had calcified by the middle of the nineteenth century. Unlike the others, he did not refer overtly to things Asian in his paintings. For him, Japanese art was an enabling rather than a controlling influence. When it can be perceived, as in *Mink Pond,* it seems just right for the subject.

In *The Blue Boat* of 1892 (plate 18), Wallace moves the guideboat forward silently with his paddle, his rifle resting on the gunwales, while Flynn scans the brush for game. Homer's own high estimate of the success he attained in painting this watercolor appears beneath

his signature: "This will do the business." He might well have written the same on *Mink Pond.*

The tallest of the trees and the point at which Wallace's paddle enters the water define the left boundary of the square into which Homer placed his main subject. He established very slightly different planes and tonalities in the rest of the sheet to give it a degree of spatial independence and to create a quiet undercurrent of tension, but he let none of this interfere with the painting's great sense of spontaneity. That Homer meant Wallace and Flynn to be hunting is clear from his inscription on the watercolor's verso: "On the trail."

A different mood fills *Camp Fire, Adirondacks* (fig. 44), a watercolor of 1892. Wallace sits, holding his rifle across his knees, before a smoldering fire. An uprooted tree shelters his back; it is the product of a blow-down, evidence of the thinness of Adirondack soil and the imperviousness of its underlying granite to the roots of trees. In both this work and *Old*

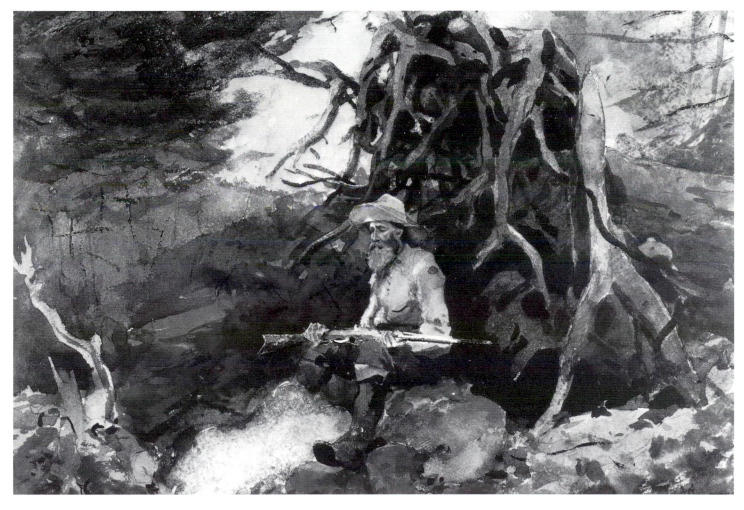

44. *Camp Fire, Adirondacks,* 1892. Watercolor, 14⅞ x 21". Art Institute of Chicago. Photograph © 1995, The Art Institute of Chicago. All Rights Reserved.

Friends of 1894 (plate 19), Homer develops the elegiac mood first seen in *The Guide* of 1889.

Especially in *Old Friends* he touches a chord of tender human feeling. This woodsman holds a staff in one hand and reaches out to touch the tree with the other, a wordless communication between two souls. The tree is dead, its bark gone, but its stands majestically, its life past but still material. Leaves from the previous year and from other trees pile against its base while new greens of the present year show beyond. Blue sky captures a corner of the painting and helps to dispel any hint of somber mood. Wallace's upward gaze reinforces the thrust of the trees. An enormous sense of dignity pervades the painting and keeps it free of sentimentalized feeling. If Homer's huntsman, surrounded by felled trees and carrying a killed deer, signified depletion, misuse, and insensitivity to nature, this woodsman and tree speak of intimacy and veneration and natural cycles of life—an ideal relationship for humankind and the world it lives in.[19]

Five years after *The Guide,* Homer painted Wallace again alone in a boat at the edge of Mink Pond with dense forest behind. Like the earlier work, the 1894 *The Adirondack Guide* (plate 20) juxtaposes an old man with an old tree, but now the tree with its cascade of branches, surrounded by color that seems at once inventive and natural, assumes a more prominent role. While the 1889 *Guide* seems an inspired record of a moment, the 1894 *Guide* transcends moments, and all time, and does so through a painterly elaboration so powerful that there could no longer be any lingering doubt that Homer was in a class by himself as America's great master of the watercolor medium or that he had moved the medium to an expressive level reaching beyond the possibilities of oil paint.

Two young men appeared in Homer's North Woods Club watercolors between 1889 and 1892. One was Flynn, the other Ernest Yalden. They came from different backgrounds and were at the club for different reasons—one was a hired hand and guide, the other a member of the club. They had in common an integrity of character that Homer seems to have admired. Late in life both recalled Homer as a painter, Flynn briefly (as we have heard) and Yalden at greater length.

When Homer painted him in a small boat in *Paddling at Dusk* (plate 21), Yalden was twenty-two.[20] Born in England in 1870, he came to the United States as a child with his parents. His father, J. Henry Yalden, a prominent accountant and civil servant in New York, was a founder of the North Woods Club. Henry Yalden participated with Homer in the unsuccessful day of deer hounding reported by Adams. A drawing exists, once attributed to Homer, but not in his style and now believed to be by another hand, titled *Homer and Friend, Henry Yalden, at Artist's Camp* (fig. 45). The drawing is undated but inscribed "Artist's Camp, Limestone Mountain."[21] Nothing is known of the circumstances of the drawing, which depicts two figures flanked by great trees and silhouetted by the light of campfire, with a lean-to beyond them, but it suggests that the elder Yalden and Homer

45. Artist unknown, *Homer and Friend, Henry Yalden, at Artist's Camp,* n.d. Ink wash and gouache on paper, 8½ x 6⅞". Addison Gallery of Art, Phillips Academy, Andover, Massachusetts. All Rights Reserved.

were good friends. Yalden, his wife, and his son's presence at the club often coincided with Homer's.[22]

The younger Yalden was still an engineering student at New York University at the time of *Paddling*. He would later join the Carnegie Steel Company, marry, and return to New York at the invitation of the Baron de Hirsch Fund to design an innovative program in manual and vocational training to serve the children of immigrant families. For a quarter of a century he headed the school established to implement this program.

The manual training aspect of Yalden's curriculum manifested the ideas of a movement that had a friendly relation to Homer's career as a painter in watercolors. The movement had developed elaborately from the simple premise that manual and intellectual skills were interdependent, that nonverbal spatial thinking (manual skills) could be taught as successfully as linear thinking (verbal skills), and that only through a mastery of both could a person fully realize his or her capabilities.[23] The roots of the movement in America ran back to the Jacksonian era's reaction against the then-dominant idea of a classical education of an essentially literary kind, one that had little regard for manual skills. Many Utopian societies of mid-century, especially those envisioning wholesale social reorganization, also promoted the belief that manual and intellectual skills were two connected aspects of a single life force. Mechanics' societies advocated the same concept. Immediately following the Civil War these beliefs and others congealed into a movement closely allied with educational reform. Its greatest impact on American life came through the development of manual training programs in the public schools and the reform of school architecture to accommodate these and other new programs. After World War I the movement deteriorated into a purely utilitarian and even anti-intellectual kind of vocational education, but a short generation earlier, it had, among other accomplishments, created a mystique for self-made objects of the highest craftsmanship, objects that owed as much to mind as to hands. The boat in which Ernest Yalden paddles in Homer's watercolor was one such object, and so too was the watercolor itself.

The figure in *Paddling at Dusk* is unique within Homer's Adirondack work. Rather than a guide, logger, sport fisherman, or hunter, the trimly dressed figure sitting erect in his boat is a craftsman. The artist inscribed the watercolor at upper right, "To Ernest J. G. Yalden, August 22, 1892." This was the date on which he completed it at Prout's Neck. He had painted it at Mink Pond between 18 June and 28 July on his first visit of the season and presented it to Yalden after he returned to the club from Prout's Neck on 17 September.

Forty-four years later, in 1936, Yalden recalled in a letter to a dealer the circumstances of the painting.

> *Paddling at Dusk* . . . was painted sometime during the summer of 1892. Mr. Homer
> and myself were members of the Adirondack Preserve Association at the time; and
> this picture was made at Mink Pond on the preserve. It is a canoe built by myself
> which interested Mr. Homer on account of its portability, for it weighed only 32

pounds. He was particularly interested in the broad flashes of light from the paddle when underway after dark; and this picture was painted when it was almost dark. The canoe, built of mahogany, was based on the model of a Canadian bateau, was 12 [feet] long and 18 inches beam. It has always been a puzzle to me how he was able to get the effect that he did when it was almost too dark to distinguish one color from another. . . . I have a number of interesting photographs of Homer that I made when with him for several summers, and I should be glad to show them to you at any time you might care to run out here.[24]

If these photographs still exist, their location has gone unrecorded since Yalden's death in 1937.

In painting *Paddling at Dusk* Homer had, as Yalden reported, been interested in the conditions and effects of light, their relation to color and reflection, and the resulting losses of definition and gains of mass. But in selecting this talented exemplar of the ideals of the manual training movement in his hand-built boat as the key element of this work, Homer surely also meant to pay a compliment to Yalden's already advanced synthesis of the manual with the intellectual, and in so doing he expressed what he valued in himself.

Yalden went on to achieve things of genuine distinction in many fields, most of them avocations. He became one of the foremost amateur astronomers of time in America, working from an observatory he built on the grounds of his home in Leonia, New Jersey. He designed, built, and collected sundials, and wrote a treatise on them; designed, built, and sailed many kinds of boats, including sea-going yachts; organized a civic orchestra in Leonia, playing clarinet when he was not conducting it. He was a skillful photographer who designed and built his own cameras. One wishes that he had told us more about Homer.

Homer's watercolors of men in boats, at river's edge, and on the forest floor reinforced the mystique of the Adirondacks as a region where the most important activities took place at water level or not far above it. In a few instances, however, he portrayed figures on heights, not hikers or guides as he had in the 1870s, but woodsmen. In *Burnt Mountain* of 1892 (plate 22), two of them rest high on a slope overlooking the forest; part of a pond is visible within it. The view is not far different from that obtained ascending Beaver Mountain—a club trail led to the summit—but it serves a more general truth also, evoking the experience of climbing to outlooks at modest heights on any of the region's lesser mountains. Fire and perhaps a blow-down explain the fallen trees. The weatherworn logs strengthen the downward fall of the composition, creating a diagonal axis as powerful in its way as those of the ledges and breakers in Homer's Prout's Neck marines of the same decade. This watercolor differs from those oils especially in the equilibrium Homer achieved in it between quietude and energy.

Wallace in a red shirt surveys the terrain; a serpentine pattern of gnarled roots radiates above him. His reclining companion, gun within reach, also appears in a small oil sketch, *The Guide*, which Homer painted on a cigar box lid and signed, but left undated. Because

both figures have the same pointed beard and similar hats, suspenders, and guns, the oil sketch probably also dates from 1892.

Burnt Mountain, like most of Homer's Adirondack watercolors from 1889 on, restates the essential subject of *The Trapper* by showing men of the woods in their natural environment. They constitute a unity of person and place that for more than a century has seemed profoundly truthful rather than contrived, a product of experience rather than ideology. If *Huntsman and Dogs* and Homer's other hunting subjects at one level critique the impact of American culture on the land, his other Adirondack works—by far the greater number—offer an ideal (and impractical) relationship of people to the land, tempting us all to become woodsmen.

1900–1910

The Pioneer

DURING THE LAST DECADE of his life, Homer visited the North Woods Club each year except 1907 and 1909. He arrived in May or June and remained as long as a month, but more often two or three weeks. Having painted nothing in the region since 1894, in 1900 he produced four watercolors; another is dated 1902. He fished, renewed old friendships, and partook of the pleasures of life in the woods. His brother Charles joined him at the club in 1902 as a prelude to their fishing expedition to Quebec in that year; he visited again in 1904.[1]

Since the mid-1890s Homer had become a less prolific artist than earlier, but there had been no decline in his creative powers or in the originality of his vision. His compositions became bolder, flatter and simpler in pictorial space, more economical in statement, and more powerful in effect. The oil paintings of this decade—and a few years before—revealed a great artist undiminished in his late maturity, but these oils came from Prout's Neck, Quebec, and the tropics rather than from the Adirondacks. The watercolors of 1900–1902 represent the conclusion of his work as a painter in this forest.

With *The Pioneer* (plate 23) in 1900, Homer painted the last of his Adirondack watercolors to include a human figure. One pure landscape dated 1902, *Burnt Mountain (Mountain Landscape)* (fig. 46), came later. In it Beaver Mountain ceased to serve as background and after thirty years became at last the main subject. This was Homer's final tribute to one of the great constants of his life at the clearing, a mountain that like Hokusai's Fuji and Cézanne's Ste. Victoire appeared ever fresh day by day and even hour by hour. Two important pencil sketches followed in 1908 but as a planned work of art including a human element, *The Pioneer* in 1900 effectively marked the close of Homer's career as a painter of human life in the north woods.[2]

Whether Homer meant *The Pioneer* to convey a valedictory mood is another matter, and one that in the absence of substantive evidence of any kind is moot. It was hardly his farewell to the medium, for stunning watercolors were yet to come from Quebec, Florida, and Bermuda. Although *The Pioneer* contains much that is new, it nevertheless sums up thirty years at the clearing and conveys a sense of retrospect.

If this old woodsman is Rufus Wallace, then Homer ends in the Adirondacks as he

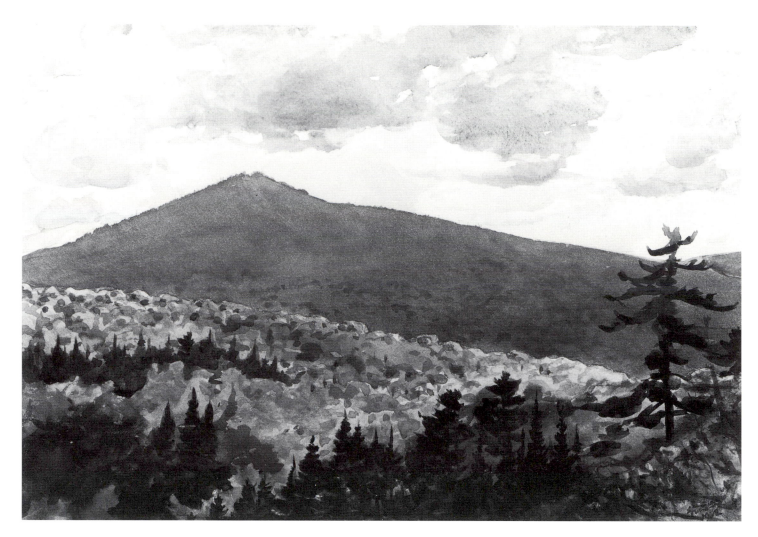

46. *Burnt Mountain (Mountain Landscape),* 1902. Watercolor, 14⁷/₁₆ x 21¹/₁₆". Addison Gallery of Art, Phillips Academy, Andover, Massachusetts. All Rights Reserved.

began, painting Wallace alone in nature. Now the figure is not a trapper at water level but an axeman on a nearly clear-cut rise of land. Ever so slightly bent by the years, he moves away from the viewer. Beaver Mountain, masked by mist in *The Trapper,* here stands clear beneath an empty sky. The mountain's main mass is a marvel of layered washes of gray, its darker, conifered south-running slope extending with poetic license across most of the sheet. A stroke of violet on the horizon at left suggests a distant mountain, while in color it answers (with other touches of violet in the foliage and foreground) the yellows of the middle ground. Sunlight floods onto the open land. A burst of foliage on the tree at right and the dense growth in the foreground speak of vigorous regeneration. There has been no logging here recently; these are old stumps. Homer may have intended an analogy between the worn landscape of the middle ground and the old woodsman, as he certainly had between the ancient tree and old woodsman (Wallace) in his *Old Friends* in 1894, but the relationship is a benign one. This woodsman's axe is no more than a necessary tool for

survival. The cutting of whole tracts of forest required logging crews with two-man saws.

The watercolor's title (which may have come from Homer's dealer) as applied to this woodsman is poetic rather than accurate. While Murray and other visitors to the Adirondacks had chosen to find in guides a survival of the rough-hewn, stalwart qualities of character that, since James Fenimore Cooper's Leatherstocking tales, had been an essential part of the image of the pioneer of earlier generations in America, the true pioneers of the Adirondacks had been the Bakers and others like them. They had brought to the wilderness qualities of character, gained far from wilderness, that enabled them to do what the settlers of the frontier had done half a century and more earlier—transform at least a small part of the forest into cultivated land.

Homer in his own profession, rather than Wallace or Phelps in theirs, had been the true pathfinder, opening ways for others to follow. It was this artist, rather than any axeman, who invented and innovated, who created rather than depleted and who said new things in paint rather than repeating old tales. When he returned to the subject of leaping fish in 1900 in his *Fish and Butterflies* (plate 24), he treated it as no one, himself included, had quite done before. In washes of blue and green he painted the most abstract background of any of his Adirondack watercolors. Only the reflected tops of pines barely visible along the roughly brushed margin between this background and the lighter hues at the bottom of the sheet suggest an Adirondack setting, and this is little more than a hint of place in a work in which everything seems to be compressed into a single plane. As a century opened in which artists would increasingly find in paint itself an expressive power that transcended subjects, this watercolor, and others by Homer, pointed the way.

The Bear

In 1905, after his return from a productive time fishing and painting in Florida, a chronic and worsening gastrointestinal disorder disabled Homer. Although he recovered, put on a brave face, and periodically forswore for a while his decades-old habits of hearty smoking and drinking, his health was never robust again. During the five years that remained of his life, he painted no watercolors and began and finished only two oils. As physical discomfort spawned psychological distress, his mood darkened. He became uncharacteristically brusque and inhospitable to strangers and even to old acquaintances. He rebuffed reporters, critics, unknown admirers of his work, and others who, now in growing numbers, sought to meet or correspond with him. Much of his reputation as a sour old Yankee comes from these late years. His bearish behavior was that of an essentially shy man—never timid but never at ease with any but his closest friends—an artist who had become embittered by decades of what he viewed as inadequate recognition of, and recompense for, his patently great achievements, and who now had reason to fear that his life was coming to an end.[3]

Illness probably explains his absence from the North Woods Club in 1907. In May 1908, he suffered a mild stroke which temporarily impaired his speech and his ability to tie his

necktie. He recovered his powers rapidly. Less than a month and a half after the onset of the stroke he took himself to Minerva, arriving at the club on 24 June. The events of the following day testify to three things: that he felt well enough to join others on a trek into deep forest, that his quickness of mind and action were as sharp as ever, and that the stroke had left his drawing skills unimpaired.[4]

The party that set off into the woods consisted of at least six people, including one or more guides. One of the guides, being a good woodsman, carried a rifle. In time the group stopped for a rest, and perhaps to sample a flask. At that point a black bear appeared on the scene. Bears in the Adirondack forest typically run from the sight or sound of humans, but this bear may have had cubs nearby for it remained in sight, looking over a fallen tree at the sportsmen, perhaps deterred by their numbers but certainly posing a threat to their safety. Homer seized the guide's rifle and shot the animal. Having never succeeded in shooting a deer at the club, despite hours of waiting, he now claimed bigger game with no wait at all.[5]

47. *Sportsmen and Bear, North Woods Club*, 1908. Pencil drawing, 4¼ x 5½"(sheet). North Woods Club, Minerva, N. Y.

He made two drawings of the event (figs. 47 and 48). One came from memory. It depicted the locations of the members of the party in relation to each other and the bear. None of the sportsmen is identified. He may have included himself as one of the figures, or he may have made the drawing from the place where he saw the bear. The second drawing was from life, later the same day, when two guides, having trussed the bear to a pole, carried it away. The drawing shows Homer's reportorial instinct as sharp as ever, his skill at foreshortening intact, and his distinctive line still strong.

In the club register, where everyone was obliged to enter a count of the fish and game caught or shot on a given day, Homer wrote in a large, firm hand: "1 Bear!"[6]

The Artist

Late in 1908, at least in part to demonstrate that his stroke had not disabled him as an artist, Homer painted a work that he described to his brother Charles as "a most surprising picture," *Right and Left.* This oil depicts close to the picture plane two ducks which, just

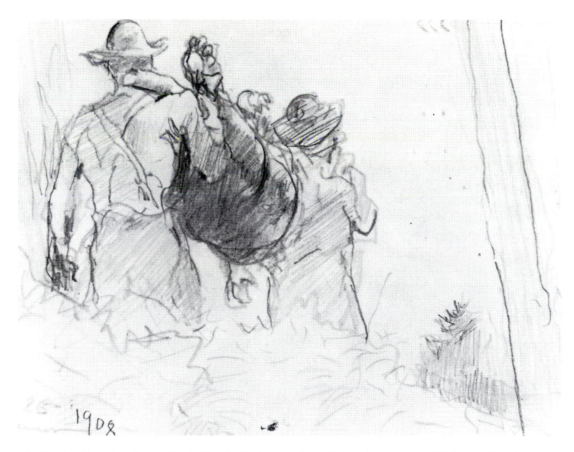

48. *Guides Carrying Bear, North Woods Club,* 1908. Pencil drawing, 4¼ x 9¼"(sheet). North Woods Club, Minerva, N. Y.

taking flight from the sea, have been shot in rapid succession by a hunter in a boat firing a double-barreled shotgun. The painting sold early in 1909 for five thousand dollars. In the fall of that year he returned to his easel and painted a marine, *Driftwood,* a freshly conceived, richly expressive, variant of a subject that he had painted for twenty years: the sea's contest with the rocky shore. This, his last work, sold without delay for twenty-eight hundred dollars. With these two paintings he had finally achieved the one measure of his artistic worth—rapid sales at good prices—that he valued above all others, but the parlous state of his health muted whatever satisfaction he gained from it.

Throughout the winter of 1909–10—the first in several years in which he did not travel south—he insisted in his letters to his brothers and their wives that he was well and happy at Prout's Neck, but they had serious doubts. During the winter he continued to consult physicians. He must now have felt himself to be akin to Turgeniev's catch: "Death is like a fisherman who, having caught a fish in his net, leaves it in the water for a time; the fish continues to swim about, but all the while the net is round it and the fisherman will snatch it out in his own good time."[7]

In June 1910 he felt strong enough to journey some distance away from Prout's Neck for pleasure, to "swim about" for the first time in several months. Though he faced a long rail trip followed by an arduous wagon ride, he made the North Woods Club his destination. He arrived on 23 June and stayed until 4 July, twelve days in all. Presumably he fished, spent time with the Bibbys and other old friends, meditated on Beaver Mountain, and again enjoyed, as best he could, the sensations of Adirondack air and light.

A few weeks after his return to Prout's Neck his health began to fail rapidly. On 29 September, with his brothers at hand, he died in his studio-home at age seventy-four. That he chose to spend some of his last days in Minerva is a measure of his abiding affection for life at the clearing where he had begun his Adirondack life forty years before.

NO OTHER AMERICAN PAINTER of his era—perhaps any era—had grown so steadily and impressively over so long a time, or produced a body of work so varied in subject, mood, and style, yet all of a piece and all charting a journey of the intellect and even the soul into the wild natural world. Having begun by painting the life of his times, he had ended as a painter of timeless life—the sea, the shore, the forest, the hunt, the life of lakes and woods. Having earlier distinguished between landscapes of war, peace, and wilderness, he had gradually transformed them into one as he came to understand that destruction and regeneration, violence and nurturance, and storm and still are all part of the same natural order of things. He had moved from the small truths of society to the larger ones of the natural world. He had come to see that we and the wilderness are one.

Appendixes

Notes

Works Cited

Appendix A

A Chronology of Winslow Homer in the Adirondacks

Limited evidence survives to document the dates and itineraries of Homer's visits to the Adirondacks in the 1870s. The record is fuller, although not complete, for his visits to the North Woods Club (NWC) in Minerva beginning in 1889. Because he typically dated his works when he finished them and this sometimes occurred months or more after he began them, the year that he inscribed on a painting does not always indicate his presence in the Adirondacks in that year. Except when otherwise noted, all information pertaining to his visits to the North Woods Club (NWC) comes from the club's register (Adirondack Museum).

1870 Keene Valley (according to tradition); the Baker farm, Minerva, September ("Mr. Homer will come up about the 1st of September," Terry to Eunice Baker, June 1870, Adirondack Museum) through late autumn (snow in two Adirondack subjects published in *Every Saturday* in January 1871).

1874 The Baker farm 14 May ("Fitch and Homer came," Juliette Baker Rice in her diary, Adirondack Museum); the watercolor *Eliphalet Terry* inscribed by Homer "June 1874"); at Walden and Easthampton, N.Y. midsummer; Keene Valley by 5 Oct (date on photograph of Homer and others on bank of East Branch of Ausable River).

1877 Keene Valley ("Mr. Homer is back from the Adirondacks," *New York Tribune*, 13 October; Roswell Shurtleff recalls that Homer painted *Camp Fire* in Keene Valley, *American Art News*, 29 October 1910).

1889 NWC 6 May—13 July.
 1 October—24 November.

1891 NWC 9 June—31 July.
 1 October—15 October or later.

1892 NWC 18 June—28 July.
 17 September—10 October.

1894 NWC 3 June—8 July.

1896 NWC 15 May—?

1899 NWC 17 July—22 July.

1900 NWC 7 June—28 June.

1901 NWC 4 May—22 May.

1902 NWC 21 May—10 June.

1903 NWC 23 May—8 June.

1904 NWC 31 May—27 June.

1905 NWC 27 June—?

1906 NWC 28 June—?

1908 NWC 24 June—c. mid-July.

1910 NWC 23 June—4 July.

Appendix B

A List of Winslow Homer's Adirondack Works

This list was originally compiled by Lloyd and Edith Havens Goodrich and published in *Winslow Homer in the Adirondacks,* the catalogue of an exhibition held in 1959 at the Adirondack Museum, Blue Mountain Lake, New York. That so few changes other than those of ownership and altered titles are reflected in the present version of the list testifies to the Goodriches' thoroughness. The present version differs in organization by incorporating undated works into the years in which Homer almost certainly began them, rather than categorizing them separately. Once-current but now superseded titles are given in parentheses. Minor changes in the dimensions of several works reflect measurements made in recent years after removal of the works from their frames. The revision of the list has been greatly facilitated by data compiled by Abigail Booth Gerdts for the "Lloyd Goodrich and Edith Havens Goodrich Whitney Museum of American Art Record of Works by Winslow Homer."

In accord with the geographic distinctions of Homer's time, which defined Saratoga and Lake George as apart from the Adirondacks, the present list does not include the artist's magazine illustrations of 1865 and 1869 pertaining to those places.

1870

Oils

Adirondack Lake, 24 x 38". Henry Art Gallery, University of Washington, Seattle.

The Trapper, Adirondack Lake, 20 x 30". Colby College Art Museum, Waterville, Me.

The Woodchopper, 10⅜ x 15¾". Private collection. (Undated, assigned to 1870 primarily on grounds of style.)

Illustrations

A Quiet Day in the Woods. Wood engraving, 6⅛ x 6½". *Appleton's Journal,* 25 June, 701.

Trapping in the Adirondacks. Wood engraving, 8⅞ x 11⅝". *Every Saturday,* 24 December, 849.

1871

Illustrations

Deer-Stalking in the Adirondacks in Winter. Wood engraving, 8⅞ x 11¾". *Every Saturday,* 21 January, 57.

Lumbering in Winter. Wood engraving, 11⅝ x 8⅞". *Every Saturday,* 28 January, 89.

1874

Oils

Beaver Mountain, Adirondacks, Minerva, N.Y. See 1877.

Playing a Fish (Guide Fishing), 11¹¹⁄₁₆ x 18¹⁵⁄₁₆". Sterling and Francine Clark Art Institute, Williamstown, Mass. Completed and dated in 1875. (Homer substantially reworked this painting in the 1890s.)

Waiting for a Bite, 12 x 20". Cummer Gallery of Art, Jacksonville, Fla.

Watercolors

Eliphalet Terry (The Painter Eliphalet Terry Fishing From a Boat), 9⅜ x 12⅞". Century Assoc., New York.

Lake Shore, 9¾ x 13¾". Private collection.

Man in a Punt, Fishing, 9¾ x 13½". Private collection.

Trappers Resting, 9½ x 13½". Portland [Me.] Museum of Art.

Waiting for a Bite (Why Don't the Suckers Bite?), 7¼ x 13¼". Addison Gallery of American Art, Phillips Academy, Andover, Mass.

Illustrations

Camping Out in the Adirondack Mountains. Wood engraving, 9⅛ x 13¾". *Harper's Weekly,* 7 November, 920.

Waiting for a Bite. Wood engraving, 9⅛ x 13¾". *Harper's Weekly,* 22 August, 693.

1877

Oils

Beaver Mountain, Adirondacks, Minerva, N.Y., 12 x 17⅛". Newark Museum. (This undated painting may be a product of 1874.)

Camp Fire, 23¾ x 38⅛". Metropolitan Museum of Art. (Although Homer painted much or all of this work in 1877, he dated it in 1880.)

The Guide. See 1892.

In the Mountains, 24 x 38". Brooklyn Museum.

The Two Guides, 24¼ x 38¼". Sterling and Francine Clark Art Institute, Williamstown, Mass.

Drawing

Study for In the Mountains, 8½ x 13". Charcoal and watercolor. Private collection.

[1880]

Oil

Camp Fire. See 1877.

1889

Watercolors

Adirondack Catch (Trout), 19½ x 13½". Private collection.

Adirondack Lake, 14 x 20". Museum of Fine Arts, Boston.

Adirondack Lake, 13½ x 19¾". Yale University Art Gallery.

Adirondack Woods, Guide and Dog (Hunter and Dog, Adirondacks), 13⅞ x 19⅞". Montgomery [Ala.] Museum of Fine Arts.

Big Trees, Adirondacks, 13⅝ x 19⅝". Private collection.

Casting, A Rise, 9¹/₁₆ x 19⅜". Adirondack Museum.

Casting in the Falls, 14 x 20". Dallas Museum of Art.

Deer in the Adirondacks, 13⅜ x 19⅜". Fundación Colección Thyssen-Bornemisza, Madrid.

Dog on a Log, 13¹⁵/₁₆ x 20". Addison Gallery of American Art, Phillips Academy, Andover, Mass.

Dogs in a Boat. See *Waiting for the Start.*

End of the Day, Adirondacks, 13⅝ x 19½". Art Institute of Chicago.

A Fisherman's Day, 12⅜ x 19¼". Freer Gallery of Art, Smithsonian Institution.

Fishing in the Adirondacks (Adirondacks), 14 x 20". Fogg Art Museum, Harvard University Art Museums.

A Good One, 12¼ x 19½". Hyde Collection, Glens Falls, N.Y.

A Good Strike, Leaping Trout, 13¾ x 19". Private collection.

The Adirondack Guide, 14 x 20". Museum of Fine Arts, Boston.

The Guide, 14 x 20". Portland [Me.] Museum of Art.

Hunting Dog on a Log. See *Dog on a Log.*

Jumping Trout, 13 x 19⅜". Brooklyn Museum.

Leaping Salmon Trout, 10½ x 20⅞". Private collection.

Leaping Trout, 14 x 20". Museum of Fine Arts, Boston.

Leaping Trout, 13¼ x 19⅜". Cleveland Museum of Art.

Leaping Trout, 13⅞ x 19. Portland [Me.] Museum of Art.

Log Jam, Hudson River at Blue Ledge, 14¼ x 20¾". Norton Gallery and School of Art, West Palm Beach, Fla.

The Lone Fisherman, 14 x 20". National Gallery of Art.

Netting the Fish, 14 x 20". Art Institute of Chicago.

An October Day, 13⅞ x 19¾". Sterling and Francine Clark Art Institute, Williamstown, Mass.

On the Trail, 12⅝ x 19⅞". National Gallery of Art.

A Quiet Pool on a Sunny Day, 13 x 20". Private collection.

The Red Canoe, 13¾ x 20". Private collection.

Salmon Fishing, 14 x 20". Private collection.

Solitude, 13⅜ x 19⅜". Private collection.

Sunrise, Fishing in the Adirondacks, 14 x 21". Fine Arts Museums of San Francisco.

Trout, 5⅝ x 10¾". Private collection.

Trout Breaking (Rise to a Fly), 13⅞ x 19⅞". Museum of Fine Arts, Boston.

Two Trout, 19½ x 13¼". Private collection.

An Unexpected Catch (A Disappointing Catch), 10 x 20". Portland [Me.] Museum of Art.

Valley and Hillside, 14 x 20". Cooper-Hewitt National Design Museum, Smithsonian Institution.

Waiting for the Start (Dogs in a Boat), 14 x 20". Museum of Art, Rhode Island School of Design.

Waterfall, Adirondacks, 13⅝ x 19⅝". Freer Gallery of Art, Smithsonian Institution.

Etching

Fly Fishing, Saranac Lake, 17½ x 22⅝". Margaret Woodbury Strong Museum, Rochester, N.Y.

1891

Oil

Huntsman and Dogs, 28¼ x 48". Philadelphia Museum of Art.

Watercolors

The Boatman, 13⅞ x 20". Brooklyn Museum.

Building a Smudge, 13½ x 20". Private collection.

Guide Carrying a Deer, 13¾ x 19½". Portland [Me.] Museum of Art. (Begun in 1891.)

Mink Pond, 13⅞ x 20". Fogg Art Museum, Harvard University Art Museums.

Two Trout, 18⅞ x 13⅜". Private collection.

The Woodcutter, 13¼ x 19⅞". Private collection.

Woodsman and Fallen Tree, 14 x 20". Museum of Fine Arts, Boston.

1892

Oils

The Guide, 11⅞ x 7⅝". Private collection. (Undated, formerly assigned to 1876 on grounds of style but now assigned to 1892 owing to the similarity of the figure to one in *Burnt Mountain*.)

Hound and Hunter, 28¼ x 48⅛". National Gallery of Art.

Watercolors

Adirondack Guide, 12⅝ x 21⅛". Art Institute of Chicago.

Adirondacks, Man and Canoe, 15⅛ x 21½". Private collection.

After the Hunt, 14 x 19¹⁵⁄₁₆". Los Angeles County Museum of Art.

The Blue Boat, 15⅛ x 21½". Museum of Fine Arts, Boston.

Blue Monday, 12 x 21¼". Fogg Art Museum, Harvard University Art Museums.

Boy Fishing, 14⅝ x 21." San Antonio Museum of Art.

A Brook Trout, 14 x 20". Private collection.

Burnt Mountain, 14 x 20". Fine Arts Museums of San Francisco.

Camp Fire, Adirondacks, 14⅞ x 21". Art Institute of Chicago.

Canoeing in the Adirondacks, 14⅞ x 21⅛". Private collection.

Deer Drinking, 14¹⁄₁₆ x 20¹⁄₁₆. Yale University Art Gallery.

The End of the Hunt, 15⅛ x 21⅜". Bowdoin College Museum of Art, Brunswick, Me.

Fallen Deer, 13¾ x 19¾". Museum of Fine Arts, Boston.

A Good Shot, Adirondacks, 15¹⁄₁₆ x 21¹¹⁄₁₆". National Gallery of Art.

Hudson River, 14 x 20". Museum of Fine Arts, Boston.

Hudson River—Logging, 14 x 21". Corcoran Gallery of Art, Washington, D.C.

Early Morning, Adirondacks (In the Fog), 14½ x 21". Fondazione Thyssen-Bornemisza, Lugano.

Hunter in the Adirondacks, 13⅞ x 22⅞". Fogg Art Museum, Harvard University Art Museums.

The Interrupted Tete-a-Tete, Adirondacks (North Woods Club, Adirondacks), 14½ x 21¹¹⁄₈". Art Institute of Chicago.

Landscape in Morning Haze (Deer at a Fence), 14½ x 21". Cooper-Hewitt National Design Museum, Smithsonian Institution.

The Lone Boat, North Woods Club, Adirondacks, 14¾ x 21⅛". Art Institute of Chicago.

Man and Boy in Boat (On the Lookout), 13⅜ x 19½". Private collection.

Mink Lake, Adirondacks, 13½ x 20¾". Cleveland Museum of Art.

Morning, 12½ x 20". Margaret Woodbury Strong Museum, Rochester, N.Y.

Old Settlers, 21½ x 15⅛". Museum of Fine Arts, Boston.

Paddling at Dusk, 15 x 21½". Memorial Art Gallery, Rochester, N.Y.

Pickerel Fishing, 10¾ x 19½". Portland [Me.] Museum of Art.

Prospect Rock, Essex Country, New York, 13½ x 19½". National Museum of American Art, Smithsonian Institution.

Ranger, Adirondacks, 13⅞ x 20". Ball State University Art Gallery, Muncie, Ind.

The Return to Camp, 15 x 21½". Private collection.

Sketch for Hound and Hunter, 13¹⁵⁄₁₆ x 20⅞". National Gallery of Art.

Two Men Rowing on a Lake, 15⅛ x 21⅜". Montclair (N.J.) Art Museum.

1894

Watercolors

The Adirondack Guide, 15⅛ x 21½". Museum of Fine Arts, Boston.

Casting the Fly, 15 x 21⅜". Portland [Me.] Museum of Art.

Dog on a Log, 14 x 20¾". Private collection.

Hilly Landscape, 14½ x 21". Private collection.

Hunting Dog among Dead Trees, 15⅛ x 21½". Museum of Fine Arts, Boston.

Indian Village, Adirondacks, 14⅜ x 20¾". Fogg Art Museum, Harvard University Art Museums.

Old Friends, 21½ x 15⅛". Worcester [Mass.] Museum of Art.

Playing Him (The North Woods), 15 x 21½". Currier Gallery of Art, Manchester, N.H.

Rapids—Hudson River, Adirondacks, 14⅞ x 21". Art Institute of Chicago.

The Tree Across the Trail, 13⅛ x 19". Private collection.

[1897]

Hudson River — Logging. See 1892.

1900

Watercolors

The Bass, 14 x 21". University Art Museum, Arizona State University, Tempe.

Fish and Butterflies, 14½ x 20¹¹⁄₁₆". Sterling and Francine Clark Art Institute, Williamstown, Mass.

The Pioneer, 13⅞ x 21". Metropolitan Museum of Art.

The Rise, 13⅜ x 20⅜". Portland [Me.] Museum of Art.

1902

Watercolor

Burnt Mountain (Mountain Landscape), 14⁷⁄₁₆ x 21¹¹⁄₁₆". Addison Gallery of American Art, Andover Academy.

1908

Illustrations

Guides Carrying Bear, North Woods Club, graphite on paper, 4¼ x 9¼". North Woods Club.

Sportsmen and Bear, North Woods Club, graphite on paper, 4¼ x 5½". North Woods Club.

Notes

Chapter 1. 1870

1. William Henry Harrison Murray, *Adventures in the Wilderness* (1869; new ed., ed. William Verner, Syracuse: Syracuse Univ. Press, 1970).

2. For reproductions of these paintings, see Gordon Hendricks, *Life and Work of Winslow Homer* (New York: Abrams, 1979). For Homer's Civil War paintings, see Marc Simpson, *Winslow Homer: Paintings of the Civil War* (San Francisco: Fine Arts Museums 1988).

3. David Tatham, "Winslow Homer in the White Mountains, 1868–1869." *American Art Journal*, in press.

4. In its exhibition at the Century Association in New York in April 1871, the painting was listed as "River Scene, Man on a Decayed Trunk, Guiding Boat," Lloyd and Edith Havens Goodrich/Whitney Museum of American Art Record of Works by Winslow Homer, City University of New York Graduate Center. The "river" is, in fact, Mink Pond, Town of Minerva, New York. I thank Abigail Booth Gerdts for reporting this early title to me.

5. For Valentine, see Linda Ayres, "Lawson Valentine, Houghton Farm, and Winslow Homer," in John Wilmerding and Linda Ayres, *Winslow Homer in the 1870s* (Princeton: Princeton Univ., Art Museum, 1990), 18–26, 73–75.

6. According to family tradition relayed to me by Lois Homer Graham. He approved of the church for others, however. See also Philip C. Beam, *Winslow Homer at Prout's Neck* (Boston: Little, Brown, 1966), pp. 193–94.

7. Patricia Junker, "Expressions of Art and Life in *The Artist's Studio in an Afternoon Fog*," in Philip C. Beam et al., *Winslow Homer in the 1890s: Prout's Neck Observed* (New York: Hudson Hills, 1990), 34–65.

8. An 1876 plot map of the Town of Minerva shows Wallace's house on the north side of the road leading from the village to the Baker's clearing. This detail is reproduced in *Minerva: A History of a Town in Essex Co., N.Y.* (Minerva, N.Y.: Minerva Historical Society, 1967), map following p. 210. He evidently owned Homer's watercolor *Hunting Dog Among Dead Trees* (Museum of Fine Arts, Boston), which is inscribed on the verso, not by Homer, "Rufus Wallice [*sic*], Chestertown, Warren Co., N.Y."

9. For the two Poussin paintings (c. 1628–29 and 1638–40), see Richard Verdi, *Nicolas Poussin, 1594–1665* (London: Zwemmer/Royal Academy of Arts, 1995), 170–71, 218–219.

10. Homer's croquet subjects are reproduced in David Park Curry, *Winslow Homer: The Croquet Game* (New Haven: Yale Univ. Art Gallery, 1984).

11. The guide as attendant appears notably in such work of Arthur Fitzwilliam Tait as *A Good Chance, Going Out: Deer Hunting in the Adirondacks* and *A Good Time Coming*, all of 1862, reproduced in Warder Cadbury, *Arthur Fitzwilliam Tait: Artist in the Adirondacks* (Newark: Univ. of Delaware Press, 1986).

12. John W. Beatty, "Recollections of an Intimate Friendship," in Lloyd Goodrich, *Winslow Homer* (New York: Macmillan, 1944), 222.

13. For the work of Cole and his followers, see *American Paradise: The World of the Hudson River School*, exhibition catalogue (New York: Metropolitan Museum of Art, 1987. For Cole's allegorical paintings, see *Thomas Cole: Landscape into History*, exhibition catalogue (New Haven: Yale Univ. Press, 1994).

14. Leila Fosburgh Wilson, *The North Woods Club, 1886–1986* (Minerva, N.Y.: privately printed, 1986). My account of the Bakers, the clearing, and the club is drawn chiefly from this centennial history.

15. Ibid., 7.

16. Terry to Eunice Harris Baker, 20 June 1870. Juliette Baker Rice Kellogg papers [MS 83-18], Adirondack Museum.

17. Terry to Eunice Baker, 2 May and 12 Nov 1868 Kellogg papers. Karst to Eunice Baker, 3 Jun 1869 Kellogg papers. Fitch addressed his letter of 7 Sept 1873 to "Hotel Baker, Forest Primeval," Minerva.

18. Homer's deeply ingrained, Victorian middle class rectitude in the matter of models can be inferred from what is known of his practice. In his New York studio he used professional models; the profession was one of doubtful respectability. Outside New York, where professional models were not available, he sometimes used friends and relatives. In Belmont, Massachusetts, and at Lawson Valentine's Houghton Farm in Mountainville, New York, he occasionally dressed boys as girls to avoid imputations of impropriety, since posing for pay would have been a morally questionable act for self-respecting middle class girls and women—a lady did not work for money. Portraits were a different matter, of course, since the sitter paid the artist. In later life at Cullercoats in England and at Prout's Neck in Maine, places where he was part of a small, closely knit community of working folk, he paid friends and neighbors to pose. His views and practice concerning models seem to have been little different from those of other American artists of his generation.

19. Frederick Kilbourne, *Chronicles of the White Mountains* (Boston: Houghton Mifflin, 1917).

20. Michael Kudish, *Where Did the Tracks Go: Following Railroad Grades in the Adirondacks* (Saranac Lake, N.Y.: Chauncy Press, 1985), 19.

21. Henry David Thoreau, *Walden* (1854; new ed., New York: Modern Library, 1950), 13, 81.

22. Warder Cadbury, "Introduction," 36–39, in Murray, *Adventures.*

23. Murray, *Adventures,* 10

24. Homer drew these subjects on woodblocks; a wood engraver cut them; each engraved woodblock was then transformed through a series of castings into a metal matrix; finally, high speed presses printed tens of thousands of impressions of each subject as a full page illustration in the magazine. This division of labor, in which artisan engravers translated an artist's original drawing into an engraved surface, was standard practice in the popular graphic arts for most of Homer's career, until satisfactory means of photomechanical reproduction arrived later in the century. Although Homer's illustrations are not "original" prints, as his later etchings are, their content and style are wholly his.

25. Martin's landscapes appeared in *Every Saturday* for 3 Sept. 1870. For a selection of satiric illustrations of Adirondack tourist life, see Cadbury, "Introduction," 41–47. See also Edward Comstock, Jr., "Satire in the Sticks: Humorous Wood Engravings of the Adirondacks," in David Tatham, ed., *Prints and Printmakers of New York State, 1820–1940* (Syracuse: Syracuse Univ. Press, 1986), 163–82.

26. Terry to Juliette Baker Rice, 18 Dec. 1870. Kellogg papers.

27. Terry to Juliette Baker Rice, May 1870, Kellogg papers.

28. Wallace to Wesley Rice, May 1870, Kellogg papers.

29. Charles Dudley Warner, *In the Wilderness* (1878; reprint, Syracuse: Syracuse Univ. Press, 1990), 31, 34.

30. Ibid., 34, 35.

31. For a history of logging in the Adirondacks, see Barbara McMartin, *The Great Forest of the Adirondacks* (Utica, N.Y.: North Country Books, 1995).

32. The standard critical biography is Lloyd Goodrich, *Winslow Homer* (New York: Macmillan, 1944). See also Nicolai Cikovsky, Jr., *Winslow Homer* (New York: Abrams, 1990)

33. For Agassiz's teaching method, see Edward Lurie, *Louis Agassiz: A Life in Science* (Chicago: Uni-

versity of Chicago Press, 1960), 240–41. For Homer and Agassiz, see Jana Colacino, "Winslow Homer Watercolors and the Color Theories of M. E. Chevreul," M.A. thesis, Syracuse Univ., 1994. I am grateful also to Elizabeth Horn for sharing information from her research into the Caribbean expedition led by Alexander Agassiz.

34. William Howe Downes, *The Life and Works of Winslow Homer* (Boston: Houghton Mifflin, 1911), 28.

35. David Tatham, "Winslow Homer's Library," *American Art Journal* 9, no. 1 (May 1977): 92–98.

36. For Homer as a fisherman in the Adirondacks and Quebec, see David Tatham, Hallie Bond, and Tom Rosenbauer, *Fishing in the North Woods: Winslow Homer* (Boston: Museum of Fine Arts, 1995).

37. The extent of the influence of French painting on Homer and the significance of his ten-month stay in France in 1866–67 have been discussed with little consensus in the Homer literature for many years. For a useful summary of the issues and a reasoned analysis of them, see Henry Adams, "Winslow Homer's 'Impressionism' and Its Relation to His Trip to France," in *Winslow Homer: A Symposium,* Studies in the History of Art 26, ed. Nicolai Cikovsky, Jr. (Washington: National Gallery of Art, 1990): 60–83.

38. Downes, *Homer,* 36. Downes assumed that Homer knew Rondel only in New York in the 1860s, but the two were acquainted in Boston in the 1850s when Rondel's interest in the Adirondacks was at its peak. For Rondel, see also David Tatham, "A Drawing by Winslow Homer: 'Corner of Winter, Washington, and Summer Streets,'" *American Art Journal* 18, no. 3 (1986): 48 and "Winslow Homer at the North Woods Club," in Cikovsky, ed., *Homer Symposium,* 116–17. Another Adirondack subject by Rondel is his lithograph, *View on the Raquette River,* c. 1858, published in Boston by F. F. Oakley, impression Adirondack Museum.

39. Downes, *Homer,* 28–29.

40. The translation from Courbet follows Linda Nochlin, in her *Realism and Tradition in Art, 1848–1900* (Englewood Cliffs, N.J.: Prentice-Hall, 1966), 33–34.

41. Ibid., 34.

42. Ibid.

43. Goodrich, *Homer* [1944], 39–42; Adams, "Homer's Impressionism."

44. David Sellin, *The First Pose* (New York: Norton, 1976), 12–13.

45. *Harper's Weekly,* 11 Jan. 1868, 25.

46. Goodrich, *Homer* [1944], 6.

Chapter 2. 1874

1. In establishing Homer's general itinerary, I have been aided by information compiled by Lloyd and Edith Havens Goodrich and Abigail Booth Gerdts.

2. Peggy O'Brien papers, Adirondack Museum.

3. Marianna (Mrs. Schuyler) Van Rensselaer, "Winslow Homer" in *Six Portraits* (Boston: Houghton, Mifflin, 1889), 272.

4. Recollections of members of the North Woods Club in conversation with the author.

5. For a discussion of Homer's use of children as a subject in the 1870s, see Nicolai Cikovsky, Jr., "Winslow Homer's 'School Time: A Picture Thoroughly National,'" in *Essays in Honor of Paul Mellon,* ed. John Wilmerding (Washington, D.C.: National Gallery of Art, 1986), 46–69.

6. Henry James, "On Some Pictures Lately Exhibited," *Galaxy* 20 (July 1875) 90, 93–94.

7. Van Rensselaer, *Six Portraits,* 242–44.

8. Goodrich, *Homer* [1944], 124.

9. A. Hyatt Mayor and Mark Davis, *American Art at the Century* (New York: Century Assoc., 1977), 54.

10. Margaret C. Conrads, *American Paintings and Sculpture at the Sterling and Francine Clark Art Institute* (New York: Hudson Hills, 1990), 70–72.

11. The word "Sawkill" appears on Homer's drawing, but the location may be in the Hudson River Valley near Hurley or in Pennsylvania. Hendricks, *Homer*, 79–80. The sketch for *The Fishing Party* is in the Cooper-Hewitt Museum, Smithsonian Institution. It is reproduced in Lloyd Goodrich, *The Graphic Art of Winslow Homer* (New York: Museum of Graphic Art, 1968), fig. 44.

12. Seneca Ray Stoddard, *The Adirondacks: Illustrated* (Albany, 1874), 134.

13. The photograph is reproduced in Hendricks, *Homer*, 169.

14. The dimensions of the 1874 oils are 12 x 20" or slightly smaller; those of the 1877 oils are 24 x 40" or slightly smaller.

15. I am indebted to the late Peggy O'Brien for bringing this photograph to my attention.

16. Stoddard, *Adirondacks: Illustrated*, 136–50.

Chapter 3. 1877

1. "Reopening the Studios," *New York Tribune*, 13 Oct. 1877, 2. I thank Margaret Conrads for sharing with me her discovery of this article and Abigail Booth Gerdts for her part in making it known to me.

2. Downes, *Homer*, 90; Goodrich, *Homer* [1944], 70; Hendricks, *Homer*, 118–19.

3. The appearance of two figures in the same costumes in the drawing, *Beaver Mountain*, and *In the Mountains* suggests that all three works came from the same season in the Adirondacks, but it is possible that the drawing came first and served as the source of the women's figures in both paintings.

4. For treatments by other artists, see Martha Banta, *Imaging American Woman* (New York: Columbia Univ. Press, 1987).

5. Lloyd and Edith Havens Goodrich, "Adirondack Works by Winslow Homer," *Winslow Homer in the Adirondacks*, exhibition catalogue (Blue Mountain Lake, N.Y.: Adirondack Museum, 1959), 21–27.

6. *Tribune*, "Reopening," 2.

7. Ibid.

8. Warner, *In the Wilderness*, 49.

9. Stoddard, *Adirondacks: Illustrated*, 136–50.

10. Ibid., 138.

11. Ibid., 137–38; Alfred L. Donaldson, *A History of the Adirondacks*, 2 vols. (New York: Century, 1921), 1:53–62; Bill Healy, *The High Peaks of Essex: The Adirondack Mountains of Orson Schofield Phelps* (Fleischmanns, N.Y.: Purple Mountain Press, 1992).

12. For a compilation of Phelps' newspaper contributions see Morris Glen, *The Keene Flats of Old Mountain Phelps*, vol. 2 of *Glen's History of the Adirondacks (Essex County, N.Y.)* (Alexandria, Va., 1987). Phelps's contributions for 1877 have not been located.

13. Undated clipping from J. P. Atkinson, "Memories of Keene Valley in the Late '80s," serialized in the *Glens Falls [N.Y.] Post-Star*, 1928–29; "Art at the Union League," *New York Times*, 14 Feb. 1890, 4.

14. Atkinson, "Memories;" "A Big Deer Hunt," *Essex County Republican*, 27 Mar. 1873, reprinted in Glen, *Keene Flats*, 37–38; "Art at the Union League," *New York Times*, 14 Feb. 1890, p. 4.

15. Stoddard, *Adirondacks: Illustrated*, 151.

16. Ibid.

17. Murray, *Adventures*, 37–38.

18. Stoddard, *Adirondacks: Illustrated*, 148.

19. Ripley Hitchcock, ed., *The Art of the World Illustrated in . . . the World's Columbian Exposition*, 2 vols. (New York: Appleton, 1894), 2:150.

20. Samuel Swift in the *New York Mail and Express,* 19 Mar. 1898; *Catalogue of the Private Art Collection of Thomas B. Clarke* (New York, 1899). For a history of the painting in the Clarke collection see H. Barbara Weinberg, "Thomas B. Clarke: Foremost Patron of American Art From 1872 to 1899," *American Art Journal* 8, no. 1 (May 1876): 52–83.

21. Kenyon Cox, *Winslow Homer* (New York: privately printed, 1914), 24; Goodrich, *Homer [1944],* 57–58. Albert Ten Eyck Gardner, *Winslow Homer, American Artist: His World and His Work* (New York: Clarkson N. Potter, 1961), 204–5. See also Conrads, *American Painting,* 73–77.

22. *Tribune,* "Reopening," 2.

23. Roswell Shurtleff, letter to the editor, *American Art News* 9 (29 Oct. 1910), 4.

24. For a succinct summary of the younger generation and its European orientation, see Edgar P. Richardson, *Painting in America* (New York: Crowell, 1956), 267–311.

25. George W. Sheldon, "Sketches and Studies II," *Art Journal* 42 (Apr. 1880): 107–8. The passage pertinent to *Camp Fire* is reprinted in Goodrich, *Homer* [1944], 66–67.

26. For the Philosophers' Camp, see Hans Huth, *Nature and the American: Three Centuries of Changing Attitudes* (Berkeley: Univ. of California Press, 1957), 96–100.

27. Patricia C. F. Mandel, *Fair Wilderness: American Paintings in the Collection of the Adirondack Museum* (Blue Mountain Lake, N.Y.: Adirondack Museum, 1990): 101–2.

28. Rondel's later career has not yet been traced in detail, but he taught privately in Philadelphia as well as New York.

29. Warner, *Wilderness,* 81–82.

30. The family tradition is supported by the resemblance of the seated figures to Homer's two watercolor portraits of his brother. Natalie Spassky, *et al., American Paintings in the Metropolitan Museum of Art,* vol. 2 (New York: Metropolitan Museum of Art, 1985), 467.

31. To cart a stretcher some two by three-and-a-quarter feet through the forest would have been unusual perhaps but by no means impossible, especially not for Holt, for there would have been little weight to it. There is no reason to doubt Homer's assertion that he painted *Camp Fire* on the spot.

32. Warner, *Wilderness,* 87.

Chapter 4. The Hiatus

1. A tradition at Prout's Neck held that Homer was an inveterate reader of magazines. He mentions *Scribners'* in a letter to Louis Prang; he contributed drawings to *Century* in the 1880s; he had long been associated with the Harper firm; for reading at a less elevated level, Frank Duveneck recalled Homer reading the *Police Gazette* on the train from New York to Pittsburgh. Charles Homer probably subscribed to *Scientific American.* For the role of magazines in popularizing Darwinism, see Richard Hofstadter, *Social Darwinism in American Thought,* rev. ed. (Boston: Beacon Press, 1960), 13–30.

2. Wilson, *North Woods Club,* 10.

3. For reproductions, see Helen Cooper, *Winslow Homer Watercolors* (New Haven: Yale Univ. Press, 1986), 52–65. See also Wilmerding and Ayres, *Homer in the 1870s,* 60–72.

4. For reproductions, see Cooper, *Homer Watercolors,* 66–79.

5. Ibid., 92–123.

6. Goodrich, *Homer* [1944], 82.

7. Ibid., 86–87.

8. Marianna Van Rensselaer, "An American Artist in England," *Century* 27 (Nov. 1883), 13–21, reprinted with revisions in *Six Artists,* 237–74.

9. In 1859, Church's *Heart of the Andes* had sold for $10,000, a price far above anything Homer earned for a single painting at any point in his career. See Debora Rindge, "Chronology," in Franklin

Kelly, *Frederic Edwin Church* (Washington, D.C.: Smithsonian Institution Press, 1989), 164. Bierstadt realized even higher prices for his colossal scale landscapes.

10. Goodrich, *Homer* [1944], 101.

11. Goodrich, *Graphic Art*, 13–19, 89–103.

12. Alexander Agassiz, *Three Cruises of the Steamer* Blake. 2 vols. (Boston: Houghton Mifflin, 1888).

13. For Homer's life at Prout's Neck, see Philip C. Beam, "Winslow Homer Before 1890," Lois Homer Graham, "The Homers and Prout's Neck," and Patricia Junker, "Expressions of Art and Life in 'The Artist's Studio in an Afternoon Fog,'" in Beam et al., *Winslow Homer in the 1890s,* 15–65. See also Philip C. Beam, *Winslow Homer at Prout's Neck* (Boston: Little, Brown, 1966).

Chapter 5. 1889

1. Goodrich, *Homer* [1944], 87, 117–18; Cooper, *Homer Watercolors,* 193.

2. North Woods Club register, Adirondack Museum.

3. Ibid.

4. Though Lancashire does not seem to appear in Homer's work after 1870, his association with the Bakers continued at least through the 1880s. He and members of his family receive frequent mention in the diaries of Juliette Baker Rice Kellogg. A typescript of the diaries is in the library of the Adirondack Museum.

5. While it has become increasingly common during the twentieth century to blur these distinctions in the cases of artists who have created major works in both media, the term *painting* continues usefully to be reserved for works in oil (or its synthetic substitutes).

6. The existence of watercolors dated 1890 has led to the assumption that Homer spent time in the Adirondacks in that year, but there is no evidence of such a visit.

7. *New York Commercial Advertiser,* 15 Feb. 1890, 6.

8. *New York Times,* 16 Feb. 1890, 3.

9. Thoreau, *Walden and Other Writings,* 315.

10. In a census conducted in 1993, the author located fewer than twenty impressions.

11. Van Rensselaer, *Six Portraits,* 244. For Homer in the context of Impressionism, see Adams, "Winslow Homer's 'Impressionism'" in Cikovsky, *Homer Symposium,* 80–82.

12. *New York Evening Post,* 19 Feb. 1890, 3.

13. Murray, *Adventures,* 10.

14. Barbara McMartin, *The Great Forest of the Adirondacks* (Utica, N.Y.: North Country Books, 1994). This revisionist study shows the history of Adirondack logging to have been more complex than earlier accounts have indicated and proposes that the fear of wholesale devastation was unwarranted.

15. Thoreau, *Walden and Other Writings,* 613.

16. Wilson, *North Woods Club,* 8.

17. Donaldson, *History,* 2:177.

18. Stoddard, *Adirondacks: Illustrated* (1891), pp. vi–vii.

19. Stoddard, *Adirondacks: Illustrated* (1892), p. viii.

20. Frank Graham, Jr., *Adirondack Park: A Political History* (New York: Knopf, 1978), 119–32.

21. While it is often noted that the three largest national parks excluding those in Alaska have in total fewer square miles than the Adirondack Park, they consist entirely of public land. Some National Forests exceed the size of the Park.

22. Michael Kudish, *Where Did the Tracks Go: Following Railroad Grades in the Adirondacks*

(Saranac Lake, N.Y.: Chauncy Press, 1985), 57. On some of his later visits to the club he may have left Prout's Neck for nearby Portland and there boarded the Grand Trunk Railroad for Montreal, changing to the Albany train and leaving it at Saratoga Springs for the North Creek line. Alternatively, he would have left Portland for Boston, changed there for Albany, gone on to Saratoga Springs and then to North Creek.

23. Juliette Baker Rice Kellogg mentions this absence in her diary. Adirondack Museum.

24. North Woods Club minute book, North Woods Club, Minerva, N.Y. It is possible that Homer and his brother participated in discussions that led to the founding of the club.

25. North Woods Club register, Adirondack Museum.

26. Goodrich, *Homer* [1944], 102.

27. North Woods Club register, Adirondack Museum.

28. *Minerva 1817–1967: A History of a Town in Essex Co., N.Y.* (Minerva, N.Y.: Minerva Historical Society, 1967), 126.

29. North Woods Club register, Adirondack Museum.

30. Ibid.

31. Wilson, *North Woods Club*, 13.

32. Ibid, 21.

33. Ibid., 12.

34. North Woods Club minute book, entry for Oct. 27, 1910.

35. Quoted in Goodrich, *Homer* [1944], 121.

36. Goodrich, *Homer* [1944], 21.

Chapter 6. The 1890s

1. North Woods Club register, Adirondack Museum.

2. Quoted in Goodrich, *Homer* [1944], 122.

3. Ibid., 123.

4. Property boundaries in the 1880s and 1890s were often ill-defined.

5. For biographical information about Flynn, I am grateful to his children Rose Flynn Brown, the late Patrick Flynn, Elizabeth Flynn Filkins, and Mary Flynn Jenkins, as well as to Noelle Donahue of the Minerva Historical Society.

6. He was also a devout Roman Catholic, as were many of the residents of the Township of Minerva, most of whom were descendents of prefamine immigrants from Ireland to northern New York State.

7. Recalled by Patrick Flynn in conversation with the author.

8. Recalled by Rose Flynn Brown in conversation with the author.

9. Beam, *Homer at Prout's Neck*, 99–100.

10. Wilson, *North Woods Club*, 11

11. Donaldson, *History*, 2:209.

12. Edwin Adams daybook, private collection. The daybook covers the hunting seasons from 1892 through 1896.

13. Ibid.

14. Ibid.

15. Ibid.

16. Quoted in Hendricks, *Homer*, 210–11.

17. Quoted in Goodrich, *Homer* [1944], 123.

18. Homer undoubtedly knew, for example, the two reproductions of Japanese prints illustrating a Japanese story in *Frank Leslie's Illustrated Newspaper* for 7 Feb. 1857. Not yet eclipsed by the new *Harper's Weekly, Leslie's* was then the major New York pictorial weekly and widely distributed throughout the nation. As a young graphic artist about the embark on a career drawing for illustrated weeklies, Homer would have studied every issue in these years.

19. An unidentified clipping at the library of the Adirondack Museum states that Wallace died in Chestertown in 1911.

20. I have drawn biographical information about Yalden from *J. Ernest Grant Yalden, 1870–1937* (New York: New York Community Trust, n.d.) and from obituaries published in *Popular Astronomy* 45 (1937): 296–98, *Science* 85 (1937): 325–26, and *Monthly Notices of the Royal Astronomical Society* 98 (1938): 262–73.

21. Reproduced in *Winslow Homer at the Addison* (Andover, Mass.: Addison Gallery of American Art of Phillips Academy, 1990), 82. Once attributed to Homer by the Knoedler Gallery, the present owner, the Addison Gallery, leaves the drawing unattributed. The location of Limestone Mountain is unknown; no mountain in or near Essex County now holds that name, but the names of numerous Adirondack mountains and lakes have changed since mid-nineteenth century. Of the two figures in the drawings, the standing one, trim, slight of stature, and erect in posture, may well be Homer.

22. North Woods Club register, Adirondack Museum.

23. For a summary of the ideas of the movement and their place in public education, see Calvin M. Woodward, *The Manual Training School* (Boston: Heath, 1887).

24. Yalden to Robert McDonald, 30 Sept. 1936. Memorial Art Gallery, Rochester, N.Y.

Chapter 7. 1900–1910

1. North Woods Club register, Adirondack Museum.

2. This work has also been known by the title *Mountain Landscape.*

3. Goodrich, *Homer* [1944], 187–201.

4. North Woods Club register, Adirondack Museum. Homer's visit to the club in 1910 was unknown to Goodrich and other biographers. Goodrich had depended on an examination of the club's register by a club member who conducted it under difficult circumstances and, perhaps assuming that Homer would not have gone to the club so close to the end of his life, failed to check the year 1910 where Homer's distinctive signature in a firm hand can be found.

5. This account is traditional, reported to the author in 1966 by an employee of the club who had learned it from the son of a club member who had been at the club when Homer shot the bear.

6. North Woods Club register, Adirondack Museum.

7. Ivan Turgenev. *On the Eve,* Trans. Isabel Hapgood (New York: Scribner's, 1903), 275.

Works Cited

Manuscript sources

Adirondack Museum, Blue Mountain Lake, N.Y.
 North Woods Club Club House register.
 Peggy O'Brien papers.
 Juliette Baker Rice Kellogg papers.

Books and Exhibition Catalogues

Addison Gallery of American Art, Phillips Academy. *Winslow Homer at the Addison*. Exhibition catalogue. Andover, Mass.: Phillips Academy, 1990.

Adirondack Museum. *Winslow Homer in the Adirondacks*. Exhibition catalogue. Blue Mountain Lake, N.Y.: Adirondack Museum, 1959.

Agassiz, Alexander. *Three Cruises of the Steamer* Blake. 2 vols. Boston: Houghton Mifflin, 1888.

Banta, Martha. *Imaging American Woman*. New York: Columbia Univ. Press, 1987.

Beam, Philip C. *Winslow Homer at Prout's Neck*. Boston: Little, Brown, 1966.

————. *Winslow Homer's Magazine Engravings*. New York: Harper and Row, 1979.

Beam, Philip C., et al. *Winslow Homer in the 1890s: Prout's Neck Observed*. New York: Hudson Hills, 1900.

Bond, Hallie E. *Boats and Boating in the Adirondacks*. Syracuse: Syracuse Univ. Press, 1995.

Brown, Rose Flynn. *Memories of Dad*. Glens Falls, N.Y.: privately printed, 1995.

Burns, Sarah. *Pastoral Inventions: Rural Life in Nineteenth-Century American Art and Culture*. Philadelphia: Temple Univ. Press, 1989.

Cadbury, Warder. *Arthur Fitzwilliam Tait: Artist in the Adirondacks*. Newark: Univ. of Delaware Press, 1986.

Cikovsky, Nicolai, Jr. *Winslow Homer*. New York: Abrams, 1990.

————, ed. *Winslow Homer: A Symposium*. Washington, D.C.: National Gallery of Art, 1990.

Conrads, Margaret C. *American Paintings and Sculpture at the Sterling and Francine Clark Art Institute*. New York: Hudson Hills, 1990.

Cooper, Helen. *Winslow Homer Watercolors*. New Haven: Yale Univ. Press, 1986.

Cooper-Hewitt Museum. *Winslow Homer 1836–1910: A Selection from the Cooper-Hewitt Collection*. Washington, D.C.: Smithsonian Institution Press, 1972.

Cox, Kenyon. *Winslow Homer*. New York: privately printed, 1914.

Crowley, William. *Seneca Ray Stoddard: Adirondack Illustrator*. Blue Mountain Lake, N.Y.: Adirondack Museum, 1981.

Curry, David Park. *Winslow Homer: The Croquet Game*. Exhibition catalogue. New Haven: Yale Univ. Art Gallery, 1984.

Donaldson, Alfred L. *A History of the Adirondacks*. 2 vols. New York: Century, 1921.

Downes, William Howe. *The Life and Works of Winslow Homer*. Boston: Houghton Mifflin, 1911.

Fuller, John. *Seneca Ray Stoddard in the Adirondacks with Camera*. Exhibition catalogue. Syracuse: Robert B. Menschel Photography Gallery, Syracuse University.

Gardner, Albert Ten Eyck. *Winslow Homer, American Artist: His World and His Work*. New York: Clarkson Potter, 1961.

Glen, Morris. *The Keene Flats of Old Mountain Phelps*. Vol. 2 of *Glen's History of the Adirondacks (Essex County, N.Y.)*. Alexandria, Va.: author, 1987.

Goodrich, Lloyd. *The Graphic Art of Winslow Homer*. Exhibition catalogue. New York: Museum of Graphic Art, 1968.

_____. *Winslow Homer*. New York: Macmillan, 1944.

_____. *Winslow Homer*. New York: Braziller, 1959.

_____. *Winslow Homer*. Exhibition catalogue. New York: Whitney Museum of American Art, 1973.

_____. *Winslow Homer's America*. New York: Tudor, 1969.

Goodrich, Lloyd, and Abigail Booth Gerdts. *Winslow Homer in Monochrome*. Exhibition catalogue. New York: Knoedler, 1986.

Graham, Frank, Jr. *The Adirondack Park: A Political History*. New York: Knopf, 1978.

Healy, Bill. *The High Peaks of Essex: The Adirondack Mountains of Orson Schofield Phelps*. Fleischmanns, N.Y.: Purple Mountain Press, 1992.

Hendricks, Gordon. *Life and Work of Winslow Homer*. New York: Abrams, 1979.

Hitchcock, Ripley, ed. *The Art of the World Illustrated in . . . the World's Columbian Exposition*, 2 vols. New York, Appleton, 1894.

Hofstadter, Richard. *Social Darwinism in American Thought*, rev. ed. Boston: Beacon Press, 1955.

Huth, Hans. *Nature and the American: Three Centuries of Changing Attitudes*. Berkeley: Univ. of California Press, 1957.

Jamieson, Paul. *The Adirondack Reader*. New York: Macmillan, 1964.

Judge, Mary. *Winslow Homer*. New York: Crown, 1986.

Keller, Jane Eblen. *Adirondack Wilderness*. Syracuse: Syracuse Univ. Press, 1980.

Kelsey, Mavis Parrott. *Winslow Homer Graphics*. Exhibition catalogue. Houston: Museum of Fine Art, 1977.

Kilbourne, Frederick. *Chronicles of the White Mountains*. Boston: Houghton Mifflin, 1917.

Knipe, Tony. *Winslow Homer: All the Cullercoats Pictures*. Exhibition catalogue. Sunderland, U.K.: Northern Centre for Contemporary Art, 1988.

Kudish, Michael. *Where Did the Tracks Go: Following Railroad Grades in the Adirondacks*. Saranac Lake, N.Y.: Chauncy Press, 1985.

Lurie, Edward. *Louis Agassiz: A Life in Science*. Chicago: Univ. of Chicago Press, 1960.

Mandel, Patricia C. F. *Fair Wilderness: American Paintings in the Collection of the Adirondack Museum*. Blue Mountain Lake, N.Y.: Adirondack Museum, 1990.

Mayor, A. Hyatt, and Mark Davis. *American Art at the Century*. New York: Century Assoc., 1977.

McMartin, Barbara. *The Great Forest of the Adirondacks*. Utica, N.Y.: North Country, 1994.

Metropolitan Museum of Art. *American Paradise: The World of the Hudson River School*. Exhibition catalogue. New York: Metropolitan Museum of Art, 1987.

Minerva: A History of a Town in Essex Co., N.Y. Minerva, N.Y.: Minerva Historical Society, 1967.

Murphy, Alexandra R. *Winslow Homer in the Clark Collection*. Williamstown, Mass.: Sterling and Francine Clark Art Institute, 1986.

Murray, William H. H. *Adventures in the Wilderness*. Boston: Fields, Osgood, 1869. New Edition.

Edited by William K. Verner. Syracuse: Syracuse Univ. Press/Adirondack Museum, 1970.

Nash, Roderick. *Wilderness and the American Mind,* 3d ed. New Haven: Yale Univ. Press, 1982.

Nochlin, Linda. *Realism and Tradition in Art: 1848–1900.* Englewood Cliffs, N.J.: Prentice-Hall, 1966.

Reed, Sue Welsh, and Carol Troyen. *Awash in Color: Homer, Sargent, and the Great American Watercolor.* Boston: Museum of Fine Arts, 1993.

Richardson, Edgar P. *American Art.* Exhibition catalogue. San Francisco: Fine Arts Museums, 1976.

_____. *Painting in America.* New York: Crowell, 1956.

Sellin, David. *The First Pose.* New York: Norton, 1976.

Simpson, Marc. *Winslow Homer: Paintings of the Civil War.* San Francisco: Fine Arts Museums, 1988.

Spassky, Natalie, et al. *American Paintings in the Metropolitan Museum of Art.* Vol. 2. New York: Metropolitan Museum of Art, 1985.

Stepanek, Stephanie Loeb. *Winslow Homer.* Exhibition catalogue. Boston: Museum of Fine Arts, 1977.

Stoddard, Seneca Ray. *The Adirondacks: Illustrated.* Albany, N.Y.: author, 1874. Revised editions published annually by the author in Glens Falls, N.Y.

Tatham, David. *Winslow Homer Drawings, 1875–1885: Houghton Farm to Prout's Neck.* Exhibition catalogue. Syracuse: Lowe Art Gallery of Syracuse Univ., 1979.

_____. *Winslow Homer in the 1880s.* Exhibition catalogue. Syracuse: Everson Museum of Art, 1983.

Tatham, David, Hallie Bond, and Tom Rosenbauer. *Fishing in the North Woods: Winslow Homer.* Boston: Museum of Fine Arts, 1995.

Terrie, Philip G. *Forever Wild: Environmental Aesthetics and the Forest Preserve.* Philadelphia: Temple Univ. Press, 1985.

Thoreau, Henry David. *Walden and Other Writings.* Edited by Brooks Atkinson. New York: Modern Library, 1950.

Truettner, William, ed. *Thomas Cole: Landscape into History.* Exhibition catalogue. New Haven: Yale Univ. Press, 1994.

Van Rensselaer, Marianna (Mrs. Schuyler). *Six Portraits.* Boston: Houghton Mifflin, 1889.

Van Valkenburgh, Norman J. *The Adirondack Forest Preserve.* Blue Mountain Lake, N.Y.: Adirondack Museum, 1979.

Verdi, Richard. *Nicolas Poussin, 1594–1665.* London: Zwemmer/Royal Academy of Arts, 1995.

Warner, Charles Dudley. *In the Wilderness.* Boston: 1878. Reprint. Syracuse: Syracuse Univ. Press/Adirondack Museum, 1990.

Wilmerding, John, and Linda Ayres. *Winslow Homer in the 1870s.* Princeton: Princeton Univ. Art Museum, 1990.

Wilson, Leila Fosburgh. *The North Woods Club: 1886–1986.* Minerva, N.Y.: privately printed, 1986.

Woodward, Calvin. *The Manual Traing School.* Boston: Heath, 1887.

Articles

Adams, Henry. "Winslow Homer's 'Impressionism' and Its Relation to His Trip to France." In *Winslow Homer: A Symposium.* Studies in the History of Art 26, ed. Nicolai Cikovsky, Jr., 60–83.

Beam, Philip C. "Winslow Homer Before 1890." In *Winslow Homer in the 1890s: Prout's Neck Observed,* ed. Philip C. Beam et al. New York: Hudson Hills, 1990.

Beatty, John W. "Recollections of an Intimate Friendship" In Lloyd Goodrich, *Winslow Homer,* 207–26. New York: Macmillan, 1944.

Works Cited

∽

Cikovsky, Nicolai, Jr. "Winslow Homer's 'School Time: A Picture Thoroughly National.'" In *Essays in Honor of Paul Mellon,* ed. John Wilmerding, 46–69. Washington, D.C.: National Gallery of Art, 1968.

Comstock, Edward, Jr. "Satire in the Sticks: Humorous Wood Engravings of the Adirondacks." In *Prints and Printmakers of New York State, 1820–1940,* ed. David Tatham, 163–82. New York: Syracuse Univ. Press, 1986.

Fuller, John. "The Collective Vision and Beyond: Seneca Ray Stoddard's Photography." *History of Photography* 11, no. 3 (July–Sept. 1987): 217–27.

Goodrich, Lloyd and Edith Havens Goodrich. "Adirondack Works by Winslow Homer." In *Winslow Homer in the Adirondacks,* 21–27. Blue Mountain Lake, N.Y.: Adirondack Museum, 1959.

Graham, Lois Homer. "The Homers and Prout's Neck." In *Winslow Homer in the 1890s: Prout's Neck Observed.* ed. Philip C. Beam et al. New York: Hudson Hills, 1990.

James, Henry. "On Some Pictures Lately Exhibited." *Galaxy* 20 (July 1875): 88–97.

Junker, Patricia. "Expressions of Art and Life in 'The Artist's Studio in an Afternoon Fog.'" In *Winslow Homer in the 1890s: Prout's Neck Observed,* ed. Philip C. Beam et al. New York: Hudson Hills, 1990.

McGrath, Robert L. "The Space of Morality: Death and Transfiguration in the Adirondacks." In *Forever Wild: The Adirondack Experience,* 16–21. Exhibition catalogue. Katonah, N.Y.: Katonah Museum of Art, 1992.

O'Brien, Peggy. "Shurtleff." *Adirondack Life.* (Nov.–Dec. 1979): 40–43.

Rindge, Deborah. "Chronology." In Franklin Kelly, *Frederic Edwin Church.* Washington, D.C.: Smithsonian Institution Press, 1989.

Sheldon, George W. "American Painters—Winslow Homer and F. A. Bridgman." *Art Journal* 4 (Aug. 1878): 225–27.

Tatham, David. "A Drawing by Winslow Homer: 'Corner of Winter, Washington, and Summer Streets.'" *American Art Journal* 18, no. 3 (1986): 40–50.

_____. "Paddling at Dusk: Winslow Homer and Ernest Yalden." *Porticus* 9 (1986): 16–19.

_____. "Trapper, Hunter, and Woodsman: Winslow Homer's Adirondack Figures." *American Art Journal* 22, no. 4 (1990): 40–67.

_____. "The Two Guides: Winslow Homer at Keene Valley, Adirondacks." *American Art Journal* 20, no. 2 (1988): 20–34.

_____. "Winslow Homer at the North Woods Club." In *Winslow Homer: A Symposium,* ed. Nicolai Cikovsky, Jr., 114–30. Washington, D.C.: National Gallery of Art, 1990.

_____. "Winslow Homer's Library." *American Art Journal* 9, no. 1 (May 1977): 92–98.

Van Rensselaer, Marianna (Mrs. Schuyler). "An American Artist in England." *Century* 27 (Nov. 1883): 13–21.

Theses and Dissertations

Colacino, Jana. "Winslow Homer Watercolors and the Color Theories of M. E. Chevreul." M.A. thesis, Syracuse Univ., 1994.

Roth, Richard. "The Adirondack Guide in History, Literature, and Art." Ph.D. diss., Syracuse Univ., 1990.

Index